In this dream you pass me a book
in which I am supposed to be a forest that
is also a hermaphrodite narrator.
You say, 'You are San San, the closed restaurant,
the overdose of introspection.'

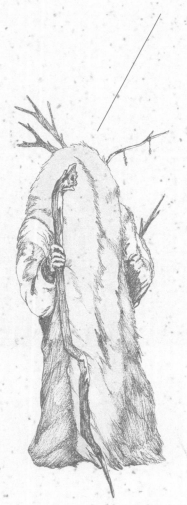

Elena Narbutaite, *Study of Water,* 2016
Watercolour on paper, 14.8 × 21 cm

The Two-Sided Lake

Episodes, Storyboards and Sets
from Liverpool Biennial 2016

The Hermaphrodite Narrator, who appears throughout this book, is illustrated by Sahej Rahal

Contents

Sally Tallant

Foreword

Liverpool Biennial 2016 explores fictions, stories and histories, taking viewers on a series of voyages through time and space. These narrative journeys take the form of six 'episodes': Ancient Greece, Chinatown, The Children's Episode, Software, Monuments from the Future and Flashback. To create each of these imaginary realms, the artists have time-travelled together, inventing a multiverse of protagonists for viewers to encounter on their adventures.

The fact that we can use technology as a window that propels us into other times and other places simultaneously, effectively collapsing geography and temporality, means that we no longer operate in a singular moment. To reflect this, the Biennial presents many collective voices, with artists, curators and Liverpool's inhabitants working together to create stories with multiple entry points and possibilities.

Archives and histories have played a critical role. By uncovering the forward-thinking work of Stafford Beer, Olaf Stapledon and others, we have brought their visions of the future from the past into the present, allowing us to better understand what might have been and what is yet come.

Liverpool Biennial 2016 celebrates what is possible when we work collectively to present work in and of the world in which we live. The exhibition is only complete when visitors play their part in the narrative. The emphasis is not on the vision of any one individual, but rather on the extraordinary worlds that can be envisaged and actualised by many people working collaboratively. This process has allowed us to explore the Biennial as an episode in time and we have found new ways to create multiple conversations with the city.

I am grateful to all of the members of the Curatorial Faculty for participating in such an open and collaborative process. It is more complicated and demanding to work in this way, but we have produced a rich and thoughtful exhibition and publication as a result, and it has been a wonderful process in which to be involved. First of all, I would like to thank Rosie Cooper, Francesca Bertolotti-Bailey, Polly Brannan and Joasia Krysa, who along with myself are the core members of the Liverpool Biennial Programme team. Raimundas Malašauskas, Dominic Willsdon and Francesco Manacorda joined the team in 2014 as co-curators and have all worked with generosity, commitment and have embraced this experimental process. Sandeep Parmer, Ying Tan and Steven Cairns all joined the Faculty at a later stage and each brought specific expertise and knowledge to expand our collective thinking.

The curatorial process has been shared from the beginning with the public and with curators and partners in the city. This has enabled us to work together through feedback and conversations, and to adjust our thinking as it has developed.

A project on this scale is only possible because of the hard work of many individuals. I would like to thank the entire Liverpool Biennial team, who work tirelessly to ensure that all of our work is produced to the highest standard and that we reach the widest possible audiences. I am especially thankful to Sevie Tsampla and Mels Evers, Assistant Curators, for their commitment and hard work, and to Aimee Johnston, Education Intern. I am also grateful to Ozkan Canguven and Lizaveta German, Visiting Curators, for their dedication in the later stages of the Biennial, to Gabriela Silva, who has developed our Mediator programme, to the Mediators, and to everyone who has been part of our Curatorial Trainee programme. I would also like to thank our communications team, especially Joanne Karcheva, Communications Officer, and David Lally, Marketing and Communications Intern.

I am indebted to the designers Sara De Bondt and Mark El-khatib, who have designed this publication with precision and care. I am also grateful to Liverpool University Press, our publisher. Very special thanks are due to those whose thoughtful contributions make up this book.

I would also like to thank each of the many individuals in our partner organisations, without whom the Biennial would not be possible. I am grateful to Julie Lomax, Director of Development and her team; Paul Smith, Executive Director and all of the staff, trainees, mediators and Trustees of the Liverpool Biennial.

I would like to thank our principal funders, Arts Council England and Liverpool City Council. I am grateful to our sponsors and partners, especially Ted Baker with whom we have been delighted to partner for the first time, and important ongoing sponsorship from Bloomberg. Working with children and young people, and developing local talent is at the heart of what we do, and I want to thank the Foyle Foundation, Liverpool John Moores University, Granada Foundation, PH Holt Foundation, and the Hemby Trust for making this work possible.

Liverpool Biennial is a truly international project and I would like to thank the international embassies and agencies that support our artists' participation, our co-commissioning partners, and support for individual artists from trusts and foundations. I want to give special thanks to British Council, who play an important part in negotiating and funding international partnerships.

Liverpool Biennial acknowledges the important support of businesses in the city, Arriva, Arup, Liverpool Commercial District BID, Weightmans, Cass Art and our ongoing partnership with Liverpool ONE. I would like to thank Virgin Trains for their continued support as Liverpool Biennial travel partner. Hospitality and hosting visitors is very important and I want to thank our hotel and restaurant partners.

Finally, I am deeply grateful to the Liverpool Biennial patrons and corporate patrons, especially the Chair of the patrons group, Alex Wainwright and the circle of galleries, without whose enthusiasm and support nothing would be possible.

This is like the Biellmann spin – the closer objects come, the faster they spin. Its success allows many objects to depart from their usual context. (I was summoned back: the air of the exhibition started to fill with strange senses temporality began to master my attention.)

Using 'to-be-out-of-context' as a method, the 9th Liverpool Biennial marks a break with previous biennials, completely discarding geopolitical context-sensitivity. This has sparked debate within cu-ratorial circles. Some suggest, worryingly, that human artists may no longer be able to make art, and that algorithms are better adapted to such contextual antipathy, whilst others claim that the 9th Biennial marks an important temporal shift in curatorial paradigms.

As I write, a voice analyst, whose work thunders out across var-ious venues, searches for a solid foundation in the sphere of visual cul-tures from the perspective of legality and aurality. He believes that time travel should not be founded primarily on acceleration, which means for him a consolidation of the establishment: a linear temporality that marries with Renaissance linear perspective. For him, real time travel should not rely on the visual – that would only be the continuation of a European Enlightenment fantasy. Greater possibilities, found within the realm of the aural and the legal, hold the potential to break through the fictional boundary between past and future. A tropical astrologer in the exhibition holds a similarly critical attitude. Her works look into the future through star signs, highlighting a logic that cuts across time: the 'foretelling' that we talk of usually refers to the way in which we grasp a particular logic in the movement of things. When Marx says history repeats itself, the repetition is not the repetition of the fact itself but that of its logic. And grasping this logic is similar to the ability to understand future events in advance, even if in actual fact this is not the case.

The Biennial's methodological consensus is this: in order to accel-erate time, one must first return the object to the degree zero. To reset, Ian creates a simulator – mathematical formulae generate his animation, drawn from newborns' spontaneous reactions to objects and phenomena. Newborns have never experienced anything in the world. In their reac-tions to the unknown, one sees none other than the voluntary creativity that lies not on our side of knowledge, but within a temporality beyond what we know or understand. An unforeseen characteristic of the work is its ability to accidentally observe the psychological effects that the exhibition has on its audience. These effects are strikingly different in children. It turns out that a child's temporal perspective is different from that of an adult: they have no way to experience nostalgia, or what an even newer world there can be beyond a novel world in front of them'. Ian later also taught himself how to understand temporal differences from a child's perspective. With this toolkit, visitors will also no longer be troubled by the apparently hard-to-digest narrative of the exhibition.

Zian Chen

Pilot Review of
Liverpool Biennial 2016

Relative to visual cultures, literature is a rather more
stable intellectual milieu – and yet overly stable foundations
are not so appropriate for real time travel.
– The curators of Liverpool Biennial explaining
their actualisation of time travel.

The psychological effects of this Biennial – for some viewers, at least – are akin to the disturbing effects of time travel. For others, especially for the organisers and the artists, the acceleration of time appears not to have that shiny, novel allure. Such a dangerous undertaking has brought about a series of nightmarish side effects, like when artists who rely on dreams for their inspiration have their own dreams disrupted. The many participating artists, who include a 'director of behaviour', a 'sleep-sculptor', and a poet whose lines of verse unintentionally appear in the titles of the works, have all expressed concern about the temporal displacements caused by this exhibition. The Biennial normalises an inverted, topsy-turvy environment. In spite of the fact that all of its artists believe in subverting the relationship between reality and a limitless imagination, the exhibition ultimately upsets the rhythm and the metabolism of their creative practice. Their impulses are no longer so creative when the backdrop starts to be creative in its own right.

How might one accelerate time by curating an exhibition? In order to enact a physical change in the world through metaphysics, the curators of the Biennial have employed the notion of 'episode' as a guide-line (its role resembles a peculiar sense of temporality, we are told). They have used concepts drawn from digital service sectors, incorporating processes such as 'co-locating' and 'multi-focusing'. (The initial part of the curatorial plot was quite fun, very 'dreamy and drifty' until the day before the opening.)

In the opening exhibition tour, a sleepwalking workshop demonstrated that the ten co-curators are in fact the ten identities of a single person. The workshop explained how the ten co-curators can receive ten conflicting messages at once, and how – simultaneously – they can grasp the totality of ten different messages. (From this moment on, I was told, some of the visitors started to lose the totality of their own consciousness.) After that, another curator explained how many works in the exhibition employ a conceptual rotation for the purposes of acceleration.

'OK', I say and open the first page. It is probably
page seventeen or 90-something, one of those
numbers that pop up whenever one grabs a certain
book for the first time and then keep coming back
to whenever one opens it again, following the
first crease of the book's spine.

Artists

Lawrence Abu Hamdan
Andreas Angelidakis
Alisa Baremboym
Lucy Beech
Sarah Browne and Jesse Jones
Mariana Castillo Deball
Yin-Ju Chen
Ian Cheng
Marvin Gaye Chetwynd
Céline Condorelli
Audrey Cottin
Koenraad Dedobbeleer
Jason Dodge
Lara Favaretto
Danielle Freakley
Coco Fusco
Fabien Giraud and Raphaël Siboni
Ramin Haerizadeh, Rokni Haerizadeh
and Hesam Rahmanian
Hato
Ana Jotta
Samson Kambalu
Oliver Laric
Mark Leckey
Adam Linder
Marcos Lutyens
Jumana Manna
Rita McBride
Dennis McNulty
Elena Narbutaite
Lu Pingyuan
Michael Portnoy
Sahej Rahal
Koki Tanaka
Suzanne Treister
Villa Design Group
Krzysztof Wodiczko
Betty Woodman
Arseny Zhilyaev

Pilot Episode

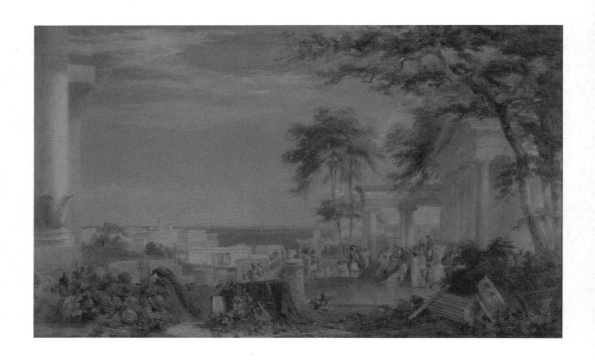

Samuel Austin
Carthage: Aeneas at the Court of Dido, 1826
Watercolour, 70.8 × 113.7 cm
Image courtesy of National Museums Liverpool

Pilot Episode

Since the beginning of civilisation, humans have told stories in episodes. Myth, brought into lived history through the epic, relies on simultaneous multiple narratives and personae. Cuts and flashbacks, parallel plotlines, were not invented by twentieth-century cinema or the modernist avant-garde: these devices originate in epics like the *Ramayana* and *Mahabharata*, the *Iliad*, *Odyssey* and *Aeneid*, and through more recent examples like the episodes of Abrahamic scriptures, Boccaccio's *Decameron*, Chaucer's *Canterbury Tales* and Dante's wandering, guided by Virgil, through the underworld in the *Divine Comedy*.

For Aristotle, epic poetry – which has many plots and subplots – relied on multiple episodic structures, but he criticised poor dramatists for bad episode-making in five-act tragedies:

> Of all plots and actions the episodic are the worst. I call a plot 'episodic' in which the episodes or acts succeed one another without probable or necessary sequence. Bad poets compose such pieces by their own fault, good poets, to please the players; for, as they write show pieces for competition, they stretch the plot beyond its capacity, and are often forced to break the natural continuity. (Aristotle, *Poetics*, Part 9)

But why should we expect plot lines to follow a logical arc from beginning to end? Perception, as the philosopher Henri Bergson reminds us, is not made in the moment of seeing, but by memories: in perceiving, 'we mingle a thousand details out of our past experience' with our present time, space, object. The re-telling of myth in the epic poetry, tragedy and comedy of the ancient world is a communal ritual, as with the ancient Greek Great Dionysia festival, in which citizens assembled to both remember and to see things anew.

Conventionally, the nineteenth-century *Bildungsroman*, or 'educational novel', used chapters to advance a story, following a protagonist through set-backs and triumphs. Modern life in the chaotic twentieth century, its upending of religious belief and its excavation of the unconscious, returns literature to its epic, mythic principles. After the *fin de siecle*, prophets of the avant-garde shatter expectations of continuous fictional narrative. Like the body of the lyric poet Orpheus, ripped to pieces (*sparagmos*) by drunken maenads, novels and poems in modernism return to the psychosis of episodic time – time as we live it in the mind. The twentieth century's great poems, T.S. Eliot's *The Waste*

Land, H.D.'s *Trilogy,* Ezra Pound's *Cantos* and William Carlos Williams' *Paterson* reveal a world that is both old and renewed, destroyed and rebuilt. Fragments of Orpheus float down the 'stream of consciousness' for us to collect.

Many TV series and animated sitcoms with a limited set of characters, like *Star Trek* or *Family Guy,* develop across episodes that have no 'natural continuity'. The arc of each episode may take the characters through different worlds, but they always return to the same state of affairs by the end. Each show's essential situation is restored within 45 minutes. The characters learn nothing; they grow and change not a bit. It is why we can watch this kind of episode in any order. It is also what allows the characters (and us) to travel to wildly different times and places, to the distant past and to the far future. Is it because the characters stay the same that the worlds can change? Perhaps the episodic opens us up to a natural discontinuity or an unnatural continuity, revealing an animated multiverse composed of portals, hyperlinks, gaps, breaks and repetitions. In the overstretching of plot, we might find the revelation of character.

Looked at in this way, an episodic narrative that reveals the lives of characters might take the form of a set of spaces or a series of time slots. Liverpool Biennial 2016 takes this form, organised as a story narrated in several episodes – fictional worlds sited in galleries, museums, pubs, unused spaces, shops and supermarkets. The episodes were developed by a group of curators, collaborators, advisors and artists, working as a fluid and evolving team like collective script-writers on a film or television show. Sometimes the individual voice is concealed in the collective voice – as in the orally transmitted epic, or as with players in a drama – at other times it is brought to the fore.

As a companion to the spaces narrated in the city, this book concerns the episodic in its own way. Combining, collapsing, re-shuffling and re-telling the stories of Liverpool Biennial 2016, it moves between the literary topoi (τόπος) of the exhibitions (Ancient Greece, Chinatown, Software, The Children's Episode, Flashback, Monuments From the Future), compiling artists' texts and images, as well as literary and aesthetic reflections on the peculiar logics of the episode.

Let's begin, as might be expected, with a 'Pilot Episode' in which we are introduced to the narrative dynamics of what will follow, led to feel what to expect from the characters, and are encouraged to follow along.

Lara Favaretto archive

Pilot Episode

'Are you saying that the narrator
is the forest and San San, at the same
time but in different dimensions?'
you ask.

Samson Kambalu

Nyau Cinema

St Pius

Synopsis (*Flamingo Pond*, 2012):
A pond full of flamingos in Africa – their heads
synchronised and buried in the water.
– 52 secs.

Synopsis (*Two Mushroom Clouds*, 2011):
A scientist is interviewed in a grainy television excerpt.
In his hands he carries two mushroom clouds.
– 32 secs.

1

In the general economy of the Chewa village, where sharing and squandering of wealth was the rule, anything subtle in fashion betrayed a calculating miser and hoarder – the miller, the grocer, the money-lender derided in Nyau as *Maloko* – 'one who locks up everything'.[1] To dress ostentatiously in Gucci shoes, Rolex watches, Pierre Cardin shirts (most probably counterfeits from China) and hang out in salons about town – as recorded in Meschac Gaba's *Museum of Contemporary African Art* [2] – listening to Papa Wemba and Fela Kuti while drinking exotic beers, tearing up dollar bills before the ladies at the bar, and inciting patrons to acts of rival squandering, was to show an optimism in the abundance of life and a trust in people always to return the gift. If one could not afford designer or tailor-made clothes, one improvised – again, as is seen in the 'Fashion Room' of *The Museum of Contemporary African Art*. There were many second-hand clothes for sale in the markets, which could be modified to rival any on the haute-couture scene in Milan or Paris. But sometimes one chose threadbare chic when wishing to give the impression that all one's earnings had already been shared with friends and relatives. The Dutch missionary J.W.M. van Bruegel has explored how the fear of being accused of witchcraft inspires an extremely austere style of dress among the Chewa.[3] It is an alternative to the fancy dress of the city. The two extreme fashions make sense within the unrestricted values of the 'gift'.

Dressed in fancy haircuts and clothes, we took Nyau as an excuse for liberation from the political rallies to the playground and into town, where dancing Nyau was accompanied by transgressive behaviour: skipping school to watch the steamy trains at Wenela exporting men to work in South African mines with bird feathers in their hats; setting fire to forests on Njamba and Soche hills and enjoying the spectacle of frantic forestry men trying to put them out with branches and leaves; running through the maize fields like a herd of elephants on a stampede. The *derive*, a potlatch of destruction, went on and on, and in that frenzy my friends and I formed lasting relationships. But the influence of Nyau licence was much more immediate in our favourite pastime at night: cinema.

One of the most popular venues for Nyau Cinema was St Pius Catholic Church Hall in Nkolokosa, Blantyre, in the late 1970s and early 80s. By parental decree we were supposed to be in bed when the doors at St Pius hall opened, so we escaped through our bedroom windows to these film shows. Having no money for entry we forged the rubber stamps on our palms using biro. But even without money or biro, Nyau Cinema was always possible at night. By a local tradition that no doubt grew out of the static economies of the villages, the last reel was for free, watched with the doors wide open to allow in those who could not afford the entry fee from the beginning.

Like Gule Wamkulu, the Nyau Cinema at St Pius had to be created out of nothing – from appropriated film footage from abroad and Banda's propaganda newsreels. Run-down comedic two-reelers of early silent film were the opening mascots of these shows – Roscoe 'Fatty' Arbuckle, Charlie Chaplin, Buster Keaton. The transgressive otherness of these films and their insatiable appetite for the joyful destruction of valued property and propriety through slapstick felt familiar. The incessant backside kicking summoned the dramaturgy of Nyau for the discerning, the Bataillean 'solar anus' proclaiming a gathering of sovereign beings – *virombo* – in the Catholic church hall. Arbuckle's immeasurable body and devilish grin and Buster Keaton's wooden-faced stunts were accompanied by lurid commentary and shouts of *Iwe! Iwe! Iwe! Iwe!* from the audience. Charlie Chaplin was Kalulu the trickster, the mythical Gule and dramatic personification of the allusive Nyau itself, cutting across hierarchies and social difference, bringing people together through what Elie Faure has described as 'sacred' laughter.[4]

In fact, there was no 'audience' at Nyau Cinema.[5] And there was no main feature film. Well, there were a few exceptions to the rule, such as ballistic[6] spaghetti Westerns that kept you on edge from start to finish. Generally after Chaplin had disappeared into the machine, more Nyau reels followed: Hollywood movies, anonymous film-noir, Ninja films and Banda's propaganda newsreels movies would be chopped up or cut to size by the seasoned projectionist – the conversation would be edited out to offset boredom. The chronological narrative would be broken up – the films were often interrupted by reels from other films, whole sections repeated, speeded up, slow-motioned or reversed to communicate a more animated and visceral experience of film.

The Nyau Cinema projectionist did everything in the open. You heard and saw his machine at work during the film show. You would see his shadow fiddling at the machine with great dexterity, coils of filmstrips falling down from his shoulders and arms like Kapoli. There were wires everywhere, holding up the screen and electrifying his act. Sometimes he would interrupt the large tattered speaker in front of him to moralise or add a witty comment from the shadows.

Nyau Cinema, like the exhibitionist 'cinema of attractions' of the early twentieth century described by Tom Gunning,[7] screened in the open air or in improvised cinema halls and circus tents, included 'spectacular' side acts, such as fire-eating magicians – the famous Haja Fosaja frequented the hall at St Pius – self-styled vendors of food and drinks, acrobats and boxers – Jetu, Short Man and Philemon Ayesu – which all contributed to the animation and generosity of the atmosphere. Nyau Cinema was more than a film show: it was in fact a modern form of Gule Wamkulu.

2

That the film star communicates with his audience as a 'mediated absence' was explored by the German philosopher Walter Benjamin (1892–1940).[8] The celebrity actor, aware of the technological distribution of his identity as a 'star', acts not for his audience but for the film's industrial apparatus. It is this liminal absence of direct communication that allows viewers to project their own desires on the star and become stars themselves. I read this relationship between the film star and his audience as rather like that of the member of Gule Wamkulu whose body is made present yet 'absent' by the Nyau mask.[9]

Benjamin's formulation resembles the French film theorist Christian Metz's conception of the film star as an 'imaginary signifier'.[10] According to Metz (1986), the 'absent presence' of the film star has the effect of making the audience 'pure lookers' in a transcendental sense.[11] One thinks of the delirium one is thrown into while

Samson Kambalu
Still from *I hold up a tree in 1936*, 2015, digital video, 22 seconds

Samson Kambalu
Still from *Snowball*, 2015, digital video, 22 seconds

watching a performance of Gule Wamkulu. It is this feeling of being a 'pure act of perception' that makes the film audience identify themselves as sovereigns – as part of a larger scheme of things – in the case of Nyau, *virombo*, transcending the limitations and conventions of everyday life and the world of necessity. The liminal absence of the film star, enhanced by the skilful intervention of the seasoned projectionist, is no doubt what made Nyau Cinema a new *bwalo* (arena) for a modern Malawi, where I was able to encounter my sovereign self in the company of fellow animated spectators.

3

The American film scholar Jennifer Wild describes the nature of early film stardom as 'diagrammatic'. The identity and mystique of the actor – one thinks of Musidora or Chaplin – were generated not only around his work, as was seen with the 'celebrity' players of traditional theatre, but also through a 'chaotic' distribution of the actor's visual currency manifest in promotional discourses, photographs, film, print and advertising, and nascent fan culture material – posters and leaflets.[12] This 'technological repetition', as Paul Klee would describe it, made film viewing conceptual and changed the masses from passive beholders of culture to active spectators.[13] The phenomenon of the diagrammatic film star encircled the globe. According to Siegfried Kracauer, the conceptual nature of film stardom in fact turned the whole world into a 'photograph' – in my reading a kind of photographic *bwalo* – in which participants were aware of being photographed as 'stars' and contingents of history themselves.[14] We experienced it as Nyau Cinema at St Pius in Malawi.

The influence of Nyau Cinema was everywhere in my childhood – along with typical Nyau subversions. Dr Hastings Kamuzu Banda, the Life President of the Republic of Malawi, dressed and behaved like a film star – he must have fancied himself as a Humphrey Bogart: Savoy three-piece suit, long trenchcoat and shiny shoes;

a homburg on his head and Saratoga dark glasses over his eyes. He always entered the stadium surrounded by a sea of dancing women, like *Chadzunda* and his *mbumba*,[15] a fly-whisk in hand, in a dirty Land Rover – but a gleaming red Rolls Royce carrying his mistress, 'the official hostess', Mama C. Tamanda Kadzamira, who always rode in front of him as part of a long police escort. The Hollywood-sized lights on Soche Hill blinked LONG LIVE KAMUZU in orchestrated succession, but every now and then, even if it was only for a few moments, there would be a fault in the wiring, and the Soche hill would loom over the city of Blantyre simply saying LIVE or LONG KAMUZU; LIVE KAMUZU even. On other days Soche hill simply said LONG. Some of these electrical faults were probably deliberate mistakes created by technicians for subtle subversion.

Samson Kambalu
Still from *Lincoln*, 2015,
digital video, 49 seconds

Everyday life was a corollary of Nyau Cinema: the fancy hair cuts at the barbershops were from cinema, most definitely the shaolin skinhead; there were self-styled thieves and *nanchaku*-wielding gangsters in the neighbourhood; fancy fashion – this was the age when second-hand clothes were not liberally allowed into Malawi and the tailors on the shop verandas competed in who would design the coolest clothes worthy of a rapturous Nyau Cinema screen; everyday language was fancy, Chichewa peppered with English and Chinese phrases from the reels. Girls talked and behaved like *Atsikana Amakono*.[16] The daytime popular drama group at the church hall, Kwathu Drama Group, under the spell of Nyau Cinema, performed whole segments of their plays in slow motion and sudden lurches in quickened time.

One of the earliest scholarly reports on Nyau, by the British colonial officer and anthropologist W.H.J. Rangeley, communicated that it was a tradition responsible for keeping people backward in Malawi.[17] The report could be read as yet another commemoration of Nyau's well-known power as a subversive cultural phenomenon since ancient times.[18] In the postcolonial era marked by capital, lucrative labour and restricted economics, Nyau Cinema was a continuation of

All Samson Kambalu
images courtesy of
the artist and Kate
MacGarry London

Pilot Episode

the Chewa gift culture around Gule Wamkulu, by other means. It was simultaneously a rebellion against the utilitarian values of capital and denial of death embedded in linear and structuring narratives of film; it was a rebellion against the corollary of colonial arbitraries analysed by Achilles Mbembe in the *Postcolony* – the African dictator,[19] in this case Banda; it was a cinematic rebellion against the individualistic classical idea of art as representation and separation from real life and of the audience as detached and passive beholders rather than active spectators.[20] It was a rebellion against the alienating influence of Christian morality.[21]

The Nyau Cinema projectionist differed from the secretive projectionist at the official cinema houses Apollo and the Drive-In in the city centre, which showed 'proper films' with a beginning and an end. My sister and her boyfriend took me to Apollo once to watch a proper film. I didn't like it. There were MCP flags outside the cinema that said UNITY LOYALTY OBEDIENCE AND DISCIPLINE. Everybody knew what those words meant: death by crocodiles if one disobeyed. I was terrified by the projectionist staring down at us from a small cut in the wall at the back. You saw his darting red eyes and thick eyebrows. I thought it was Dr Hastings Kamuzu Banda himself, keeping an eye on us, making sure we behaved and stayed still in those red velvet seats. No wonder there were not many of us in there – some wanted to come in but because they were late the doorman wouldn't let them. He spoke to them from behind a thick glass screen, saying they were late. You had to stay to the end of the film at Apollo. I was dying for the toilet but I dared not go with those eyes watching me. At St Pius you came and went as you pleased, talked when you were bored. You could even ask the projectionist to speed things up a little. Here at the Apollo there was no life, only film and a searchlight. I slept and woke up and the film was still on.

The age of Nyau Cinema ended abruptly with the advent of VHS tapes in the mid-1980s. I went back to St Pius once and they were watching *African Queen*, and there were no breaks. Some Nyau Cinema elements had morphed into adverts selling soap and cars. Another time we kids were not allowed in because they were watching pornography. So ended Nyau Cinema, but not before it had left a lasting impression on me.

Lara Favaretto archive

1 Nyau is a Chewa philosophy of excess that involves ritual performances and dances with masks. Nyau mask performances are known as Gule, literally 'the Great Play'. Since 2005, Gule Wamkulu has been classified as part of UNESCO's 'Masterpieces of the Oral and Intangible Heritage of Humanity'. See Claud Boucher, *When Animals Sing and Spirits Dance – Gule Wamkulu: The Great Dance of the Chewa People of Malawi*, Kungoni Centre of Culture and Art, Mua, 2012, p.248.

2 A conceptual museum of contemporary African art, conceived by the Benin-born artist Meschac Gaba between 1997 and 2002, now in the collection of Tate Modern, London.

3 See J.M.W. van Breugel, *Chewa Traditional Religion*, Kachere Publications, Zomba, 2001, p.263.

4 See Leon Moussinac, *La Danse sur le feu et l'eau*, Cres, Paris, 1927, pp.16–17.

5 The importance of audience participation in Nyau has been explored by E.T. Mvula. Nyau spectatorship is always active, pertaining to the communal values of Gule Wamkulu. See E.T. Mvula, 'The Performance of *Gule Wamkulu*' in C. Kamlongera, (ed.) *Kubvina: Dance and Theatre in Malawi*, University of Malawi, Zomba, 1992.

6 See Jennifer Wild, *The Parisian Avant-Garde in the Age of Cinema (1900-1923)*, University of California Press, Oakland, 2015, on the excitable cinema of ballistics in early film.

7 See Tom Gunning, 'The Cinema of Attractions: Early Film, Its Spectators and the Avant-Garde', *Wide Angle*, Vol. 8, nos. 3 & 4, Fall, 1986.

8 See Walter Benjamin, 'The Work of Art in the Age of Its Reproducibility', in *Walter Benjamin: Selected Writings vol. 3*, Harvard University Press, Cambridge, MA, 2002.

9 It is taboo to identify a mask as an individual. He is an 'ancestral' spirit or an 'animal' – *chirombo* – a blossoming other, *Gule*. To accidentally reveal one's everyday identity at *bwalo* comes with a heavy fine and prolonged exile from the village; see Boucher, 2012.

10 See Siegfried Kracauer, *The Mass Ornament*, Harvard University Press, Cambridge, MA, 1995, p.59.

11 See Christian Metz, *The Imaginary Signifier: Psychoanalysis and the Cinema*, Indiana University Press, Bloomington IN, 1986, p.49.

12 Wild, 2015, p.80.

13 Paul Klee saw modernity as the 'relaxation of individuality' – which I read as a form of Nyau – and saw technological repetition as a new arena for encountering our profound 'moi': 'Modernity is a relaxing (*allegement*) of individuality. Upon this new terrain, even repetitions can express a sort of originality, becoming never before seen forms of "moi", and this is not to speak of weakness when a certain number of individuals gather together in the same place: each wait there for the blossoming of his profound "moi".' See Wild (2015), p.102.

14 Kracauer, 1995, p.59.

15 Chadzunda, with his chorus of women (*mbumba*), is generally regarded as the lord of Gule Wamkulu performance.

16 A Nyau mask in heavy pink and red make-up, meaning 'modern girl', which in the village performed at funeral vigils, initiation ceremonies and commemoration rites. She wears a notoriously short skirt; see http://www.kasiyamaliro.org/pdf/atsikana_amakono.pdf.

17 W.H.J. Rangeley, 'Nyau in Kotakota District', *The Nyasaland Journal No. 2*, Zomba, 1949, p.35.

18 Many Nyau masks, such as Simoni (colonial officer), Bambo Bushi (missionary), Maliya (The Virgin Mary) express resistance again colonial rule (*chitsamunda*) and religion; see Father Boucher's Nyau mask archive, http://www.kasiyamaliro.org/.

19 See Achille Mbembe's analysis of the African dictator in *On the Postcolony*, University of California Press, Berkeley CA, 2001.

20 See Wild, 2015, on spectatorship in early cinema, which resembles many aspects of Nyau Cinema.

21 Rangeley, 1949, specifically noted Nyau resistance to the Christian missionaries' attempts to stamp out Gule Wamkulu and the many other cultural aspects that surrounded the 'cult'. The colonial aim in Southern Africa in the footsteps of the explorer David Livingston came in three Cs – Christianity, Civilisation and Commerce.

'Yes, that's right. I've been calling this
kind of shift "transversal recasting".
But never mind about that for now –
just keep on turning the pages.
Or flipping up and down.'

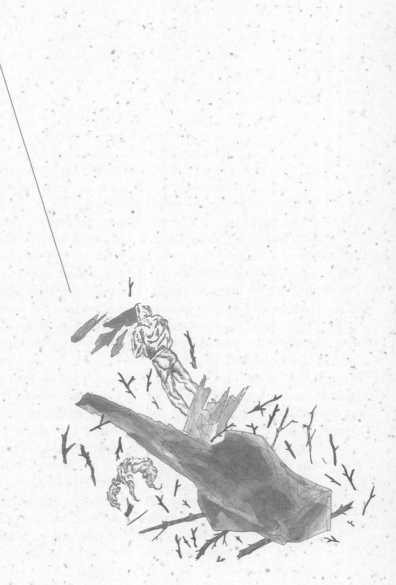

Matthew Garrett

Episodic Poetics

Episodes
are nothing new to
literary criticism. Homeric epic is
famously episodic, and the literary analysis
of episodic form goes back at least to Aristotle's
Poetics. 'Episode' itself comes from the ancient Greek for
'coming in besides' (ἐπεισόδιον, *epeisodion*, the neuter form
of ἐπεισόδιος, *epeisodios*) and was first used to designate the di-
alogue in tragedy that took place between two choral songs, or an
act. For Aristotle's normative theory, overly episodic plots violate the
strict formal economy of tragedy, 'stretch[ing] the plot beyond capacity'.
The philosopher's distaste eases a bit when he discusses the *Iliad*, in
which supplemental episodes enrich the plot, 'diversifying the poem'. In
epic, the episode plays a quasi-cathartic role; it is the form through which
multiple events may be represented as occurring simultaneously: as the
unit of the subplot (or parallel plot), the episode can provide a diverting
release (or suspension) of tension. Aristotle tells us that '[e]pic here has
an advantage, and one that conduces to grandeur of effect, to diverting
the mind of the hearer, and relieving the story with varying epi-
sodes. For sameness of incident soon produces satiety, and makes
tragedies fall on the stage.'[1] At the moment of its emergence into
Aristotelian literary criticism, the episode already marks the
formal divide between key categories: between order
and variety, between consolidation and complex-
ity, between shape and distention, between
one story and the many stories it
may contain.

What is
an episode? An episode
is, first an *integral* but also *extract-*
able unit of any narrative. This twofold
character is nicely captured in the *Oxford English*
Dictionary's entry on *episode*: 'An incidental narrative
or digression in a poem, story etc., separable from the main
subject, yet arising naturally from it.' These two aspects of
the episode are essential to narrativity. Provisionally self-en-
closed portability is what enables any particular episode to mean,
even as the episode connects with and opens onto other episodes
that constitute the syntax of the narrative. Episodes are *parts* of
narrative *wholes*, and we need not cling to Romanticist organicism to
recognise the inescapable significance of part-whole relationships
to the study of literary forms. The episode nevertheless troubles
a fine distinction between part and whole because it raises ques-
tions of prioritisation. Indeed, such questions already produce
static in the otherwise staid transmissions from Aristotle
quoted above. What might it mean for a *structural* unit of
narrative to be sometimes an aberration, sometimes a
source of diversionary pleasure? How should one
draw a line between the episode in its integral
moment and its appearance as excess
awaiting extraction?

Wayne
Booth considered the
question to be a matter of 'cutting':
'In appraising episodic materials [...], we
can distinguish four levels of resistance to cutting:
those incidents that are *essential* if the experience is to
be what it is; those that are perhaps replaceable but at least
useful – something *like* them is required; those that while not
especially useful are at least *appropriate*; and those that, because
they are neither especially useful nor appropriate, not only can be
dropped without a trace, but *should* be, because they are in fact harmful
to the whole.'[2] Booth's primer on textual mutilation is intended for prac-
tical use, but for a criticism interested in the episode as such, it is more
illuminating as a symptomatic illustration of the problem with episodes:
namely, that they insist upon the question of the part's relationship to the
whole and in so doing they unsettle any easy assumption about interpre-
tive prioritisation. Is the episode 'essential' or 'harmful' to the text as a
whole? Is it *useful*? Useful for what, essential to whom, harmful to what?
The questions occurred to Booth, of course. But in an Aristotelian
search for formal clarity and a well-shaped plot, criticism's various
guides to literary surgery overlook the foundational point: that
the episode is always, every single time it appears within lit-
erary history, a part that exists as such only in relation to
a real or implied whole. It is a relational, dialectical
form – and therefore hard to see, harder still
to talk about as a form or narrative
unit.

Pilot Episode

As
readers, we can
'get lost' in a single episode – lin-
ger over it, reread it, even decide that it
can be rewritten as a synecdochical repre-
sentative of the larger narrative in which we stum-
ble upon it. But we can also find our way back to the
overall narrative line, however wavering or tenuous it
may be. The episode is defined by this doubleness, by the
fact of its being simultaneously both 'open' and 'closed'. The
variable relationship between the open and closed aspects of
the episode is both a fundamental characteristic of narrative
and a (historically and culturally) specific source of readerly
pleasure. For the dynamics of episodic structuration, even in
the most perfectly plotted narratives, both keep us reading
and allow us to stop – and thereby license us to commit our
attention unevenly to the narrative. In elaborating on the
specific difference of the episode as a form, we must
consider briefly the way literary-critical interest
in a plot has built upon episodic form even as
it has displaced attention from the con-
ceptualisation of the episode
itself.

At
the outset of his
major work on the subject, Peter
Brooks provides a sweeping introduction to
plot. 'Our lives', he writes, 'are ceaselessly inter-
twined with narrative, with the stories that we tell and
hear told, those we dream or imagine or would like to tell,
all of which are reworked in that story of our own lives that we
narrate to ourselves in an episodic, sometimes semi-conscious, but
virtually uninterrupted monologue'. Developing this initial statement
toward a definition, Brooks continues: 'Plot is that principle of inter-
connectedness and intention which we cannot do without in moving
through the discrete elements – incidents, episodes, actions – of a narra-
tive.'[3] Were we reading for it, we might notice the repetition within three
pages – *episodes* and *episodic* – of an essential but perennially underde-
fined term within narrative theory. Plot, for Brooks, is implicitly defined
against the episode; from the inchoate narrative episodes of our lives, in
dreams, fantasies and waking consciousness, we produce plot – the *form*
whose Kantian necessity is conveyed in the most common figure for
it, the *line*: 'the organising line and intention of narrative'.[4] Brooks's
approach to the study of plot, emphasising as it does narrative
structuration and plot as desire – as the libidinal apparition
par excellence through which we make meaning of expe-
rience – does not ignore the episode wilfully. Quite
the contrary, plot and episode are bound tightly
together at the definitional beginning of
his account.

<div align="center">

B u t

as so often in literary

criticism, it seems that plot and

episode can never be in the same place

at the same time, as though to attend to both

together would somehow amount to a scandalous (or

perhaps merely too mundane) revelation of their mutual

conceptual constitution. My study takes a different ap-

proach, with the aim of producing a literary criticism attuned

to episodic organisation across narratives and literary genres.

My emphasis on reading is not simply on overall narrative plot

but, rather, on the configuration of its *components*. This study thus

tries to conceptualise plotting through variations in the *episodic

poetics* that sometimes produce and often trouble tidy narrative

lines; it analyses the significance, historical and formal, of those

texts in which episodicity refuses plotted structure or in which

plot itself only takes shape through an ostentatious yet un-

steady integration of the unwieldy parts. Such a crticisim

may help us to produce a literary-historical account of

narrative forms that approaches plot through the

episode itself; an account that takes plot to be

a historically determined *problem* rather

than an ever-ready solution.

</div>

1 Peter Brooks, *Reading for the Plot: Design and Intention in Narrative*, Harvard University Press, Cambridge, MA, 1984, pp.3, 5

2 Wayne C. Booth, 'The *Poetics* for a Practical Critic' in Amélie Oksenberg Rorty (ed.), *Essays on Aristotle's 'Poetics'*, Princeton University Press, Princeton, NJ, 1984, p.6

3 Peter Brooks, *Reading for the Plot: Design and Intention in Narrative*, Harvard University Press, Cambridge, MA, 1984, pp.3, 5

4 Ibid., p.37

Fabien Giraud and Raphaël Siboni, '2045 — The Death of Ray Kurzweil',
The Unmanned, season 1, episode 1, 2014, video HD, 26 minutes.
Image courtesy of the artists

— In which genealogy is broken and the father-son of a son-father drifts in an emerging new world —

Joasia Krysa

The Episodic in Computational Worlds
A conversation with Franciszek Krysa Cox (aged six)

Joasia Krysa: It's just like being interviewed on the radio.
My first question is for you to describe Minecraft.[1]
What kind of world is it?

>Franciszek Krysa Cox: It's made up of squares and square stuff and as well there's creatures, I think you should know.

JK: Say a little more about that world. What does it look like and how is it made?[2]

>FKC: It's made up of squares and squares.

JK: OK, squares, but how do you build things?[3]

>FKC: You lay things down, place things down, like you just put your own stuff in, like placing things down.

JK: So how do you place things down?

>FKC: You just touch the screen where you want things. It's square stuff and you place it down.

JK: What's in this world and how do you build things?[4]

>FKC: You tap on the screen and a block comes there. You just keep adding blocks.[5] You can build houses and castles and roads.

JK: And then there's trees and grass and rivers and hills. What else?

>FKC: There's villages.

JK: What are these villages like?

FKC: They're pretty good and all of them have a castle.

JK: And then there's this parallel world called the Nether, isn't here?
Tell me about this.

FKC: Like, the Nether has Netherrack.[6] I don't think you know about
the Netherrack. And as well the Nether has hot lava on the bottom
and also floating bits of Netherrack that's the floor in the Nether.

JK: And is it underground? Where is it?

FKC: It's like in the sky, like heaven.[7]

JK: In the sky, really? and is it a scary place?[8]

FKC: It's a scary place.

JK: Why is it scary? What else is there?

FKC: Because there's lots of things and you could fall down
into the lava and there's lots of fire. And there are monsters.

JK: Which ones?

FKC: Pigman can attack you with a golden sword and Garths
that can set you on fire and Magma Cubes just attack you.

JK: What can you do in the Nether?[9]

FKC: Well, I'm not quite sure to be honest.

JK: So why would you want to go there?[10]

FKC: Just for fun.

JK: I see, and what if you want to get out, if you decide it's too scary?

FKC: You just go back through a portal.

JK: Through a portal?

FKC: Yeah.

JK: Can you describe what a portal is?

FKC: Like, it's, if you go through it you can go to another
world again.

JK: So you go through a portal in the Nether and you end up in
another world?

FKC: Yes.

JK: And you can go to the Nether by going through a portal as well?

FKC: Yeah. It has to be the same portal.

JK: What's a portal like? They sound amazing in that you can go
through them to go to another world.

FKC: You just put an Obsidian,[11] then a plinth and frame
in the middle, then you can just go there.

JK: It's like a doorway is it?

FKC: Yeah.

JK: What does it look like?

FKC: It's ... I'm not quite sure really.

JK: It's got a frame around it hasn't it?

FKC: And purple smoke.

JK: So if you step through there, you can go from one world to another.

FKC: You can only go to the Nether.

JK: So there's two worlds and they're in parallel.

FKC: Actually there isn't. There's one more world.

JK: What's that?

FKC: The End.[12]

JK: And to get to the End, do you go through a portal as well?

F. Yeah. It can only be on the ground. And you can only find it,
you can't build it. And you can only have it on the Xbox.[13]

JK: So you use portals to go from one space to another.
Can you do that in the Overworld as well?

FKC: Yes, you can.

J. Can you say more about that? Where would you go?

FKC: Like, you build different kinds of portals to go to different kinds of stuff.

JK: So you just think 'I'll build one to go somewhere else'?

FKC: No. You have to build different portals to go to different places. You don't need them to look the same and there's only two. Like, some of them, like the Nether portal has to be standing up and the End portal has to be in the ground.

JK: Oh, I see. One is vertical and one is horizontal. Do you decide where you're going to go or do you just end up somewhere?

FKC: You decide where you go.

JK: You decide. And you're a person playing the game. Are there other people?

FKC: There aren't other people really. But you can make people into the same world as you.

JK: 'Make people'? You mean build people?

FKC: No. You can only make people come into your world. You have to be on the same wifi.

JK: But there are other people moving around, like villagers. Where do they come from?

FKC: They just … Villagers come from villages. They just 'spawn'[4] in the world. They just come alive. And all the animals are just there all the time.

JK: There are animals as well? Of course.

FKC: And also the monsters only come out at night.

J. Monsters … of course. Are they part of the mobs?

FKC: Yeah.

JK: Tell me about the mobs.

FKC: There's Endermen. I think all of you will be scared of Endermen because they teleport to another place.

JK: Teleport? Is that like going through a portal?

FKC: Yeah.

JK: Can you teleport?

FKC: No. You can only teleport by throwing an Ender Pearl and then where it lands, you land there.[15]

JK: Right, I see. So they teleport. Mobs teleport.

FKC: No, only Endermen teleport.[16]

JK: What else is part of the mob?

FKC: Like ... definitely, definitely swords and arrows.

JK: What about other creatures and figures?[17]

FKC: Yeah.

JK: I seem to remember that Steve is frightened of mobs in the story we read together.[18]

FKC: Yeah. And also ... I bet you wouldn't like this one more than the Endermen: Herobrine.[19] His eyes are all white and he can actually set you on fire.

JK: Brian?

FKC: No, Herobrine. And also you can still attack him but he can fly, as well, and without any wings. You can only fly in Creative mode but it seems that Herobrine is half Creative and half Survival.

JK: And there are skeletons too, aren't there? Are they part of mobs?

FKC: Yeah.

JK: And what do they do?

FKC: They burn in the day, without shelter or without water. And also zombies are the same. They're the same as skeletons except they don't shoot arrows.

JK: And you'll have to correct me if I'm wrong on this, but are you Steve?

FKC: You can be whatever guy you want.

JK: So how does that work? I've seen you with a toolbox from which you can choose things.[20] You can even choose to be invisible.

FKC: Yeah.

JK: Will you tell me about that?

FKC: You just drink a potion, which says on it 'invisibility'.

JK: Right. So then you're invisible. I've even just seen a pair of
trousers walking around in the world.

FKC: Yeah. You just put armour on when you're invisible.

JK: Armour is like clothes is it?

FKC: Yeah.

JK: With your toolbox, you can decide what armour or what clothes
you want to wear?

FKC: No. You can only put the armour on when playing in the game.

JK: I've seen a toolbox where you can choose things, like a 'skin'.

FKC: Yeah.

JK: You can choose a different skin. Why choose one skin rather
than another?

FKC: I don't know.

JK: Is it how it looks?

FKC: Just if you like it or not.

JK: If you decide you want blue trousers or green skin ... how do you
decide how you want to look?

FKC: Well, I normally just change skins all the time.

JK: I see, for variety. Are you the same person when you change
your skin?

FKC: No. That's all the time true.

JK: Does it change the way you act as well?[21]

FKC: No.

JK: What then?

FKC: It's just that you look very different.

JK: You look very different but you're the same person?

FKC: Yeah.

JK: So the world stays the same unless you go to the Nether or the End.

FKC: I'm not quite sure really.

JK: I'm trying to find out how things change.

FKC: You just change things and things change in the game.
You build things and things just appear.

JK: You know what an episode is, don't you?[22]

FKC: Yes.

JK: Can you tell me?

FKC: Because it's just like a film.

JK: Like a film?

FKC: Yeah, but there's different chapters.

JK: Like a film with different chapters. So is Minecraft like that?
Does it have episodes?

FKC: It does have episodes but no chapters.

JK: Right. What kind of episodes does it have?

FKC: I have no idea.

Lara Favaretto archive

Pilot Episode

1 Minecraft is a construction video game originally created by Swedish programmer Markus Persson in 2009 and later developed and published by the company Mojang, before its sale in 2015 to Microsoft (Xbox Studios) for 2.5 billion US dollars. 'Capturing popular imagination since its first release, Minecraft serves not only as a powerful metaphor and a portal to a parallel dimension, but also can be seen as a way to conceptualise the episodic in computation.' (https://minecraft.net).

2 Minecraft is software, and more specifically, a series of computer programmes, code-written to direct the computer to perform multiple specific operations, in combination with other technical objects, hardware and wider socio-technical infrastructures that together serve to create the Minecraft world and to translate players' instructions into logical outcomes in the game.

3 It hides its computational layers: how it follows logical processes and various defined methods of processing information (for example an algorithm) but also how it opens up further thinking about cultural computational objects, practices, processes and structures more broadly (http://computationalculture.net/computational-culture). In this conversation, we attempt to expose the computational layers behind other aspects of culture.

4 The intention in this piece is to propose that software follows the logic of episodes – as a series of separate coded objects and events that have no set causal connection, without temporal continuity, and that can be endlessly reworked. Lines of code can be stored and reused, and can reappear in other programmes or software – somewhat like characters in episodes of soap operas that appear again and again but remain unchanged in their nature. Code can be used and reused, each time

keeping its core characteristic qualities but appearing in different programmes or episodes. For instance, in software development, by building up a library of frequently used sequences of code, a programmer can write complex programmes more easily and efficiently. More interestingly in this context, they can also begin to think of their code in literary terms, and structure it into episodic constructs and operative forms.

5 Minecraft is a world where almost anything seems possible. In this world everything is 'crafted' out of Lego-like blocks 'mined' from rock, soil and wood, which you can make into whatever you want and place it wherever you want, whenever you want. 'At first, people built structures to protect against nocturnal monsters, but as the game grew players worked together to create wonderful, imaginative things. It can also be about adventuring with friends or watching the sun rise over a blocky ocean. It's pretty. Brave players battle terrible things in The Nether, which is more scary than pretty. You can also visit a land of mushrooms if it sounds more like your cup of tea.' (https://minecraft.net).

6 Netherrack is a flammable rock-like block that is only found in the Nether (http://minecraft.gamepedia.com/Netherrack).

7 Actually, the Nether is more like Hell. The Nether is Minecraft's 'fiery inferno ruled by burning beasts and smothered in lava', peopled by dangerous and powerful mobs (http://minecraft.gamepedia.com/The_Nether). It makes reference to the 'Netherworld' or underworld, a mythological realm beneath the surface of the world, and to the 'Nethersphere', a reference to virtual reality in the BBC TV series *Doctor Who*.

8 The worlds of Minecraft can also be peaceful, when made in 'Creative mode', where

huge structures can be built from scratch with unlimited resources, and where blocks of all shapes and sizes can be invented. In 'Survival' mode, the worlds are full of dangers and 'come with gangs of monsters who want to break/explode/eat your bones, one pixel at a time; where you are crafting and creating out of necessity'. In this mode you have '10 hearts and you have to survive from Zombies and Skeletons and gather up items and survive or else you die from the hostile mobs' (https://minecraft.net).

9 Portals in Minecraft allow entities to travel and to teleport between the Overworld and the Nether as well as the End.

10 Each time players enter Minecraft, they can create a new world from scratch or access previously created worlds from a saved list, like a series of separate yet loosely connected parallel worlds, or episodes, without temporal continuity. Various types of blocks allow the creation of different things, for instance housing structures, music or portals to access other dimensions such as The Nether (http://minecraft.gamepedia.com/The_Nether).

11 Obsidian is a lava source block used to create a Nether portal frame (http://minecraft.gamepedia.com/Obsidian).

12 To access the End, the player must go through the process of finding, repairing and activating the End portal (http://minecraft.wikia.com/wiki/The_End).

13 Franciszek is distinguishing the Xbox from the iPad version, which has more limited functionality.

14 'Spawning' refers to players and mobs being created and placed in the game world. Players will respawn at their spawn point, or at the bed they last slept in upon death. Mobs will despawn upon death (http://minecraft.gamepedia.com/Spawn).

15 Ender Pearl is an entity used to teleport (http://minecraft.gamepedia.com/Ender_Pearl).

16 Endermen are black, neutral mobs from the End that have the ability to teleport, and spawn in mobs or packs (http://minecraft.gamepedia.com/Enderman).

17 Minecraft has a range of characters, including the central protagonist Steve, Endermen, animals, Zombies, Skeletons, Zombie Pigmen, Snow Golems, Squids and others. All can be customised by players (i.e. by applying different skins) although essentially their character doesn't change. This is another example of the episodic.

18 I am referring to Mark Mulles's *The Quest: The Untold Story of Steve*, Create Space, 2014.

19 Herobrine is the subject of a community-made 'creepy-pasta' (creepy story) and one of the major community icons of Minecraft. Herobrine has not been present in any version of Minecraft and interestingly there are no references to him at all in the original source code (http://minecraft.gamepedia.com/Herobrine).

20 In *A History of Modern Computing*, MIT Press, Cambridge MA, 1998, Paul E. Ceruzzi compares the development of building code libraries to the more general notion of a high-level computer language with the computer generating fresh machine code from the programmer's specifications. The principle of reusing or sharing code is reliant on storing collections of code lines or functions in libraries. Subroutines, often collected into libraries, are frequently coded so that they can be executed several times or from several places during a single execution of the programme. They can be adapted for writing more complex code sequences, and are an important and efficient mechanism for sharing and reusing code. There is a social dimension to this, and the principle of sharing source code is instantiated in online repositories such as GitHub (https://github.com/). Related to this and even more overtly episodic, 'versioning' is the process of assigning either unique version names or unique version numbers to states of computer software to indicate new developments in the software. 'Version control' is used for keeping track of the different versions of computer software but is more widely applied as a concept in other cultural fields (e.g. democracy 2.0).

21 In terms of the behaviour of humans and machines, Cybernetics forms a backdrop to this discussion in its understanding of control in systems, structures, constraints and future possibilities. The term 'Cybernetics' (from the Greek for 'steersman') was borrowed by Norbert Wiener for his book *Cybernetics: Or Control and Communication in the Animal and the Machine* (1948); Stafford Beer called it 'the science of effective organisation', Gordon Pask called it 'the art of defensible metaphors', and Andrew Pickering called it 'the science of the unknowable'. See Pickering's *The Cybernetic Brain*, University of Chicago Press, 2010, and his essay for this volume for further articulation of these connections.

22 Minecraft arguably follows a similar logic to literature, where the episodic plot structure is made up of a series of chapters or stories linked together by the same character, place or theme, but held apart by their individual plot, purpose and subtext. In 'Cybernetics and Ghosts' (1986), Italo Calvino draws together storytelling and cybernetics to question how algorithms might begin to create new combinatory possibilities and, we might add, how the episodic can be a productive force in a culture that is ever more computational in nature.

On the next page I am sitting on your lips
counting numbers and colours. Two to yellow,
three to red, green to one hundred, through
all the variations of indigo blue, it takes longer
than yellow, it takes longer than two.

Mark Z. Danielewski and David Hering

The Fiction of the Episode:
A conversation

David Hering: I want to begin by talking about the idea of the episode as a particular 'moment'. I'm interested in your thoughts on how the episode figures experientially in your work. Your new multi-volume novel *The Familiar*[1] is, after all, constructed as a series of episodes.

Mark Z. Danielewski: I guess the question that comes to mind is how much of a fiction this notion of an episode is. If we think about it in terms of television, there are certain fictional forms that create certain types of episodes so that in a certain kind of episodic TV show the story and plot are contained, it's an entire unit. You don't necessarily have to see what preceded it or what followed it. Or you can watch an episode from *Mad Men* or *The Wire* or *Battlestar Galactica* or *Breaking Bad* and you really do need to know what was going on beforehand, so that immediately introduces an aesthetic of the episode: which way are you choosing to go? You can certainly see that *Harry Potter's* origins were far more self-contained, even though at the beginning they had scope to expand. By the end it was clear that Rowling had let go of any need to create a self-contained penultimate volume. It was clear that if you were to read the last one you needed to know the preceding ones. And yet at the same time, episodes are a kind of fiction – a way for us to create narratives, for us to compress and handle information that's a lot more sticky and leaky, that bleeds into its contexts more. So certainly in *The Familiar* you have these self-contained volumes. I call them volumes too because it's a lot more about *space*, the space that they take up – they imply a certain amount of this sense of size that's always interested me. This isn't just an episode as in 'an addition' but also about whether a portion is 'empty' or 'full'. And in that sense each one is self-contained by a theme, by a certain intrinsic narrative

construct, but they're dependent upon this larger volume of the world within which these narrative arcs and these characters interact with us. I think these volumes in particular, which is common in my work, are aware of how they are. They're being limited just as they're being delimited. So they tell you they're a volume while announcing that you also really need to read Volume One or Volume Three. However, I actually like the notion, and this is definitely for the advanced reader, of jumping into the middle – reading Volume Three if you haven't read One and Two. I say 'advanced', because it requires a certain kind of patience and a certain awareness of how false these episodes are and how we recognise it as soon as we jump into a moment where we have to figure out what's going on. For example, you're rarely in a relationship with someone where you've gotten to know that person for their entire life. Some people have that experience. But not often. And even so, even that kind of familiarity is a mental deceit — that you've been privy to this person's every action and thought. Even identical twins begin to recognise the strangeness that time and growth interposes between them.

DH: This is something that I'm beginning to sense in *The Familiar*. In the first two volumes we experience a series of events in chronology from May to June in the year 2014. But there's also this glimpsed framing narrative, and this is the moment where you discover that the whole process of time in this novel seems to not necessarily be working chronologically. There seems to be some grand frame that's standing at once in the middle – I think literally in the middle – of the first volume, but also outside everything as well, and maybe we're going very, very far back into past episodes and very, very far forward into future episodes at different ends of the book.

MZD: Oh, I think we are. That's well observed. It's certainly something that will become clearer as the frame re-instantiates and re-establishes itself with every subsequent volume. You begin to feel the momentum of these big wheels. As specific as these small moments are, when you look at a scale that large, you begin to realise how random they are. And so, as attached as you can become to these episodic chronologies and these mechanisms, because of this magnitude, it allows you to let go of it. And the thing I'm already anticipating is that I'm aware of how much is in *The Familiar* and I'm aware of how much time I've worked on it. I'm aware of how unwieldy in some ways it is, but there's a pleasure in the fact that even if you've read all three volumes, by the time you read Volume Four you're going to have a familiar sense of about what happened, but I'm not expecting you to remember every single moment. I have no interest in you becoming a 'priest' of *The Familiar*, but still actually kind of indulging that experience of 'I kind of remember that' and 'Oh, am I misremembering that?' And maybe even more significantly, what happens when the *characters* misremember things, or we remember things? And I think that begins to approach an experience that books for the most part don't offer because of their framework. To go back to the television episode,

to take a more simple, condensed view – if you have a *Seinfeld* episode which is 22 minutes, you know the characters, you know the space that's going to be kept, you know that most of it's internal, that someone at the beginning of an episode will return, a certain theme will be paid off and will be this hermetically sealed little moment. That was a standard form that was played with with a great deal of agility and skill, but it took a kind of rupturing of that, which I think was probably enabled technologically, by not only the intelligence and aptitude of the viewers out there but also by the kinds of technologies able to broadcast and stream these things. You suddenly got these longer shows that were more like novels, where the episodes were really like chapters. And that began to change what television was actually doing. That's why people bandy around the term 'The Golden Age' of television. Curiously, we desire new experiences from the novel yet keep on insisting that the novel look and behave a certain way. We'll get slight variations from that approach, but we become like these obsessive-compulsive engineers of a varying type of poodle – that based on a certain colour, or a certain set of markings or certain minor shapes this somehow constitutes a new poodle when in fact we just need to go out beyond ourselves. I think *The Familiar* is starting to do that. Just going back to your point about time, the pace of the storytelling is so much more like a really slow glacier ploughing through a mountain. It's not rapid story, story, story. Already its timing and its narrative movement begins to change what's familiar to you in the novel. *Moby-Dick* is a great example of something that keeps going further and further, and you kind of expect a certain beat because it's a yarn and yet suddenly it's an examination like an encyclopaedia or dictionary or whatnot.

DH: It's interesting that you should say that because I recently saw a seminar given by David Milch [creator of *Deadwood* and co-creator of *NYPD Blue*] and he was talking specifically about Melville's narrative technique, about how Melville exhausts every single possibility of the narrative that you can imagine and then at the point of absolute reader exhaustion he gives you the chase at the end of *Moby-Dick*. And thinking about my experience of that novel, when you start reading *Moby-Dick* you're going 'Where's Moby-Dick? I want to get to the chase.' And then you get to the chase but by that time it's absolutely immaterial. What matters is all that time, all those episodes in between.

MZD: It performs this sense of exhaustion. What's wonderful about it is that you're delving into these various aspects and observations of the whale and it renders it even more open and more mysterious and more unavailable, and one of the curious powers of that novel is that you're really not interring but *resurrecting* the spirit of the whale. With each moment of exhaustion, whether it's the colour white or whatnot, Melville is telling us that of course the whale isn't going to be killed, of course the whale is going to survive. I think there's a little bit of play of that in *The Familiar*. It sets out to be so complete in

each of its moments. With *The Familiar*, you've only just got a sliver of a day, a sliver of a lifetime.

DH: In the second volume, even more so than the first volume, you're making real use of the cliffhanger at the end of an episode. That moment at which an episode is suspended, and where we must wait to come back.

MZD: You point out, rightly, how in the micro world of *The Familiar* there are these little episodes almost down to a granular level, but then there are also the larger rhetorical devices like the cliffhanger, like the piecing together of the chapters, these broad story arcs, like 'Will Xanther get a dog?' No, she's not going to get a dog. In fact, she gets a cat! It's like the classic expectation that's set up in a television show where in the very beginning the woman says 'I'm getting a dog, I'm going to get a dog, I can't wait to get a dog', and every single viewer knows that no, she's not going to get a dog. Those are also things that are being played with. And then there's also literally the element of how the screen or television brackets visually what we can know. In some ways the page seems to do that as well. The way we come across people in the book, we don't immediately experience certain things the way we do when we're dealing with a visual medium. So then there's a kind of play there – how do we encounter these people? And then later we learn that they're something else.

DH: Something we haven't mentioned yet is that in *The Familiar* you have other episodes that 'bracket' the main narrative. Both volumes begin with a page that says 'New This Season' and then what look to me like little discrete episodes that are almost trailers for something that's coming later on. Then, after the main narrative has finished we get a short little parable about animals that, thus far, appears unrelated to the rest of the book. And it almost seems like these are episodes that will eventually migrate into the main narrative, maybe or maybe not. It's kind of hard to know.

MZD: The overt tension, without even knowing any bit about the plot, is 'How are these characters going to somehow interact?' We know by virtue of the fact that they're encased in this book that they will in some manner intersect. We suspect physically or thematically they might, but we know their lives will cross. And ultimately, the entire book, its moral compass if you will, is centred on the cat. It's centred on this voiceless animal with which we as a species are going to require some kind of reckoning and compatibility if we're going to survive. So much of our culture is anthropocentric that we have to begin to find a language for that which doesn't have a language, and find a place within our language so that it grants us the capacity to interact with the world. We'll require this if we're going to survive. So whatever one thinks of the various idioms floating around *The Familiar,* the point is that there are a lot of them. That's the kind of world we need to experience and then realise there's a whole other

level of music and vocalisations and non-vocalisations that are there, and if we don't hear them we're going to run into trouble.

DH: The concept of the Anthropocene contains us as human beings within an episode of time. It makes us think about the beginning and the end of our own episode, our human era.

MZD: It does. And also in *The Familiar* it's like one of those television or movie tropes of '400,000 years ago in the desert, something was uncovered – Cut to present day!' There are people who don't have any faith in the structure so they just assume it's a random spattering of episodes. But, as you said earlier, the idea is to use these episodes outside the main narrative as if they're little previews to see before an HBO show. And are they just other shows or are they pointing to a kind of connectivity that's going on? There are certainly hints within the book about the form, and if you look closely you start to see that there are these connective tissues. But it seems that what we're talking about is that we're pointing out that there are episodes that correspond *to* the volumes and then there are episodes that exist *within* the volumes – the chapters and the various characters, or the previews at the front and parables at the end, all the way down into these tiny little episodes that can be as small as a bracketed thought by two characters who share a similarity. Is the permeability of these borders beginning to increase down to even the granularity of the font that's used between one section or another? These episodes are contained, and at the same time they're opened back up.

1 The first volume of *The Familiar* was published in 2015.

Which colour is now?

IBM

the rema

GARRY
KASPAROV

Fabien Giraud and Raphaël Siboni, '1997 — The Brute Force',
The Unmanned, season 1, episode 2, 2014, video HD, 26 minutes.
Image courtesy of the artists

— In which defeated he leaves the scene and the stage is left in search of its scale —

Yin-Ju Chen

A Tarot Reading
for Liverpool

Question 1: What will the economy in Liverpool
be like in the second half of 2016?

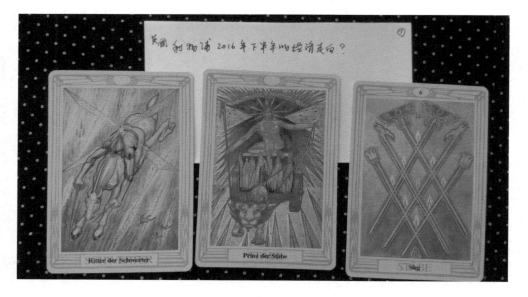

Answer:
From left to right, we have this three-card spread:
1. Knight of Swords → 2. Prince of Wands → 3. Six of Wands (Victory)
The spread suggests that progress will be positive.

The knight holding his sword represents Air. Riding his horse over the water, with the swallows following, means that basic human emotions and sensations (Water) will be ignored. From the beginning, even before June, the development of the economy will be all about the strategy of those who are in charge. They will take action with intelligence, logic, astuteness, skill, tactical cleverness, and without emotional projection. However, they need to ensure when making 'clever' decisions that these benefit the society at large – minorities also need their rights and be taken care of.

And then it will be all about taking action. With the darting flame, we see the prince riding his wild lion and holding his wand (Fire) running towards us with passion, eagerness, impatience and arrogance, possibly in a phase of storm and stress. There are many plans that the city would like to realise, but both the municipal administration and its citizens should be patient and take every factor into consideration.

With the powerful energy of the Prince of Wands combining with the 'coolness' of the Knight of Swords, the development of the economy will be undertaken optimistically, as can easily be read from the Six of Wands, 'Victory'. On this card we also see an astrological symbol: Jupiter in Leo. Relating to the Prince of Wands, the wild and adventurous lion seems to lead the city, the administration and the people, to a promise of abundance and prosperity.

> *Additional information from astrologer and tarot-card reader Amber Tang:* The city should: Expand its vision / combine resources from outside / enhance tourism, entertainment and cultural affairs / create more propaganda / focus on social services (the number six represents Virgo, which means service).

Question 2: What will cultural development in Liverpool be like in the second half of 2016?

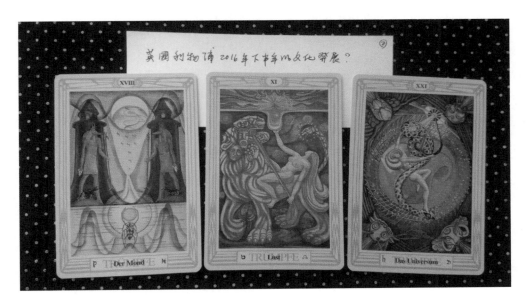

Answer:
From left to right, amazingly, we have three trump cards,
which means this is a very important message.
It is rare to see a spread made up entirely of trump cards
(there are 21 trump cards in a 78-card deck).

1. XVIII the Moon → 2. XI Lust → 3. XXI the Universe
This spread also shows positive progress.

XVIII the Moon suggests that to develop cultural affairs one should descend to a very basic level and dig out what is worth developing, look inward and backwards to review the city's history and investigate the depths of its soul, as well as perceiving deep-seated fears. The Moon also means mother, evoking the womb, when we slowly formed our consciousness and our physical being. When we developed fully, we left the dark womb and came to the world and faced new challenges. The Moon is saying 'Let's travel back to our origins and discover something there that has been forgotten.'

Or, perhaps the Moon is saying that there is something or even someone hiding in the darkness, making unclear gestures.

Here comes the lion again: XI Lust. Echoing the first spread about the economy, here we also have a fiery card in the middle, or as part of a transition of progress. In astrology, Leo represents pride, passion, desire and creativity. A strong and vital feminine power is taming this beast, and the grail she holds is an extended symbol of the womb. Once we have descended and dug deeply of what is the essence of this city, we will be able to turn this deep investigation into visible, integral forms.

The last card, XXI the Universe, is a message from the Universe that means what goes around comes around. Readers will also notice a Saturn symbol on the card (to the left of the words 'the Universe'). Astrologically speaking, Saturn represents karma and perseverance. Saturn will not let anyone be lazy and get what they want without effort. Saturn wants you not only to work hard, but to work extremely hard. If you ignore Saturn's message, you will not achieve anything, and the karma will come back in seven to fourteen years to demonstrate this deity's power. But if you work hard and struggle through, Saturn will reward you.

'The Universe' suggests careful and well-maintained projects that will lead to success, and even reach the international level. It is the climax of development.

Additional information from astrologer and tarot-card reader Amber Tang: The first two cards indicate that there are some people doing something under the table. These people want to control the power of cultural development. However, they are only aiming to achieve their own personal ends. / One should avoid superficial works. / One should have a holistic perspective. / One should extend one's horizons. / One should collect and consider new views or opinions. / In the end, cultural development is positive.

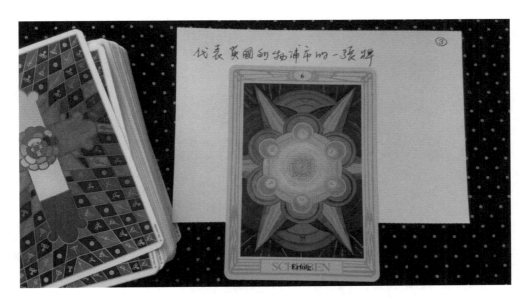

Answer:
Six of Disks (Success)
It's needless to explain more about this card.
It means success, pure and simple.

Disks are based on the element Earth. Therefore the success indicated here is based on a grounded and harmonious attitude. On the card, we see six celestial bodies circling and illuminated by the Sun. They are the Moon, Mercury, Venus, Mars, Jupiter and Saturn. Along with the Sun, they are the most important elements to 'form' a person, a country, a city, in fact, everything. They are the elements for astrologers to predict the future and to review the past. Here the celestial bodies are dancing harmoniously, which is a very good sign and positive answer to this question.

Additional information from astrologer and tarot-card reader Amber Tang: One needs to discover and utilise resources in the right way. / One needs to improve the connection and communication between the municipal administration and its citizens / The city has a rich history and culture; however, it needs to push the boundaries to flourish. / Self-contained comfort leads to laziness and poor coordination.

Illustrations: **Yin-Ju Chen**, *A Tarot Reading for Liverpool*, 2016

Yin-Ju Chen

Alisa Baremboym

Left: *Synescent Impression*, 2016, ceramic, sheet steel, acrylic, vinyl, 41.91 × 43.18 × 17.78 cm.
Photo by Joerg Lohse

Right: Toxteth, Liverpool: Empty property security. Image courtesy of the artist

Denise Riley

Time Lived, Without its Flow

I'll not be writing about death, but about an altered condition of life. The experience that not only preoccupied but occupied me was of living in suddenly arrested time: that acute sensation of being cut off from any temporal flow that can grip you after the sudden death of your child. A child, it seems, of any age.

Because this state is not rare, but for many is lived daily, I shan't be having recourse to the diction of 'trauma'. And whether it might be considered to fall within the compass of pathology doesn't greatly bother me here. Then certainly someone could produce an account of this freezing of time as an act of dissociation, or a borderline psychotic effort to erect a shield against the reality of the death. Or someone else could produce neurological accounts of the brain flooded with its own – this time, biochemical – defences. But I want to avoid offering my amateur speculations about existing theories. Instead, while trying not to lapse into melodrama or self-regarding memoir, I'll try simply to convey that extraordinary feeling of a-temporality.

But how could such a striking condition ever be voiced? It runs wildly counter to everything that I'd thought we could safely assume about lived time. So this is also a question about what is describable, and what are the linguistic limits of what can be conveyed. I'm not keen on conceding to any such limits. Yet it seems the possibilities for describing, and the kinds of temporality that you inhabit, may be intimately allied. For there do turn out to be 'kinds', in the plural.

This stopping of time can, for those who find themselves plunged into it, be lived. It turns out, surprisingly, not to be necessary to live in a time that runs with the usual standard mobility. You discover that you can manage well enough inside your private non-time of pure stasis. That such an experience is not uncommon, I'm sure, as I've listened closely for the last three years to what bereaved parents say in meetings, in online discussions, or in private encounters – and this in two countries. Yet any published mention of this seemingly a-temporal life seems to be rare. Before speculating about its absence, I want to insist that such a prolonged cessation of the flow of time is not conveyed by the remark 'time stopped'. There's nothing that feels either familiar or metaphorical in living out this condition in which time, for years on end, is arrested. Once you're plunged into it, the actual metaphoricity of our usual accounts of the passage of time is laid bare, for now you realise that the real espousal of figurative speech would be to maintain that, inevitably, 'time flows'.

Hard to put into words, yet absolutely lucid as you inhabit it daily, this sensation of having been lifted clean out of habitual time only

becomes a trial if you attempt to make it intelligible to others who've not experienced it. The prospect of recounting it in a written form stayed, for me, both repugnant and implausible for well over two and a half years after the death. You can't, it seems, take the slightest interest in the activity of writing unless you possess some feeling of futurity. Describing would involve some notion of the passage of time. Narrating would imply at least a hint of 'and then' and 'after that'. Any written or spoken sentence would naturally lean forward towards its development and conclusion, unlike my own paralysed time. Why, though, should you even dream of explaining how, after an unexpected death, you might find yourself living in this profoundly altered temporal state? The risks of trying are clear enough: you'd resemble the survivor of the 1960s who bores everyone with tales of his acid trips – then, as if worse were needed, you'd top it off with the layer of unassailable pathos due to your status as the mother of a dead child.

Nonetheless, and however common this condition of being outside time, when you're first in it, it's so quietly astonishing that you can't do other than take a cool interest in conveying it. This, for several reasons. Because to concede at the outset that it's 'indescribable' would only isolate you further, when coming so close to your child's death is already quite solitary enough; because it's scarcely rare, for immeasurable numbers have known and will continue to know this sense of being removed from time, so your efforts might well be familiar to everyone else who's also struggled to speak about this vivid state. Perhaps it's also my vanity, this hope that describing it might ring true for others who are in the same boat.

There's no specific noun for a parent of a dead child; nothing like the terms for other losses such as 'orphan' or 'widower'. No single word exists, either, for an 'adult child' – an awkward phrase which could suggest a large floppy-limbed doll. For such a historically frequent condition as outliving your own child, the vocabulary is curiously thin. The same phrases recur. For instance, many kindly onlookers will instinctively make use of this formula: 'I can't imagine what you are feeling'. There's a paradox in this remark, for it's an expression of sympathy, yet in the same breath it's a disavowal of the possibility of empathy. Undoubtedly it's very well meant, if (understandably) fear-filled. People's intentions are good – a respect for the severity of what they suppose you're enduring, and so a wish not to pretend to grasp it. Still, I'd like them to *try* to imagine; it's not so difficult. Even if it's unsurprising that those with dead children are regarded with concealed horror, they don't need to be further shepherded away into the inhuman remote realms of the 'unimaginable'. So I want to try, however much against the odds, to convey only the one striking aspect: this curious sense of being pulled right outside of time, as if beached in a clear light.

My own instincts happen to run in favour of de-dramatising; but to properly de-dramatise, first you'd need to admit this strangeness fully into the compass of the discussable. Perhaps there may be at least a half-tellable ordinariness here. This demands witness. I'll offer some of that, if hesitantly, as I'd have rather steered clear of autobiography. A few of my notes are reproduced below, though they're condemned to

walk around only the rim of this experience. At times they loop back on themselves, for one effect of living inside temporal suspension is that your reflections will crop up all over again, but as if, on each occasion, they were newly thought.

What follows is what I set down at very infrequent intervals at the time, in the order that I lived it.

Two weeks after the death:

In these first days I see how rapidly the surface of the world, like a sheet of water that's briefly agitated, will close again silently and smoothly over a death. His, everyone's, mine. I see, as if I am myself dead. This perception makes me curiously light-hearted.

You share in the death of your child, in that you approach it so closely that you sense that a part of you, too, died instantly. At the same time, you feel that the spirit of the child has leaped into you. So you are both partly dead, and yet more alive. You are cut down, and yet you burn with life.

One month after the death:

This so-called 'work of grief' is turning out instead to be a shatteringly exhausting apprehension of the needed work of *living*. It demands to be fully lived, while the labour of living it is physically exhausting – like virulent jetlag, but surging up in waves.

The notes and emails of condolence have stopped arriving and I've acknowledged each of them. Yet after all this ritual and effort, he *still* hasn't come home. What more does he want?

So intricate and singular a living thing can't just vanish from the surface of life: that would run counter to all your accumulated experience. The day after his death, studiously wiping away what you realise are the last tangible traces: tiniest bits of his hair from the edge of the washbasin. This solid persistence of *things*. So then the puzzle of what 'animation' is – of exactly what it is that's been crushed.

His death has put me in mind of those millions whose children were and are lost in natural disasters, or accidentally killed, or systematically obliterated; no wonder that bitterness and a loss of hope have filtered down the generations, and then the disengagement. Millions disorientated, perhaps, by this quiet feeling of living only just at this near side of a cut. At the death of your child, you see how the edge of the living world gives onto burning whiteness. This edge is clean as a strip of guillotined celluloid film. First came the intact negative full of blackened life in shaded patches, then abruptly, this milkiness. This candid whiteness, where a life stopped. Nothing 'poetic', not the 'white radiance of eternity' – but sheer non-being, which is brilliantly plain.

Five months after:

Apparently almost half a year has gone by since J. disappeared, and it could be five minutes, or half a century, I don't know which. There is

so very little movement. At first I had to lie down flat for an hour each afternoon, because of being crushed as if by a leaden sheet, but by now I don't need to lie down. This slight physical change is my only intimation of time.

Knowing and also not knowing that he's dead. Or I 'know' it but privately I can't feel it to be so. These fine gradations of admitting the brute facts of the case, while not feeling them; utterly different, though, from supposing that he's still alive somewhere else in this world. This isn't some ambiguity designed to blur the hard fact. Nor is it an imperfect anaesthetic.

This knowing and not knowing is useful, for it allows the truthful richness of all those shades of acknowledging and dissenting. Half-realising while half-doubting, assenting while demurring, conceding while finding it ludicrously implausible – so many distinctions, all of them nicely in play. To characterise such accurate nuances as my 'denial' of his death would be off the mark. Yet who is policing my 'acceptance' of it?

What a finely vigorous thing a life is, all its delicate complexity abruptly vanished. Almost comical. A slapstick fall.

There's no relation, simply, between your recall of the courageously optimistic dead and your knowledge of sudden blackness. But you struggle to hold both in mind at once. You try to slot together the snippets of evidence – coffin, ashes, silent house, non-reappearance of child – to become fully convinced by the deduction that you have conscientiously drawn in theory.

My head can't piece together the facts of a coffin under its roses and lilies, then the sifting gunmetal grey ashes, with this puzzling absence of the enthusiastic person who left home to work abroad for a few days but has still not walked back in the door.

Not that I have *delusions*, as such. But a strong impression of being torn off, brittle as any dry autumn leaf liable to be blown onto the tracks in the underground station, or to crumble as someone brushes by me in this public world where people rush about loudly, with their astonishing confidence. Each one of them a candidate for sudden death, and so vulnerable. If they do grasp that at any second their own lives might stop, they can't hold on to that expectation. As I do now. Later everyone on the street seems to rattle together like dead leaves in heaps.

Wandering around in an empty plain, as if an enormous drained landscape lying behind your eyes had turned itself outward. Or you find yourself camped on a threshold between inside and out. The slight contact of your senses with the outer world, and your interior only thinly separated from it, like a membrane resonating on the verge between silence and noise. If it were to tear through, there's so little behind your skin that you would fall out, towards the side of sheer exteriority. Far from taking refuge deeply inside yourself, there is no longer any inside, and you have become only outwardness. As a friend, who'd experienced the suicide of the person closest to her, says: 'I was my two eyes set burning in my skull. Behind them there was only vacancy.'

I work to earth my heart.

There's No Place Like Home

Episode 1

The narrative is familiar to us: obscure fighter, epic challenge, super-human effort, moral victory. In this way *Creed* (2015), the sixth sequel to the film *Rocky* (1976), follows the path of the original story. The hero this time is Adonis Creed, son of Apollo (named, let's assume, after the prophetic deity of the Oracle in Delphi), one time foe then friend of Rocky Balboa. His challenge is to confront a brutal half-man, half-beast: the World Champion 'Pretty' Ricky Conlan in Liverpool, England.

Returning home after the big fight (which takes place at Goodison Park in North Liverpool), Rocky and Adonis visit the Philadelphia Museum of Art. In truth, they visit the Rocky Statue and the Rocky Steps in front of the museum. This is where (once upon a time) Rocky, finishing his early morning training, bounced up and down, celebrating an imaginary world title. That statue has a curious dual existence. For Philadelphians of our universe, it is a real monument to a fictional figure. But it is also a fictional monument to a real figure: Rocky and Adonis can visit it in *Creed* because the civic leaders of their fictional Philadelphia also erected a statue to Rocky. The Rocky Statue is fictional in our real world and real in their fictional world.

That statue, those steps, make the Philadelphia Museum of Art a site of pilgrimage. For many, the museum, with its epic Greek portico (for the founders of that Museum, much like the founders of the Walker Art Gallery, Liverpool, which opened a year later in 1877, civic buildings should pay homage to Ancient Greece) is merely a theatrical backdrop to the Rocky story.

Let us return to Liverpool. It is a city built to resemble Ancient Greece (by architects such as John Foster and Harvey Lonsdale Elmes working in the early 1800s), so that Liverpool's merchant class, the rising elite (wealthy through colonial trade and the industrial revolution) might see themselves and their civic commitment in the image of the legendary cradle of democracy.

This collapsing of space, time and stories – imaginary Liverpool, real Greece, fictional Philadelphia – mirrors the way in which Ancient Greeks imagined and depicted their myths. Hand-drawn images on a Grecian vase fold into each other to show multiple times, spaces and characters on a single plane, expressing the way in which the gods exist on earth and in the heavens, assuming multiple shapes and characters as circumstances required. Such fictions were instrumentally resurrected in Georgian and Victorian times to validate a set of economic and political circumstances.

So, if Liverpool has always been a kind of set, what else has been enacted here? If you look down Berry Street you can see it: John Franklin's neoclassical church (now the Black-E), from 1840, right next to the Chinese arch. This arch is the gateway to Liverpool's Chinatown.

Chinatown has existed in Liverpool since the late 1890s. Nowadays there are numerous Chinatowns across the world – sometimes there are several in a single city. Many have a traditional Chinese arch to mark their location. Liverpool's arch was imported in pieces from Shanghai, and it is decorated in red and gold, with 200 dragons. Perhaps this arch, and others like it, is a portal to all the other Chinatowns, everywhere. The universality of these displaced and artificial versions of China points to the original immigrants' desire to produce a version of their country of origin, a fictional world to compensate the hostile environment of the host country. Chinese immigration was – like many migratory fluxes today – motivated by geographical labour demands and, in contrast to the Greek fiction used by Liverpool's ruling class, this world was beneficial to sailors and workers from a different continent.

These days, Chinatown is more dispersed. The old neighbourhoods with their arches are, for many, a nostalgic image that has very little to do with contemporary reality. A new Chinatown exists in the imagination, in memory, or in online networks such as Facebook or Instagram, whilst the power of contemporary China reveals itself through investment in speculative economies.

We will learn more about fictions, portals, Chinatowns and Ancient Greece in this next section of this book. Let's continue.

Lara Favaretto archive

They say I was born inside the dragon's head in
Otterspool – the one in the ornamental garden, close to the
roundabout. I don't think I was ever actually born though,
I may still linger in the Drexciyan darkness of The Atlantic.

But one day I would like to be born as a dance or as
a song. Yesterday Kool Keith called me his daughter.
'Why not a son or a mother?' I wondered in retrospect.
The book falls open again.

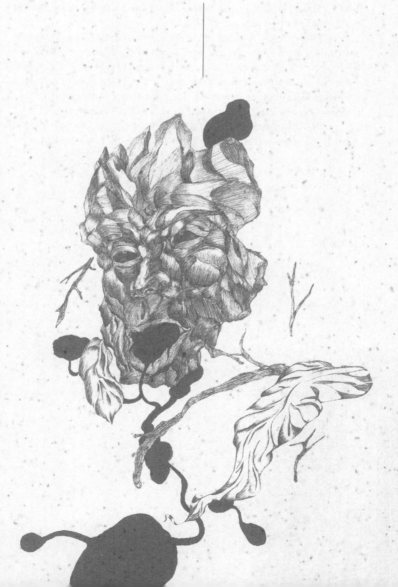

Today I would like to be born
as a planet whose movement is
all a lover's dream. Tomorrow
I would like to be born as a
dream where three characters
meet. One is called San San,
like me – two others are
nameless and unidentified,
dressed like a drop.

Francesco Manacorda

Silence and Commotion
Towards a possible iconology inspired by Furio Jesi

In an essay published in 1966 under the title 'Simbolo e silenzio', the young mythologist Furio Jesi sketched up the parameters for his theory of myth as a non-translatable epiphany. Jesi's considerations took their cue from a comment by Jakob Bachofen concerning funerary symbolism in Ancient Rome. In the following years, this was to become a key aspect of the Italian mythologist's theory of myth. Bachofen observed that the symbols on Roman sarcophagi 'rest in themselves' and make no reference to anything that is not present. Jesi elaborated on this paradox, explaining how these images refer to an absence rather than to another reality, as the standard definition of 'symbol' would normally have it. According to Jesi, the silence of the funerary image that rests in itself evokes the silence of death, creating an epiphany of mythical death that is direct and not mediated by a linguistic system. He wrote: 'saying that they are empty vases is like saying they are full of the unknowable, or that they are full of death'.[1] The convergence of death, myth and the unknowable is an important aspect of this model, and we shall return to it later.

In the same essay, and possibly in the only case in which Jesi analyses modern and contemporary art in his work, he compares the different approach to symbols and mythopoeia adopted by the Surrealists and the Dadaists. The former still had ties with myth, implying a transcendent reality, while the latter aimed to reveal a void:

> Surrealism always restricted itself to immersing the ancient faces of the gods only halfway into darkness, so as to veil, but not negate, ancient symbolic relationships. Dada excluded *a priori* that a symbol might represent anything known, and it focused its interest on the perceptive appearances of symbols while at the same time denying them any power of revelation. Basically, the greatest provocation of Dada consisted in its wish to deny symbols their ability to enlighten, while also continuing to consider images and materials as symbols, even though they declared that they did not symbolize anything known.[2]

Head of Eros, Roman, marble, 45 cm. Henry Blundell Collection. Image courtesy of National Museums Liverpool

In this model, the Dadaists put forward a relationship with the symbol that is similar to the original, non-instrumentalised myth. Jesi spent his career demonstrating this idea as the only positive attitude towards myth: a symbol that rests within itself is, as such, ultimately unknowable. In an interview that he published towards the end of his life, almost fifteen years after 'Simbolo e Silenzio', Jesi said:

> I am convinced that, as I see it today, the best way for me to approach my own and other people's works and mechanisms, whether ancient or contemporary, consists in recognizing in some of them a language that cannot be reduced to others. One that is absolutely autonomous and 'resting in itself' (Bachofen), with some characteristics that can be defined with extremely vague approximations if – as is inevitable when we have to *define* them – we resort to another language.[3]

The Dadaist impulse that Jesi tried to demarcate doesn't point to a 'linguistic turn' in the iconic domain whereby images form an integral part of a universal system of signs. Rather, images are a step before signs, in which they are not yet turned into *logos* but remain mythical epiphanies. In other words, a direct and unmediated enunciation of *mythos*. Jesi's analysis of the expressive potential of Dada carries on into a criticism of the different uses of symbols in the art of the late 1950s and early 1960s:

> The most recent artistic achievements that would appear to link back to the Dada experience generally lack its power to provoke, since the artists aimed to fill the void of the symbolized unknown with reasonings of various kinds: from the search for a new visual language to the experience of a new space, and from the promotion of the object as a chance product (and thus indicative of an existential norm) to the morals of provocation for provocation's sake. They are all forms of exorcism against the darkness that inevitably emerges behind the sphere of the symbol, when the faces of the gods and the great mythical archetypes disappear.[4]

Head of Apollo, Roman, marble, 50 × 27 × 17 cm. Henry Blundell Collection. Image courtesy of National Museums Liverpool

In this description it may be possible to see Fontana's Spazialismo, Pollock's Abstract Expressionism, American neo-Dada, Nouveau Réalisme, and possibly even Fluxus, among others, and the notion of exorcism against the darkness is undoubtedly an instrument that is still of great value for the critical analysis of much of today's contemporary art.

We can now add a second aspect to this first element of Jesi's iconic model that will show how his work on images is much more

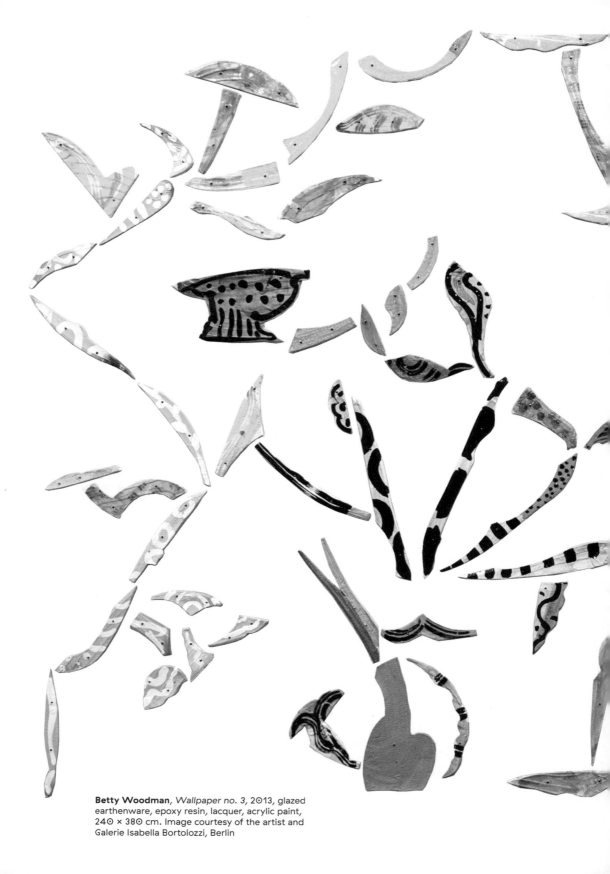

Betty Woodman, *Wallpaper no. 3*, 2013, glazed
earthenware, epoxy resin, lacquer, acrylic paint,
240 × 380 cm. Image courtesy of the artist and
Galerie Isabella Bortolozzi, Berlin

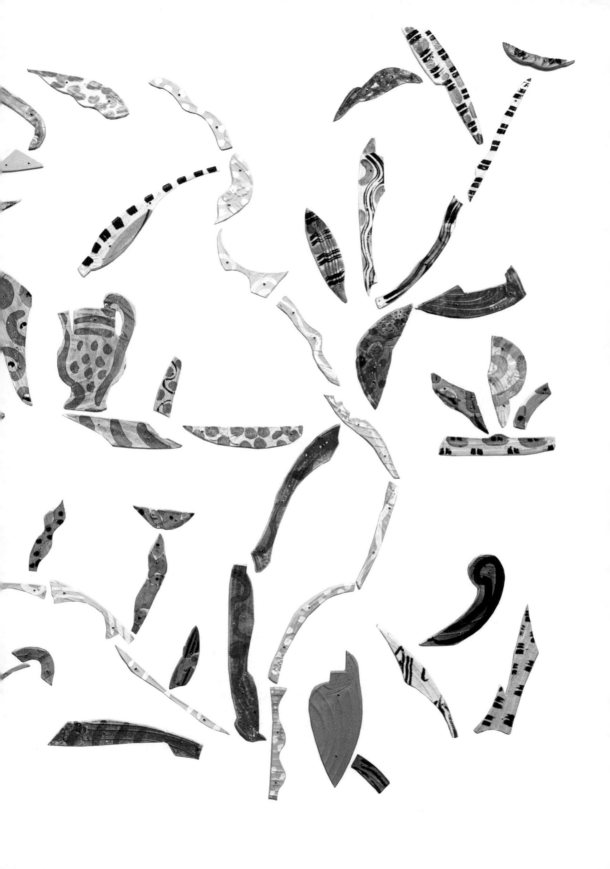

complex. Besides the mythical epiphany resting in itself, the young mythologist explores the idea of experiencing mythological material as 'being captured' by images. This idea comes chronologically earlier in Jesion thinking but remains parallel to the silent symbol one. In this paradigm, rather than being untranslatable, the image activates through the emotion it arouses an 'archetypal connection', which 'is established between two (abstract or concrete) images, following a psychic schema that must be imagined as in potency within each individual'.[5] This was written by the *enfant prodige* when he was aged just seventeen, and he used this theory to start questioning and unpacking mythological materials. In his preface to the book *La ceramica egizia*, he talks of:

> concepts bound to each other in connections that can surpass logic so as to be understood in a purely fantastical atmosphere [...] we used the term 'archetypal image' to indicate the image relating to the complex of concepts linked by the aforementioned connections. But I would go so far as to consider that the connections themselves may deserve the attribute 'archetypal', remaining independent one from the other.[6]

A surprising postscript to this critical concept – but one that is revealing with regard to Jesi's method of interpretation – states the necessary reversibility of the connections:

> the archetypal connection can come about between an abstract and a concrete image; but it can also come about between two concrete images. One cannot talk of different phenomena, just as in the first case I could not talk of the image and its meaning if I used the term *image* to mean just a materially exemplified concept and the term *meaning* to mean an abstract concept. We can indeed affirm the presence of a reciprocal relationship: the chthonic-oracular concept is the meaning – the value of the image of the serpent – just as the serpent is the meaning, which is to say the value of the chthonic-oracular concept.[7]

The value of this 'emotional knowledge' (a concept borrowed from Leo Frobenius's *Ergriffenheit*, which is sometimes translated as 'commotion') leads to a knowledge at the limit of the intelligible and of the verifiable that is clearly in conflict with any rational and linguistic demarcation. Jesi goes so far as to say that the interpretative game around mythology can be played only if we accept that it must be possible to state that the knowledge produced by the connections – and even by its methods – need to be affirmed and denied at the same time. In order to draw on this knowledge, the player must also conceive 'the potential for the nonexistence of the connections that determine a mythologem, conceive that the belief that everything said so far is false, together with a belief in its correctness, or in its approximation to the truth'.[8] The radical nature of this scientific proposal implies a 'principle of contradiction' – similar to those operating in quantum

Statue of Aphrodite, Roman, marble, 12.6 × 47 cm. Henry Blundell Collection. Image courtesy of National Museums Liverpool

logic – which, if used genuinely, represents a possible weapon against the technicisation of myth.

On the one hand, there is pure myth and incomprehensible enigma, while, on the other, there is a form of thinking through images. The latter is brought about by archetypal connections that produce a kind of knowledge that cannot be verified other than through the ability of the connections to form spontaneous relationships. These are different in each individual, who nevertheless experiences them emotionally as fulminating. The first model resists any attempt to subject the images to linguistic encoding. The second postulates an iconic turn that does not guarantee any certain correspondence between the connected images but which, for this very reason, does propose the connection itself as the key linguistic element. So, 'in truth, it is indeed the emotion that "survives" in the representation, by expressing the movement of the figures. This consideration quickly brings Jesi's theory close to Warburg's theory of the "formulas of pathos".'[9] In both cases, the iconic relationship with mythical thinking is in no way denigrated as in Hegelian idealism. What Hegel calls *Vorstellung* is generally translated into English in the compound form of 'picture-thinking' or 'figurative thinking'. In Hegel's view, this form of reflection and expression precedes the word and language as a way of presenting us with what the enunciator has previously experienced.[10]

The fact that it precedes – we are tempted to say that it possibly exceeds – the word coincides with Jesi's idea, although the two authors have different views concerning the epistemic merits of this pre-linguistic elaboration. What the two thinkers do have in common is the idea of the non-translatability of the representation into word and concept. In Hegel's view, this makes the process inferior – to the point that he declares the end of art necessary – while for Jesi it activates a form of non-knowledge, a gnosiological appetite that is not solely conceptual. This activation has interesting similarities with the concept of 'animation' that Hans Belting views as essential for putting images 'in motion'.

On the slopes of the Himalayas currently in southern China, the Naxi people are believed to have first developed the Dongba pictographic writing system in the seventh century. As in Egyptian hieroglyphs, the signs are pictographic, and in most cases they directly represent the object they portray. Dongba is the only pictographic writing system still in use. A number of factors further complicate this potentially infinite system of signs. The signs may be used phonetically for words that sound similar to what is depicted, and also in compound forms, as rebuses, using the sound of the object's name in order to make up other words. For example, while the representation of

food means 'food', it can also mean 'sleep' because the way the word 'food' (*xa*) is pronounced corresponds to the sound of the word for 'sleep', but another pictogram can be added to the same sign in order to create a different compound word. Furthermore, to define meanings that vary too greatly (different writers and readers may attribute different values to the same signs), in some cases the Geba syllabic system is also added in order to reduce ambiguities by adding determinant signs. What is most relevant to our disquisition is the fact that these manuscripts consisting of sequences of images are not real texts but rather 'visual scores' used by priests as mnemotechnical tools for narrating myths. Since they are used as *aide-memoires* or visual aids, only the key 'words' are written in the pictorial phrases, which means that a single logogram may contain groups of different words or even entire phrases. The result is an iconic form of writing that makes use of memory and emotion to evoke the myth.

Lower part of *Venus* statue, Roman Imperial, marble, 50 × 39 cm. Henry Blundell Collection. Image courtesy of National Museums Liverpool.

The Dongba logograms that represent themselves are not just icons in the Peircian sense but, as evocative of mythical epiphanies, they are actually comparable to Bachofen's symbols. On the other hand, the separation between the sign and the signified, which can be dictated by memory or by the use of rebuses and syllabic additions, creates connections that are not natural and therefore not merely based on the principle of iconic resemblance. In deciphering them, the priest who is able to read Dongba manuscripts thus sets in motion two cognitive and animation skills: one dictated by mythical epiphany, and the other by emotion; one by silence, in which the icon rests in itself, and the other whereby the connection – archetypal or otherwise – is set in motion in order draw on the source of the myth and to 'let him or herself be known by knowledge'. Only the capacity for such double interpretation that can be found in a language combining logograms and phonograms provides us with an analogy for the possible iconology that Jesi suggests to us. As is the case when interpreting a Dongba manuscript or an Egyptian inscription, we need to read both the iconic symbols that represent themselves (in Egypt, these signs were accompanied by a single vertical bar, indicating that the image represents what it illustrates) and the determinant phonograms (rebuses) or syllables that represent a connection between image and sound, or again those based on non-visual conventions (in hieroglyphs, for example, the plural is indicated by three vertical bars).

If we want to let images speak for themselves in Jesian terms, we must start from the apparent contradiction between images as epiphanies and images that reveal connections. We need to shift what Hegel, but also Frobenius, described as a diachronic evolution in the simultaneity of the three registers: the connective emotion that thinks through images, the untranslatable mythical epiphany, and the logos

Episode 1

Top: *Orpheus Among the Satyrs*,
Roman Imperial, marble, 33 × 47 cm.
Henry Blundell Collection.
Image courtesy of National
Museums Liverpool.

Right: *Altar*, Roman, marble,
71 cm. Henry Blundell Collection.
Image courtesy of National
Museums Liverpool.

Lara Favaretto archive, Jerusalem, IL, 2013

that revolve around myth. These three are in Jesi's view a single polyphonic interpretative score. This is particularly helpful and relevant in decoding art and visual language on a more general level: the flow of images like those in Dongba manuscripts cannot but remind us of the potential offered by the connections between images in the simultaneous reading brought about by the display conventions of contemporary art. This is true both in the case of a diachronic succession of works by a single artist and in that of a synchronic succession made possible by the exhibition format as a process that Harald Szeemann referred to as similar to writing.[11]

Top and right:
Betty Woodman
Aztec Vase and Carpet no. 8, 2015, glazed earthenware, epoxy resin, lacquer, paint, canvas, 36.25 × 54 cm. Image courtesy of the artist and David Kordansky Gallery, Los Angeles

Jesi's idea is possibly not that far removed from Hegel's, but unlike the latter, he advocates a synchronic approach in which contradictory elements coexist in a musical relationship. In this framework, he suggests overlapping the notions of the concept, emotion and silence. For Jesi, who takes from Jean-Pierre Vernant in this, the evolution of mythical epiphanies in ancient Greece can be seen in the knowledge brought about by the first Greek philosophical speculations. Philosophy at that stage replaced epic poetry in its role of mythological evocation. This happened when *mythos* was adopted by the pre-Socratic philosophy of the Milesians (Thales, Anaximander and Anaximenes), whose prose writings made myth 'a lexical repertory of truth, allowing mythical epiphanies to take on the shape of symbols'.[12] As Jesi puts it, they imposed the supremacy of the:

> *mythos*-symbol: the lexical formula – form – which is true in its 'resting in itself'. Speech becomes the enunciation of truth [...] the meaning of this 'resting in itself' of the symbol-word and of the symbol-myth is crucial for understanding the mythological quality of Anaximander's *áhich i*, an inexhaustible reservoir of reality, as well as Thales' 'all things are full of gods'.[13]

If image-thinking does not precede the *logos* of philosophical knowledge but is rather a generative and simultaneous aspect of it, then this mode of multiple thinking is even more urgent today and not only in artistic disciplines. The sophisticated visual literacy that this model offers us is not easily pray to manipulation and has a number of affinities with contemporary art and its multiplicity of registers. The exchange of tools and approaches between mythology and art theory proposed here would provide us with powerful instruments to help us critically find our way through the jungle of iconic meanings in present-day culture.

Next spread:
Betty Woodman
Lucia's Room, 2013, glazed earthenware, epoxy resin, lacquer, acrylic paint, canvas, wood, 172.5 × 215 × 30 cm. Image courtesy of the artist

1 Furio Jesi, *Letteratura e mito*, Einaudi, Turin, 1968, p.27.

2 Ibid., p.24.

3 Unpublished interview quoted in Andrea Cavalletti, 'La maniera compositiva di Furio Jesi', appendix to Furio Jesi, *Materiali Mitologici*, second edition, Einaudi, Turin, 2001, p.368.

4 Ibid.

5 Michele Cometa, 'L'imagine in Jesi', in Marco Belpoliti and Enrico Manera (eds.), Furio Jesi, *Riga*, no. 31, Marcos y Marcos, Milan, 2010, p.265.

6 Furio Jesi, *La ceramica egizia. Dalle origini al termine dell'etàt ceram*, SAIE, Turin, 1958, pp.18–19.

7 Ibid., pp.19–20.

8 Ibid., p.22.

9 Michele Cometa, op. cit., p.262.

10 'When religion has been raised to the level of picture-thinking (*Vorstellung*), it acquires a polemic cast. Its content is not grasped in sensory intuition nor immediately in picture form, but rather mediately, on the way to abstraction, and the sensory or pictorial has been lifted (*aufgehoben*) into the general: and this sublation necessarily includes a negative relationship to the pictorial. Yet this negative direction strikes not only the form – such that the difference between intuition and *Vorstellung* would be present in form alone – but also touches content. In intuition idea and mode of representation are so closely connected that both appear as one, and the pictorial as the meaning of an idea so essentially connected with it that it cannot be separated from it. Picture-thinking, however, emerges from the conviction that the absolutely true idea cannot be grasped by way of a picture, indeed that pictorial representation is a limitation of its content; picture-thinking thereby sublates the unity of intuition, destroys the unity of the picture and its meaning, and lifts the latter up for itself.' Georg Wilhelm Friedrich Hegel, 'Vorlesungen über die Philosophie der Religion' (1821), in *Werke*, vol. 16, pp.139–40, trans. Frederic Jameson, in Frederic Jameson, *The Hegel Variations*, Verso Books, New York, 2014, p.122.

11 Harald Szeemann, *Écrire les expositions*, La Lettre volée, Brussels, 1996.

12 Furio Jesi, *Il Mito*, Mondadori, Milan, 1989, p.26.

13 Ibid., p.27.

Francesco Manacorda

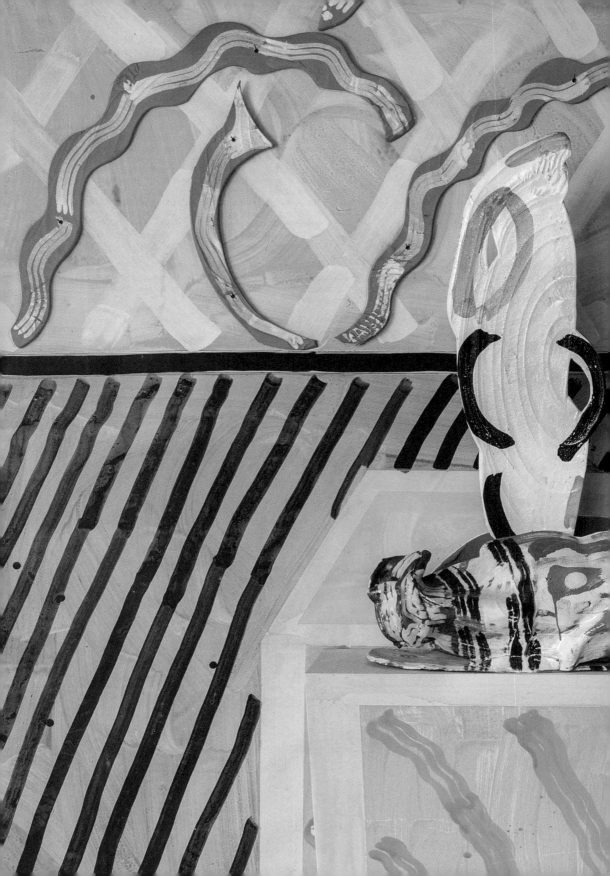

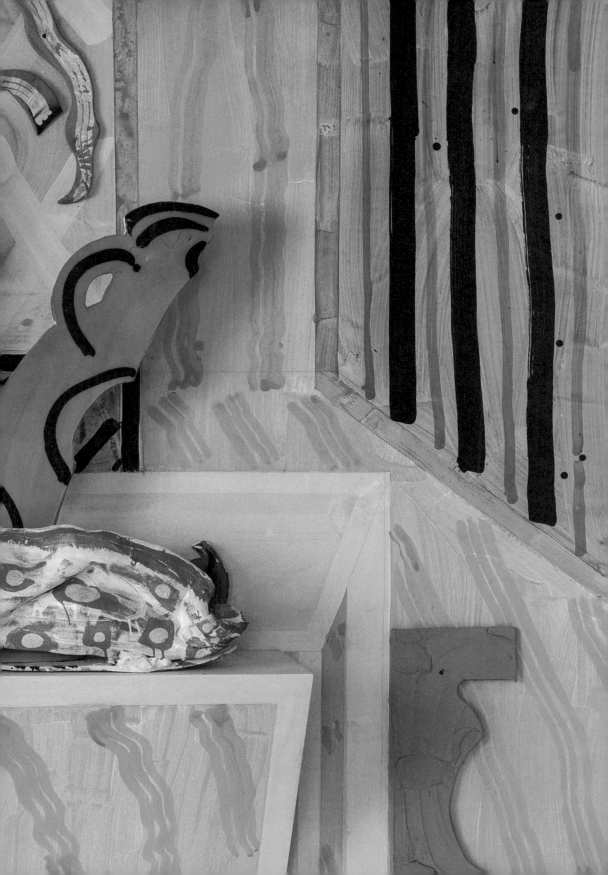

Sometimes I live several days at once.
It happens in the same room, in the same
window, in a single frame or a single vase:
being inside and outside of the vase at once,
like skinless liquid with separation, distinc-
tion and difference suspended.

Here I am making a selfie with the help of no hands.

In the next season I will be serving you
drinks the same way.

Ana Jotta

Excerpt from
At Swim-two-birds,
Flann O'Brien, 1939

'Bernard Fann?'
'No.'
'Joseph Poe or Nolan?'
'No.'
'One of the Garvins or the Moynihans?'
'Not them.'
'Rosencranz O'Dowd?'
'No.'
'Would it be O'Benson?'
'Not O'Benson.'
'The Hardimen or the Merrimen?'
'Not them.'
'Peter Dundy?'
'No.'
'Scrutch?'
'No.'
'Lord Brad?'
'Not him.'
'The O'Growneys, the O'Roartys or the Finnehys?'
'No.'
~~'That is an amazing piece of denial and denunciation,' he said.~~
He passed the red cloth over his face again to reduce the moisture.
'An astonishing parade of nullity,' he added.
'My name is not Jenkins either,' I vouchsafed.
'Roger MacHugh?'
'Not Roger.'
'Sitric Hogan?'
'No.'
'Not Conroy?'
'No.'
'Not O'Conroy?'
'Not O'Conroy.'

Ana Jotta

Oliver Laric

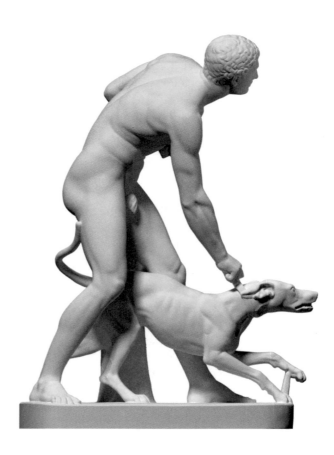

Gibson's sculpture was scanned by Laric as part of a commission by the the Collection, Lincoln. Laric 3D scanned numerous objects from the Collection and the Usher Gallery, Lincoln, making the data publicly available online, free and without copyright restrictions, at lincoln3dscans.co.uk

The project aims to make the collection available to an audience outside of its geographic proximity and to treat the objects as starting points for new works. Laric's scan of *The Hunter and His Dog* has been downloaded over 100,000 times, and in 2015 it appeared as part of the stage design of the Italian contribution to the Eurovision Song Contest.

3D scan of John Gibson's *The Hunter and His Dog*, 1838, stone, marble, 147.5 × 58.5 × 99.1 cm.

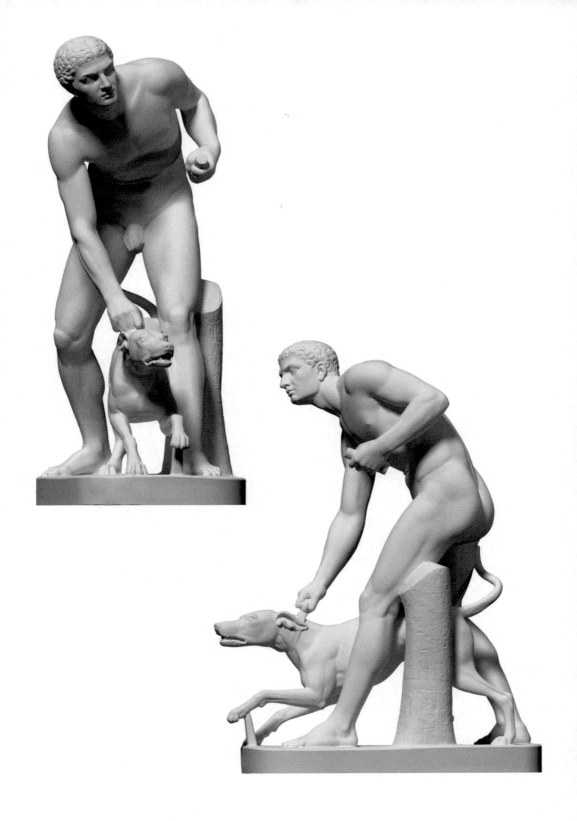

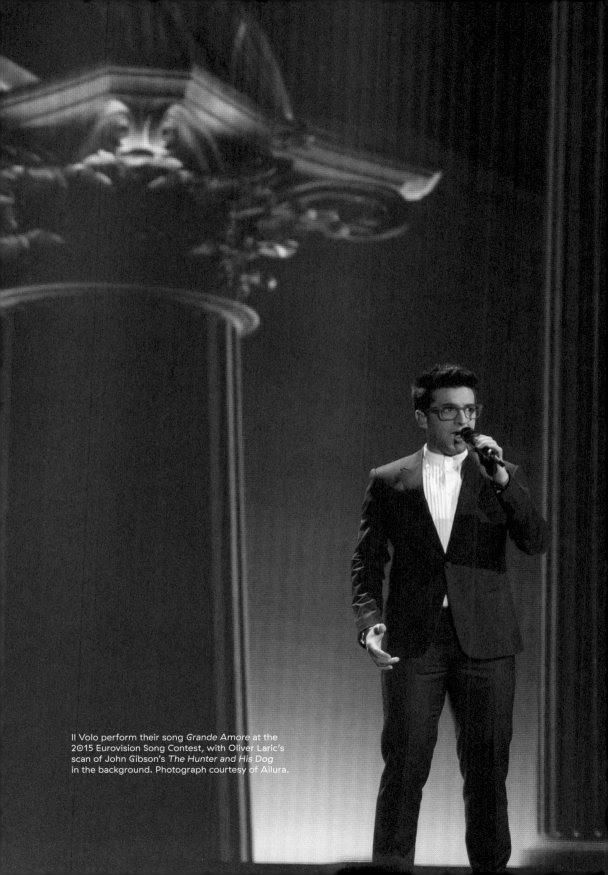

Il Volo perform their song *Grande Amore* at the 2015 Eurovision Song Contest, with Oliver Laric's scan of John Gibson's *The Hunter and His Dog* in the background. Photograph courtesy of Ailura.

Xiaolu Guo and Ying Tan

{Chinatowns}

Between going and staying
the day wavers,
in love with its own transparency.
The circular afternoon is now a bay
where the world in stillness rocks.

All is visible and all elusive,
all is near and can't be touched.
– Octavio Paz

Ying Tan: When you pass through the arches of a Chinatown gate, it's as if you're moving through fictional pasts as well as fictional futures. The arches are signifiers of time and space, and your own particular Chinatown – the one you're most familiar with, perhaps, or even the one you see in films – can shape the narrative of your belonging. Creating an artifice in this way is a useful gesture, socially and polit-ically. Or perhaps the gates of Chinatown function like a punctuation mark: two bracket-shaped objects to frame our stories in.

Xiaolu Guo: For me, a Chinatown with gates and arches represents a rather heavy and emotional past: the desire of dislocated Chinese immigrants to recreate their homeland or their home village, even if it's only in miniature. Of course, that's the desire of older gener-ations who've spent their past life in their native country and have realised that the past will never return to them. Re-creation is an act of nostalgia. Nostalgia sometimes has nothing to do with aesthetics or beauty. It's about the loss of a particular past. I've always loved the feeling of entering a Chinatown – whether in New York or in London or in San Francisco. But my favourite one is in Bellville in Paris – a Chinatown without gates. It's so alive, open, mixed with members of the Arabic community and Parisian dandies. It's formed its own way of regenerating itself. In Western countries, whenever I enter a

Chinatown, I instantly feel the familiar energy and hear the sound of a familiar tongue, all of which gives me comfort and warmth. Within the Chinese quarter, I don't feel so much a foreigner as I do in other areas. This is very different from the world of the new generation and new immigrants. For example, the second-generation Chinese or the third generation prefer to create a Chinatown in their heads, on the internet, or on Facebook, without gates or walls. But coming back to my own reality: my current life resembles the life of a bohemian artist and I can't be satisfied with living in the small and limited world of a Chinatown. I need to have a different environment. Other people surely share my feelings.

YT: Do you think that architecture or a sense of place is important to the younger generation you talk about, or is it a different kind of architecture/place – physically but also perhaps in the way that social media might be seen as 'place' or structure?

XG: Yes, why not? Space is a very complex concept. The internet is a hugely dynamic space, for instance – and I don't think we can define what it means yet. Lots of experimental art and writings are published via social media and online. And sometimes it's the only place and outlet. Architecture is also a complex human invention – it's not about cement or arches or gates, it's about shaping and finding a certain identity.

YT: Do you think this decision to create a nostalgic image together with others can exist in virtual space? For me, this act of recreation or transplantation links to a desire to be part of something, the need to belong, physically. The problem with virtual spaces like Facebook or Wechat[1] is that these platforms are no longer experiential, personal, individual relationships rooted in physical place.

XG: Online freedom has its limitations as well. So this depends on the particular social environment. But if we talk about the need to belong and traditional identity, this is so much to do with which generation one comes from. I'm not a big fan of Facebook, but I can see why lots of young people only use that to connect to others. It's lighter and it's open-ended (at least in the way it appears to me). For the older generation – let's say the first generation of Chinatown people – they have a more physical and earthy way to connect to their past even though the past is already another country. For the Facebook generation, perhaps they're less interested in their past and more in the present and the future. I'm interested in both, from the anthropological point of view.

YT: Speaking from that perspective, then, a good friend of mine was recently in the Los Angeles Chinatown and said it was rather dispiriting. It was clearly in decline and increasingly taken over by non-Chinese hipsters opening restaurants and art galleries. The same thing is happening in Vancouver's old Chinatown. There's a new bagelry in

the Liverpool Chinatown. So you could say that internationally, traditional Chinatowns are in decline while suburban newer ones are on the rise. The difference between older Chinatowns and newer Asian centres turns on its head the narrative of Chinatown as a repository of safety and comfort for Chinese people in a new and unfamiliar land, since the new Chinatowns are pulsing with new immigrants highly familiar with travel and the forces of globalisation of which they're beneficiaries. In some ways, this is a sign that there's less discrimination today than in the past. Chinatowns are treated like any other area, all equal in the impartial eyes of gentrification. People have got more used to Chinatowns. But in other ways, something special is slowly being lost. I feel both profound ambivalence and loss whenever I think of Chinatown, the idea of which is inexplicably bound up in collective memories. It's fluid, changing from generation to generation – there's an ephemerality to it.

XG: I think you put it well. But for an artist, the collective memory is only attractive and can only be deeply understood from a personal point of view. Reading a dry report about a certain immigration history may not touch me at all, but through individual stories I'll connect to that history in an emotional way. I try not to be a theorist – that's a failure for a novelist.

YT: The way that the Biennial's Chinatown episode unfolds across the city is within 'in-between' spaces – places like Octavio Paz's poem 'Between Going and Staying'. This reflects the idea of our identity not being one thing or another – something you touch on in a lot of your books. The notion of dislocation and nostalgia reminds me of the characters in your stories – Zhuang, for example, in *A Concise Chinese-English Dictionary for Lovers*. And in your most recent novel *I Am China*, there's a translator, Iona, a negotiator and the conduit of the narrative, who's at the same time British and Chinese but also neither of these identities. Do you identify with Iona? Do you see yourself as a 'negotiator', or perhaps 'translator'?

XG: Since I left China for Britain in 2002, I've been trying to translate many things for myself and for other people: literature, film projects, and cultural backgrounds in general. I've tried to find a middle way for myself to live as a writer and an artist. Having seen both the strong and weak aspects of the two worlds, I feel happier that I can live outside of a one-dimensional cultural identity. And this position gives me many possibilities to create work. Something great for one culture can be utterly wrong for another culture. It depends on whether we're talking about subjects such as democracy (pursuing it in a much more open society or living with its limitations), or physical habits (should someone like me continue a Chinese way of life or adopt a new life by having both cultures in me?), or the decision of whether to become a monolingual or bilingual writer. Everything has a different effect and I can't be judgemental here. As a writer, I need to play with the ideas of differences and commonalities. Therefore I create conflict between

characters in my novels and films and I use them as a narrative device. In A *Concise Chinese English Dictionary for Lovers*, the two lovers were a device to express a certain internal conflict within one person. It's my own conflict about cultural difference, adopting the new culture or not, but I had to create a male character and a female character to bring this out. So the jokes about the English breakfast, weather, and the concept of time, love etc, became funnier and more personal when two lovers were arguing at the table. With my book and the film adaptation *UFO in Her Eyes* I played a lot with humour, and readers in different countries responded very well despite the story being set in a Chinese village.

YT: You've talked about this new trans-national identity – something I can definitely subscribe to, coming from a Chinese immigrant family. My own parents immigrated to Kingston, Ontario, in 1990 after the events in China in 1989, and I'm always interested in hearing stories of migration and displacement, which is why I loved your novels from *Village of Stone*, to *A Concise Chinese English Dictionary for Lovers*, and especially *I Am China*. You said in an interview once that in a way you're 'stateless': 'Which is a good thing, at least for my type of character. Technically I'm a British citizen, but that doesn't define me at all. I could be a French citizen or a US citizen if I lived in those countries long enough.' Do you still feel this way?

X: Yes. I think it's a good thing that a person can live beyond these restricted and artificial constructions of national identities. Why do we surrender our life to meaningless politics and border controls? Despite cultural differences, we share certain universal values and agree about many things: the nature of love, happiness and even humour. Nothing is permanent and the material world is fragile, including our physical homes and national identities. We're free, and we should exercise this freedom. That makes us much more open and dynamic as human beings.

Lara Favaretto archive

PRISON AT ANDERSONVILLE, Ga.

1. Wechat is now the most popular mobile text and voice messaging communication service used in mainland China.

Xialu Guo and Ying Tan 89

Top: *Anemones, Kafr Sabt, Palestine,* 1909, photograph, 10 × 8.5 cm.
Image courtesy of the German Protestant Institute of Archaeology Collection Jerusalem

Right: *Bouquet of Flowers in a Vase,* undated, photograph, Uvachrom AG print, 15 × 30cm.
Image courtesy of the German Protestant Institute of Archaeology Collection Jerusalem

Episode 1

Koenraad Dedobbeleer

The Greek war of Independence (1821–32) began precisely at the time when the ideal of Ancient Greek civilisation held sway over the ruling classes of Europe and America. The vision of a revival of the ancient classical models was on the verge of becoming a reality. The *Acropolis* precinct is now partly made up of replicas in order to safeguard the remaining originals from the devastating effects of pollution. So what we see today is very similar to the nineteenth-century imagination of it: the reconstruction of an idealised ruin.

Athen mit Akropolis. Athens. Athènes.

This picture might be a copy after one of Franz Karl Leopold von Klenze's famous sketches of the **Acropolis**. Von Klenze was court architect to King Ludwig I of Bavaria, whose son Otto was made King of Greece following Greek independence in 1832. Thus von Klenze was imagining the Acropolis as a site of new national cultural identity following independence. By re-planning the layout of the city of Athens for Otto and his father in Munich, as well as advising on the reconstruction of the Acropolis as a historical site, von Klenze brought his Greek Revival fantasy back to Greece. An architectural style born in the West under the influence of the austere moderation and harmony of classical Greek antiquity thus returned to the land in which it had been neutered.

In 1839 Charles Fellows started excavating the ruins of what we commonly know as the ***Nereid Monument***, operating at his own expense but under the auspices of The British Museum. This interpretation dating from 1969 and set up in room 17 of the museum, is what the temple-like tomb may have looked like in its day, the fourth century BC.

63721 New York — The New York Stock Echange

Integrity Protecting the Works of Man is the title given to the group of sculptures adorning the pediment of the New York Stock Exchange. This, Ladies and Gentlemen, is the spirit behind a kind of paternal capitalism emerging in the nineteenth century and leading to twentieth-century Realpolitik. The New York Stock Exchange opened in its current building in 1903, after designs by George B. Post. The pediment conceals a group of marble sculptures conceived by John Quincy Adam Ward and carved by the Piccirilli Brothers upon his instructions. What we see today is a 1936 replica of the same group of sculptures made from copper and lead sheets and made to look like marble, covering the crumbling original. This empty replica is almost metaphorical: what remains of the image is the moral without its eroded substance.

After severe bombing by allied forces during World War II, Berlin's Pergamon Museum faced a long period of decline, only opening again in 1958 after extensive renovations and a diplomatic battle with the USSR to reclaim parts of it stolen content. What we see here is the freshly re-opened interpretation of the ***Pergamon Altar*** (second century BC), housed in the third reconstruction of the museum. A team headed by Carl Humann excavated the Altar in the ancient Greek city of Pergamon. By agreement of the Ottoman government of the 1870s it became the property of Germany. Against the nationalistic backdrop of the time, the German state claimed to have captured the finest example of Hellenistic architecture.

63. ΜΟΥΣΕΙΟΝ ΔΕΛΦΩΝ – ΑΝΑΠΑΡΑΣΤΑΣΙΣ ΤΟΥ ΘΗΣΑΥΡΟΥ ΤΩΝ ΣΙΦΝΙΩΝ
MUSÉE DE DELPHES – RESTAURATION DU TRÉSOR DE SIPHNOS

Ἐκδόσεις Υ.Δ.ΑΠ.

The original remains of the **Siphnian Treasury** were found only a few hundred metres away from the Delphi Archaeological Museum, in which they are on display. This replica of 1961 is an out-dated attempt to reconstruct it and even today there is still speculation as to the exact order of the frieze. The fragments on which this imaginative building was based are in room 5 of the museum, leaving it up to the viewer to rediscover the idealism amongst the wreckage.

The **Philadelphia Museum of Art** came to completion in 1928, although it was chartered for the 1876 Centennial Exposition, which was to commemorate the 100th anniversary of the signing of the Declaration of Independence. The building, in the so-called Greek Revival Style, was greatly criticised for being vastly over-scale. Since its opening, its pompous setting has become the permanent home for Marcel Duchamp's Étant donnés, amongst other things that were 'being given'.

Long before the days of Contextual Irony, in 1893, Higgs and Hill (O! Hill and Higgs. O! Higgs and Hill.) commenced the construction of the National Gallery of British Art in an architectural style that seems related to Eclecticism. Erected on the grounds of the demolished Millbank Prison, the enterprise was almost entirely financed by sugar sweet Henry Tate – yet to become Baronet – to house the collection of paintings he bequeathed to the British State. Nowadays, the museum goes by the name of **_Tate Britain_**.

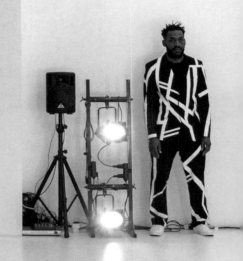

Michael Portnoy

Relational Stalinism —
The Musical

Michael Portnoy, *The Agglutinators (Rigoberto)*,
2016, part of *Relational Stalinism — The Musical*
at Witte de With Center for Contemporary Art.
Originally commissioned by Witte de With Center
for Contemporary Art, Rotterdam together with
A.P.E (Art Projects Era). Photo by Aad Hoogendoorn

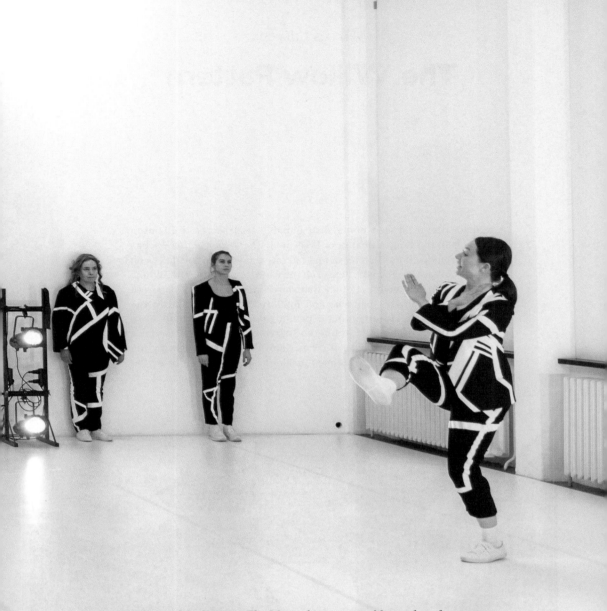

Relational Stalinism – The Musical is an assemblage of performances created by Michael Portnoy, enacted and developed with a diverse troupe of dancers, actors, singers and improvisers. Many different registers of performance simultaneously cohabit the theatre, mixing taiko micro-dance, exhausting feats of reading, experimental physical comedy, melodramatic operatic interlude, call-centre language-torture games, and satire of the *Immaterial Turn*. The piece premiered at Witte de With in 2016 and was spread over seven rooms of the institution over a six-week period. For Liverpool Biennial, a new iteration has been adapted to fit a theatre setting.

Michael Portnoy

Marcos Lutyens

The Willow Pattern

Named after a broken china dish found in the secret Williamson Tunnels in the Edge Hill area of Liverpool, *The Willow Pattern* seeks to infiltrate itself as a temporal and narrative layer into the daily ebb and flow of passers-by who approach the Chinatown Gate. The Willow Pattern is an eighteenth-century British re-interpretation of imported Chinese earthenware patterns and folklore. The dish found in the tunnel was pieced together, but depending on which fragments were placed next to each other, a different narrative emerged. Sometimes the lovers turned into birds; at other times they were caught by the Duke; on one occasion they stayed inside the pavilion and threw the jewels into the lake.

Episode 1

The double yellow lines that pass under the inductive portal or *pai-fang* in Chinatown are traces of the Yellow River. These 'no waiting at any time' markers give birth to the carp that transforms itself into a dragon as it crosses the gateway's threshold. The terrestrial becomes immaterial: the temporal immortal.

The portal, like the Biennial itself, is a reconditioning gateway of overlapping instances and locations dispersed around the city, which in this instance is layered over by a disembodied voice.

'Whenever you're ready' the voice inside my mind whispers.

Overlap 1: Cains Mystery Lake

The pavement opens up beneath my very feet and I am swimming on the crystal clear surface of an underground lake. A closed box or perhaps a coffin with an empty person inside slides by, sending ripples over the dark mirror's skin. Pebbles softly reach the bed of the underground lake, one by one, and yet the lake grows continually deeper, tunnels boring off in opposite directions. A wooden dinghy floats by, un-manned, un-womanned. It contains your memories: those of a photographer who lost a camera such a long time ago.

Overlap 2: Blundell's Cobbling Together

My body is twisted and turning. I can sense a hollowness reverberating within. I have three possible legs from unknown time periods. My hands are broken at the knuckles and several surrogate fingers have been fitted on cluelessly. One has a ring snaking around my brittle skin, another is weathered away almost completely, and a third is tiny and thin, perhaps a toe, as if the tips of my body are peripheral and infinitely interchangeable.

I follow the cracks on my face and down my torso. Each crevice becomes a possibility of opposing choices. At each junction I change sex, I change time, I change name, I change language, I change change.

I am a creature of mistakes: other's errors become my own. I wear them through the porosity of time, enabled now at last not to be reduced to the self that others once assumed me to be.

Overlap 3: Williamson Tunnelling

There are times when I follow hollow spaces all the way down. The broken china from lost banquets moves through my body just as I find myself sinking all the way back into the damp-sponge tunnel. Indecisions forking ahead and behind. Onion layers of suggestions linking to every different level of wakefulness. Enamelled numbers scattered throughout the passageways that dissolve the moments, backwards. My footsteps undo themselves with each thought that goes away. I will only find my way out if I stay still inside. Still.

Chinatown gate, Liverpool. Photo by Oleksandr Burlaka, 2016, with collage elements overlaid by Marcos Lutyens

Marcos Lutyens

En Liang Khong

All Under Heaven
Fearing and desiring China in twenty–first century Britain

A veritable octopus had fastened upon England – a yellow
octopus whose head was that of Dr. Fu-Manchu, whose tentacles
were dacoity, thuggee, modes of death, secret and swift.
Sax Rohmer, *The Insidious Dr. Fu-Manchu*, 1913

'London rolls out the reddest of carpets', ran the front page of the Chinese state-owned *Global Times* newspaper in October 2015,[1] as president Xi Jinping began his tour of the United Kingdom. If any-one had previously failed to recognise the radical realignment in Sino-British foreign policy, they couldn't miss it now: Xi's visit marked a sea change in UK-China relations. The Chinese novelist Ma Jian, who lives in self-imposed exile in London, also observed the pomp and pageantry laid on for the president. 'I saw this sea of redness, like I was seeing a reenactment of the Cultural Revolution', Ma told me, 'I felt a sense of spatial and temporal misplacement.'

Xi Jinping's arrival in the British capital came after the long, deep freeze between the two countries, which followed the UK prime minister David Cameron's meeting with the Dalai Lama in the summer of 2012. The first signs of a thaw only came in March 2015, when the UK applied to join the China-led Asian Infrastructure Investment Bank. A few months later, the British chancellor George Osborne led a trade delegation to China. His itinerary included a stopover in the contentious Muslim region of Xinjiang, where the Chinese state has come under intense criticism for its heavy-handed treatment of the Uighur ethnic minority group. Osborne's decision to bring his trade mission there had little to do with investment and everything to with ingratiating himself further with the powers that be in Beijing. Most importantly, this act signalled an institutional change. 'It is now clear that the British Treasury rather than the Foreign Office runs China policy', wrote King's College London professor and former diplomat Kerry Brown, all of which 'leads us to the depressing conclusion that it is not just British business and expertise that is for sale in China – so is British government policy'.[2]

Since 2015, a whole multitude of anxieties have coalesced around Chinese power and the UK, largely revolving around a 'fear and desire' complex. There has been a feverish rush towards seeking a new 'golden' age in UK-China relations, and at the same time, the emergence of a deep-rooted foreboding about this. One intelligence officer described the policy shift as 'a pure, mercantilist, unprincipled, self-serving decision'[3] – although you might argue that this could equally describe how Britain has approached China ever since the nineteenth century. Meanwhile, UK television channels have been airing shows like 'Britain's Billionaire Immigrants',[4] gawping at the Anglophile pretensions of a new wave of China's super-wealthy.

In fact, a fascination with the 'rise of China' has been drifting around British pop culture for at least a decade now. In twenty-first century Britain, sino-mania and sino-phobia contend in increasingly hysterical ways. In 2003, as producers increasingly looked to the east, UK grime (the music scene birthed in London) spawned a sub-genre: sino-grime. Sonically, musicians began playing around with all that was aurally Asian, from rough video-game muzak to *wuxia* film soundtracks, dipping grime's gritty sound-worlds into an imagined east Asian cityscape. It's important to remember that, for a musical genre defined by its obsession with the future, sino-grime was not just an orientalist fantasy (though it was certainly that, too). Music journalist Dan Hancox saw sino-grime as bound up in a sociopolitical vision reflecting the 'current, gradual shift in superpowers from west to east, incorporating China, and rejecting America: in terms of the US, it's notable that grime has always been *not* hip-hop'.[5]

The Awakening Dragon

A plan presented to Xi Jinping during his UK tour was for Liverpool's 'New Chinatown', one of the many projects underpinning the Conservative government's 'Northern Powerhouse' push. The £200 million development is now under way, led by North Point Global and backed by its Chinese investment partners. The project is situated on land off the city's Great George Street, promising a complex of domestic and leisure facilities aimed at rejuvenating Liverpool's Chinatown. It will function as both a retail home for Chinese businesses in the UK and a 'beautifully designed living space' that comes complete with a luxury spa.

Liverpool's deteriorating Chinatown is the oldest Chinatown in Europe, and one of the most historic parts of the city. Its 'regeneration', via New Chinatown, could be seen as an attempt to halt a process that we can also see in Manchester. In the early 2000s, Manchester had lost interest in investing in its own Chinatown – or in other words, experienced a neoliberal divergence from the 'multicultural turn' of 1980s regeneration efforts. Manchester's Chinatown was excluded from the city's recent redevelopment drive (even the Centre for Chinese Contemporary Art has situated itself in the tasteful Northern Quarter), its reputation stagnating as a bastion of traditional culture – an 'ethnic

enclave' – that was no longer in keeping with the city's cosmopolitan, futuristic aspirations.

Liverpool's answer to this, however, has required a radical redefinition. The promotional material for the Liverpool site raves about 'the burgeoning energy and dynamism of modern China transplanted into the heart of an historic World Heritage City'. Bursting in at the point of a paradigm shift in UK-China relations, Liverpool's New Chinatown represents 'a historic moment ... This is a unique investment opportunity.' The bombast continues, straining the idea of the 'design philosophy's' blend of modern and classical Chinese architecture, and even 'the ancient art form of *zhezhi*'. Inevitably, the masterplan is likened to the motif of 'the awakening dragon – a powerful symbol of China's resurgence and status as a new global power'.[6] The voice that emerges from New Chinatown's PR material is what the scholar William Callahan would call 'sino-speak',[7] projecting an essentialised China that is culturally determined to rule the world. This rhetoric constitutes a new orientalism that uses the language of an 'eternal civilisation' to explain China's 'return'. In its strong geographical and cultural privileging of the 'homeland', it papers over the ways in which the idea of China, and Chineseness, has always been a battleground in the UK, between the British state, Chinese migrants and, hovering in the distance, the pull of mainland China itself. For Liverpool's Chinese community, there is great historical trauma surrounding this process of negotiation: in 1945 the British government undertook a violent repatriation of its Chinese immigrant community, and overnight, even those Chinese men who had married and had children with British women were shipped out, never to return.

Is there a Chinese identity beyond the monolithic dictates of the British and Chinese states? Ma tells me that 'being Chinese, and living in Britain, is a paradox. Your thoughts never left China, but your body is walking in this country.' This is a great contradiction to carry, but one that cannot be shaken off. 'I am what I am: Chinese', Ma continues, 'but with the years I spend in the UK, I feel that I can only bring myself to love other individuals. To love China, or to love a nation – these are meaningless concepts.' For Ma, it is by exploring the periphery that Chineseness and the idea of what China means can be renewed and reshaped.

But the blockbuster New Chinatown development is typical of the new China-UK paradigm, where even the idea of what a 'Chinatown' traditionally could and should be is swiftly reaching breaking point. No longer a home for migrants to stake their (necessary) claim to space, the idea of a Chinatown backed by mainland Chinese capital now becomes something more invisible, amorphous, snaking through neighbourhoods and continents. This is Chinatown reimagined from the top down, the creation of developers as a financial opportunity, rather than a community that has emerged out of necessity. Is Chinatown in Liverpool, or is Liverpool now, in fact, in Chinatown? When you pick away at what lies beneath the surface of Liverpool's regeneration, whether it's the giant red 'megamax' cranes, each 132 metres high, shipped over from China for the Liverpool2 deep

water container terminal, or the heady promises of New Chinatown's promotional literature, a fascinating new picture of economics and place-making emerges.

I recently spent some time walking around the construction site, which has been surrounded by advertising boards that deploy images of dragons circling fantastical visions of luxury living. But from New Chinatown to the city's North Docks, I left Liverpool thinking that perhaps these sites said more about British aspiration than Chinese reality. I spoke to KCL professor Kerry Brown, who ran the Liverpool-Shanghai Partnership organisation back in the 2000s. There is a historic relationship, Brown admits, but he is keen to leave me with a sense of perspective. 'Liverpool has a population of 500,000. Shanghai has 14 million people, and relationships with over sixty other cities.'

At the end of the day, infrastructural investment, tourism and education (despite significant university partnerships and a proliferation of Confucius Institutes) are not why China remains interested in the UK. It is the importance of London as a crucial platform for the internationalisation of the *renminbi* that ultimately commands China's attention. It turns out that this is the one language both sides can speak with fluency.

The Rich List

I was recently invited to the studio of British-Chinese artist Gordon Cheung, in south London. Cheung, of Hong Kong origin but born in the UK in 1975, has felt increasingly compelled to explore Chinese history in his recent pieces, despite an earlier aversion to allowing diasporic identity politics to enter his work. In particular, he interrogates the rhetoric of the 'rise of China' and its 'economic miracle' in the age of globalisation. In his Mao triptych, he feeds the classic 1967 propaganda oil painting by Liu Chunhua of *Mao goes to Anyuan* into an open-source algorithm, splitting it into drifting pixels, and then reorganising the image according to a digital glitch.

Cheung tells me that at a recent exhibition he held in Shanghai, a Chinese journalist said to him, 'I don't see anything Chinese in your work, I only see Britishness.' At the same time, over in the UK, people never stop 'seeing China' in his work. Cheung seeks expression through 'focusing on the kind of space that's in-between – this information space, the landscape that is globalisation, whatever you want to call it. The existence of being in-between is part of my identity, both British and Chinese, but simultaneously not. It's a constantly flickering status.'

I sense that what he's getting at is the idea that China and Chinese identity are far from being caught in some kind of essentialised past – or if I can seek refuge in the words of Stuart Hall, it's not a matter of 'who we are' or 'where we came from', but rather, 'what we might become'.[8]

I thought about this sentiment as I entered the China Exchange in London's Chinatown, 'a home of ideas, discussion, and creative

expression that stimulate greater understanding of and curiosity about China's impact on the world.' The Exchange is the creation of the Hong Kong businessman and socialite Sir David Tang, and was formally opened in February 2015 by the Prince of Wales. Surveying the line-up of events plastered on the Exchange's walls, I managed to make out a style and food programme called 'the curators of taste', and then something called the 'Prudential series', whose speaker list was an endless run of British Conservative politicians, including Zac Goldsmith, Michael Heseltine and Rory Stewart; so far, more the shallow waters of Notting Hill than the bright lights of the Shanghai Bund.

The questions always remain: whose China, and whose Chineseness is at stake? And as ever, there are great swathes of shallowness across this new map. On the day I visited, the Exchange was hosting an exhibition of contemporary Chinese art, supported by the Huron Art Foundation. I had never heard of this foundation before, but it is apparently part of a research unit set up by a British accountant in the late 1990s, who called it the 'Huron China Rich List'. I picked up a programme and turned to the first page. 'Nobody', it sang out in bold letters, 'knows China's rich better'.

1 'China media praise "reddest of carpets" welcome for Xi Jinping visit', Neil Connor, *The Daily Telegraph*, 20 October 2015.

2 'Why did Britain's Chancellor Visit Xinjiang?', Kerry Brown, *The Diplomat*, 6 October 2015.

3 'Britain's red-carpet welcome for Xi baffles traditional allies', George Parker, *Financial Times*, 18 October 2015.

4 'Britain's Billionaire Immigrants', Channel 4, 3 May 2016.

5 'To my east-side crew, get paper: more sinogrime', Dan Hancox, 18 December 2009, http://dan-hancox.blogspot.co.uk/2009/12/to-my-east-side-crew-get-paper-more.html (accessed 15 May 2016).

6 'Our Vision', New Chinatown Liverpool, http://www.newchinatownliverpool.com/ (accessed 15 May 2016).

7 'Sino-speak: Chinese exceptionalism and the politics of history', William Callahan, *The Journal of Asian Studies*, February 2012.

8 Stuart Hall, 'Who needs 'identity'?', in *Questions of Cultural Identity*, Sage, London, 1996.

Lara Favaretto archive, Tel Aviv, IL, 2013

Ramin Haerizadeh, Rokni Haerizadeh
and Hesam Rahmanian

Ramin Haerizadeh, Rokni Haerizadeh, Hesam Rahmanian and Udaya,
Pond of Language XI: Manouchehr II, 2014—2016, stone powder, plaster, wood,
plastic sandals, 245 × 83 × 70 cm. Photo by Maziar Sadr

Alisa Baremboym

Water Street, Liverpool, 2015
Image courtesy of the artist

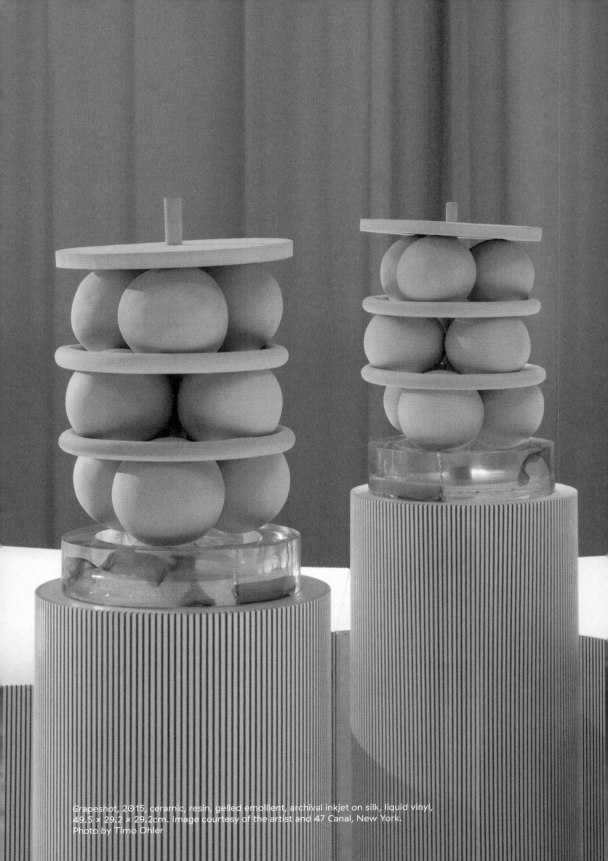

Grapeshot, 2015, ceramic, resin, gelled emollient, archival inkjet on silk, liquid vinyl,
49.5 × 29.2 × 29.2cm. Image courtesy of the artist and 47 Canal, New York.
Photo by Timo Ohler

Jocelyn Penny Small

Telling Tales in Classical Art

The King of Hearts in *Alice in Wonderland* knows how to tell stories: 'Begin at the beginning ... and go on till you come to the end; then stop.' Excellent advice, unless you're an artist with a limited amount of space to decorate. Then you have to be highly selective in choosing what episode and which figures to depict.

What is most notable about Greek story-telling in art is its timelessness, achieved in part by neglecting the where and the when. You will look in vain for indications of setting beyond that of a modern elementary school play where the least gifted child plays the tree to symbolise the forest. Occasionally, part of a building may be portrayed, but most often a single element sets the scene. For example, a laurel tree implies Apollo and grapevines indicate Dionysos. In contrast, the Romans believed that setting was an integral part of events. Lucretius (first century BC) said that the Trojan War would never have occurred without a 'place in which things happen', because 'events never at all/ Exist by themselves'.[1] In other words, classical art is not monolithic. Greek art and Roman art often depict the same story in different ways.

Part of the problem depends on knowing what time is. St Augustine (*Confessions* 11.14) in the late fourth century AD wondered, 'What therefore is time? If no one asks me, I know; if I were to explain it to a questioner, I do not know.' In his era, as in the classical period, time was not duration – how long something takes to happen – but motion through space. Hence a change of place was necessary to indicate the passage of time, similar to our giving the amount of time it takes to travel between two places rather than the actual physical distance. Therefore you have to understand the culture in order to interpret the depiction, because no representation exists in a vacuum.

Some scholars have accused classical artists of 'defying time'. What the scholars mean is that these artists have defied *their* idea that time proceeds in a linear fashion like beads on a necklace. For instance, classical artists sometimes used systems of organisation that defy our sense of story-telling, but were popular in both visual and verbal stories. Homer did not literally write the *Iliad* and the *Odyssey*, but composed the two epics in his head for oral performances. Only later were they preserved in writing. The poet often used a method, strange to us, to keep track of what he was saying and to help the audience follow the story. We don't know if they had a name for the device, but we call it 'ring composition' to indicate that the poet used imaginary concentric rings to organise his tales. He would begin by

Fig.1
Circe transforming
Odysseus' men, side A
of an Attic black–figure
Kylix by the Painter of
the Boston Polyphemos,
560—550 BC, 13.2 ×
21.7 cm. Photograph
© 2016, Museum
of Fine Arts, Boston.
Henry Lillie Pierce
Fund, 99.518

referring to various figures or events, but would not say what hap-pened to them immediately. Instead, after reciting all the elements, the poet would return to each in reverse order so that the set, so to speak, began and ended with the same figure.

Visual artists used a similar system. For example, a sixth-cen-tury BC Attic kylix shows a story from book 10 of the *Odyssey* in which Circe the sorceress stands in the centre of the scene mixing one of her potions to turn men into animals. (Fig.1) Facing her is a man with a boar's head and human torso. This central pair is flanked by three figures on each side. On the viewer's right are two men who have al-ready drunk the poisonous elixir, as a third, still wholly human, runs off to the right. On the left, two of the mixed creatures flank a normal man, Odysseus coming with a sword. The man with the lion's head, on the far left, likewise dashes from the scene. Rather than describing this scene from left to right, as art historians usually do, I have instead started from the centre and then described the figures according to which 'circle' they share. Visually I find it easier to think of the fig-ures as linked together not in concentric circles, but by nested boxes or letter 'U's. From the point of view of time, Circe as the most impor-tant figure takes the centre. Next in importance is the outmost circle or U two men, the left man transformed and the right still human, on either side flanking the scene. Ideally, the position a figure takes in space should depend on the time slot in which he performs his action. I call this arrangement 'hierarchical' time.

At this point we become confused by this representation, because the storyline does not precisely correspond to the visual arrangement of two groups of four figures facing each other. While the outermost figure on the left and right runs away from Circe, the one on the left is there only to balance visually with the figure in a similar pose on the far right. From the point of view of the narrative and time, however, the fleeing figure on the right, Eurylochus, should have shared the same U as Odysseus, because Eurylochus is the one who gets Odysseus to rescue the men. The two men's positions on op-posite ends of the scene disturb us because they are directly linked in

Jocelyn Penny Small

115

the story, but to us seem visual worlds apart. In between the two 'end' humans and Circe are one half-transformed man on the left and three on the right. This arrangement also coincides with how our memory works. We tend to remember ends and are often muddled about the intermediaries. In short, this painter did not come up with an elegant solution of resolving the contradictions between his artistic need for balance and the narrative's need for linking events appropriately. He selected three episodes from the one tale: a poisoning, those already transformed, and the messenger getting the rescuer. The use of nested Us was especially popular in pediments on buildings like temples because the triangular space limited the design. Such an ordering of figures continues into the Roman era, as on the much later Great Trajanic Relief reused in the Arch of Constantine in Rome.

Another method of compressing more than one episode into a single visual scene also appears in archaic Greek art, but rarely thereafter. In the blinding of Polyphemus on a Laconian (from Sparta) kylix from the mid-sixth century BC, the artist tells the entire story of the escape of Odysseus and his men from Polyphemus, the Cyclops, in one frame. (Fig.2) Scholars call this kind of representation 'synoptic' because it gives a capsule summary of the story. I think the painter treats the figures like words. In inflected languages like Greek, Latin and modern German, different endings on words reflect their number and role in a sentence. Polyphemus is inflected with two legs, a cup and a stake. The legs are all that remain of a Greek whom he has just enjoyed for dinner and explain why the Greeks have to escape. The cup held by a Greek shows that the Cyclops is not sipping some wine to wash down the last morsel of the Greek, but instead to make him drunk. The four Greeks driving the burning stake into his eye tells us both why he had to be drunk – he had to be incapacitated so that he couldn't fight back – and that he had to be blind so he couldn't find them to kill

Fig.2
Blinding of Polyphemus, interior of Laconian Kylix by the Rider Painter, c. 56ᴑ BC, 12.5 × 21.5 cm. Cabinet des Médailles. © Bibliothèque Nationale, Paris

Fig 3
The story of Daedalus and Icarus, 1–5⊙AD, fresco panel from the East Wall
of the House of the Priest of Amandus, Pompeii, Italy

Jocelyn Penny Small

them. The Greeks couldn't kill the Cyclops, because they needed him to move the enormous stone blocking their exit from the cave. Inflecting figures with elements as reminders of the episodes is related to the idea, mentioned above, that figures like Apollo and Dionysus can be identified by their elements or attributes.

The previous examples focused on ordering events in time and telling the whole story. Sometimes, especially in Roman art, 'space' or a setting is the organising principle. For example, a painting from the House of the Priest Amandus in Pompeii (first century AD) tells the story of the death of Icarus from flying too close to the sun. Daedalus, a master craftsman, was the first to construct wings that enabled humans to fly. He warned Icarus, his son, not to fly too close to the sun, but, like most children, something forbidden was a challenge. So the wax holding his wings together melted, and Icarus plummeted to his death. Helios, the sun, drives his chariot across the sky from left to right as Icarus begins his descent. (Fig.3) Below on the right is a walled city, to the left of which is a large gap in the painting that once showed Daedalus, of whom only the tips of his wings remain. Below are two ships, and on the shore on the left two women point to the flying humans. A second Icarus lies dead in the centre at the bottom. Today we wouldn't think of repeating the same character twice in one frame unless one of the images was a portrait and the other the character in action. Instead, Icarus would appear dying in one panel and dead in another. We might even add a third panel to show the shock of the bystanders at his death.

Finally, consider a scene of *lustratio*, a rite of purification, from the early second century AD on the Column of Trajan in Rome. (Fig.4) While each of its parts seen in isolation seems to obey our rules of linear perspective, together they contradict our expectations. Outside a wall on the bottom left, a group of Romans follow a bull, ram, and boar that are about to be sacrificed (technically a *suovetaurilia*). At the right, some men turn left to enter the walled precinct. Within the walls a group of men wear animal headdresses as another man plays the double flutes. Virtually in the centre of the scene, Trajan (the emperor), with his toga pulled over his head like a priest, makes an offering at an altar. All the figures, both within and without the walls, are the same size, even though those that are farther away from the viewer and within the wall should be smaller. Trajan, however, is treated differently. He is taller, slightly separated from the rest, and takes up more space. Representing the stature of figures according to the importance of their roles is known as 'hierarchical perspective'. Furthermore the artist has conflated two separate moments within the overall celebration of the sacrifice. Trajan performs the libation at the altar before the animals have arrived within the camp.

If an artist portrayed this scene in our familiar linear perspective, he would need four separate frames to capture both the information *and* the narrative sequence: (1) the procession of sacrificial animals with attendants, (2) the figures on the far side of the walls, (3) the figures within the walls, and (4) a semi-bird's eye view of the walled area or camp. In addition, a label might be necessary to identify Trajan, who for all we know might have been short.

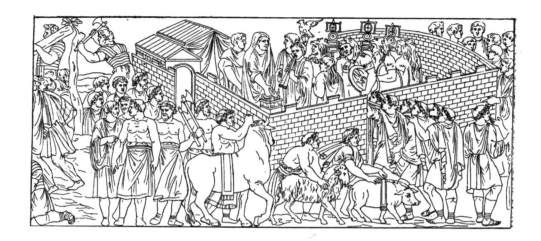

The King of Hearts, no doubt, would disapprove of the way the works considered here tell stories. Since we all too often assume that the way we work and think is universal, we are prone to misinterpret visual scenes based on other rules. We have to recognise that linear perspective, a Western invention of the Renaissance, is the anomaly, not the other systems discussed here. Moreover, linear perspective, as an organising principle, is probably the most constricting method of telling stories visually. Only one thing matters: how things (people, places, etc.) 'look' physically. The rise of photography and the way we use photographs today not only reinforces this approach, but requires that each frame contains a single moment in time at a particular place and with a particular set of participants. Hence it is now fashionable to 'read' art. Since anything verbal – whether oral or written – is by nature just 'one damn word after another', it confirms our belief that the way to tell a story visually is to follow the verbal pattern of a serial unfolding of one episode after another. Just because we need words to describe what is happening in a picture, to whom and where, it does not inevitably follow that a visual version must also be sequential. While visual and verbal versions share a number of elements, it does not make them clones of each other. Each tells stories differently. Both are necessary, because there never has been and never will be just one way to tell a tale.

1 Lucretius, *On the Nature of Things* 1.482, 478-479. Translation from
 Ronald Melville, *Lucretius. On the Nature of the Universe*, Oxford University
 Press, Oxford, 1997. The translation of St. Augustine that appears a little later
 in this text is mine.

Subject:	Re:
From:	Tai Shani (taishani ▮▮▮▮▮)
To:	▮▮▮▮▮@yahoo.com;
Date:	Sunday, 25 January 2009, 13:30

The night we went on an adventure through the tangible histories of that breathing, brimming place, these are the thoughts I had when I came to your door, when I came to you for the first time.

I could not remember the number of your room but you believed that I would recognize it because it was appropriately broken, walking down the cinematic corridor, my insides unstable, filled with the movement of thousands of moths exposed to sunlight, I found the stone, a slab of marble lying on a piece of cloth on the floor. Marble so monolithic and strong was there lying on it's back, dead and destroyed, detritus, pushed away from the wall, expelled and banished from the pantheon, now helpless and bereft, its place marked hollow and haunted with crumbling, powdery plaster.

Your door was left open. Anyone could have walked in to destroy you, a stranger or an enemy, it was me that did, and though I thought you so brave for leaving your door open, I found you inside lying on a little bed, a child's bed, your arm folded under your beautiful head, wounded, soft and warm. I wanted to kiss you already, a long encapsulated kiss with all of your mouth and all of mine and all of our pasts, a kiss so long, we would have to grow marine lungs.

I sat on the floor by your bed, and for a moment I hallucinated heroic visions to conquer you; I wanted you to see I possess unimaginable powers over nature, I wanted you to believe I was not of this world, I wanted you to know I was not scared of danger, I wanted you to love me, I wanted you to witness my humanity.

When I returned from that expanded instant, we were filling the immense space with our big mythical words speaking of our affection for the transient nature of hotel rooms, you said that you, a transient animal, felt there at home. Because of many things I felt there at home too, because of all those important things and more importantly because you were there, strange and familiar in your childhood bed and I was very, very close to you... and I am not an animal.

At the end of the night you came back to my white room, I washed you ceremoniously in that marble bathroom and we restored it to its former glory. We fucked in the dark and I was bleeding heavily, I didn't care, outside they were running in the corridors screaming. In the morning when we woke up the white room looked like a crime scene, it was all trauma, it was all heavy melancholy.

You broke me from the moment I met you and from that moment, apart from the miasmic moments we share in each other's tunneled company I can only find a form of happiness or rest in those rare instances where I feel like I hold the warm gun in my incapable hand, this is terrible.

In that beast-like hotel, I was so happily and excitedly overpowered and domesticated by this wild, wilderness love. But now I feel tired and restless, extended and unhappy and I don't want to feel that way anymore. I want to be present again and susceptible to happiness, desire and all which is bearable.

You make things, and you make me other, and I miss you so terribly already, deeply, like cats that cannot consume a scent fully and have to open their mouths to taste the smell, to understand it, consume it all, that is how I miss you.

It is impossible that I should ever regard you with indifference. You are always new and my soul aches with sorrow. You are bottomlessly beautiful to me. I can not see you anymore.

With all my love. T

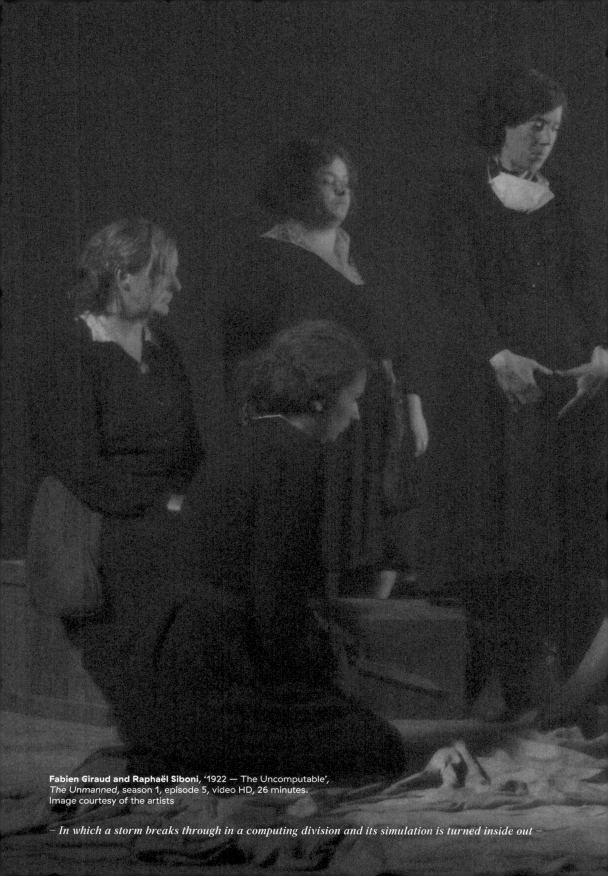

Fabien Giraud and Raphaël Siboni, '1922 — The Uncomputable',
The Unmanned, season 1, episode 5, video HD, 26 minutes.
Image courtesy of the artists

– In which a storm breaks through in a computing division and its simulation is turned inside out –

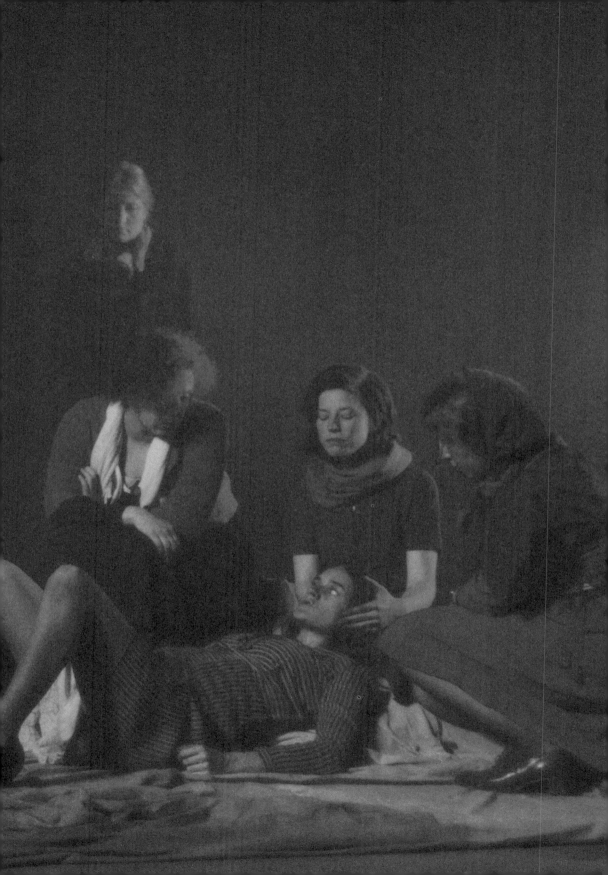

Lu Pingyuan

The Two-Sided Lake

There was a freshwater lake in a village in China. One day, a foreigner emerged from the bottom of the lake wearing diving equipment and covered with weeds. The townspeople who lived there rushed to the source of the surprise, and the foreigner, so tired he was out of breath, explained to them that his home was on the other side of the world, next to a similar lake. He had dived through his own lake to emerge out of this one. He told them that back home, on the wall of his house, there was a circular imprint, like a hollow ring. One time, he had seen his son take a blue pen and connect the two sides of this circle by making a line through the middle. He had suddenly wondered: through the lake outside the front door, on the other side of the world, could there be a lake of just the same size and shape? The connecting line his son had drawn haunted his thoughts until at last one day he could no longer restrain himself; he had to confirm his crazy hypothesis. So he dove into the lake, and arrived here ...

In ancient times, in China, there is record of the following occurrence: in the middle of the night an old man was carrying a lamp, walking along a lake and reciting mantras with his prayer beads. Suddenly the string broke and the beads spilled all over the ground. When the man bent down to pick up the beads, he saw all of the stars that filled the sky reflected in the lake. He had a sudden epiphany: this lake was the hole through which the thread strings the beads together. On the other side of the earth there had to be a lake that was just the same.

Adam Linder

Some Strands of Support

Some Strands of Support, 2016, Choreographic
Service, duration variable, photo by Shahryar Nashat

e) Puts forward that the need for HAIR CARE
underlines that the designated sculpture or statue
may not be as resilient or assured as inanimate
objects are often presumed to be.

Some Strands of Support, 2016, Choreographic
Service, duration variable, photo by Andrea Rossetti

f) Acknowledges that HAIR CARE is a claim
for an empathic form of service provision.

Episode 1

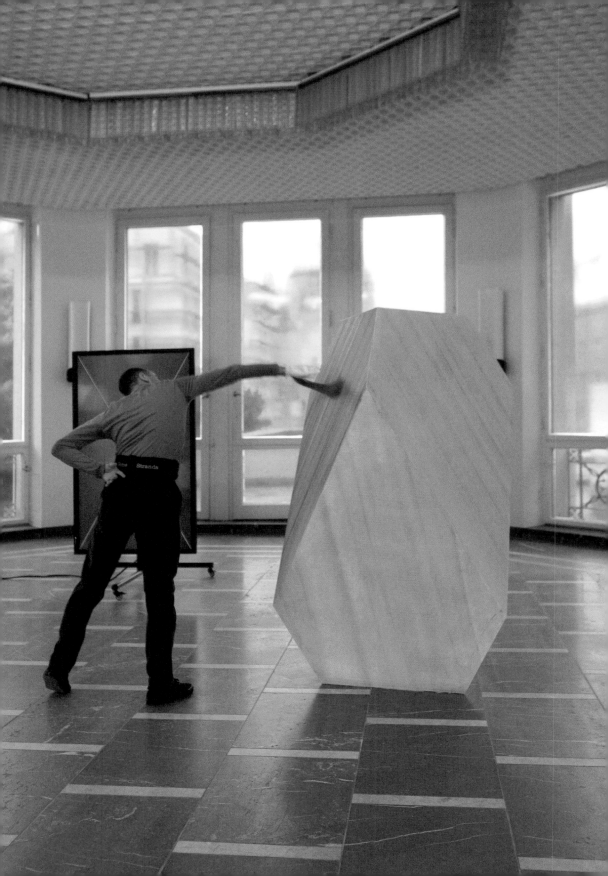

Ranjit Hoskote

Eight Poems from the Cycle
'Memoirs of the Jonahwhale'
(2016)

1: SEVEN ISLANDS

sand-wrought storm-humped
 these islands
 never complain
 they take what comes
craft
 one name for seven
from dropped iron lost rivers and
 spits of reclaimed land starved
 ocean
 wind-ripped light-riveted
 gravel-spun overrun
 roads that take you step by step
 to where the water is
 sweet and deep
 the only way up
 until help arrives
 is south

2: OCEAN

my name is Ocean
 I shall not be contained
 my tides spell
 starting gun and finish line
afterwards only shells
 and scattered roofs
will remind you I was
 there
my combers wash away the roots of trees, towns, the shaken heart
 but mortals there's hope
 my breakers hurl seeds back at your shores
 after the flood the chroniclers will write
 in Konkani, Sabir, Aymara, Tulu, Jarawa, Krio, Tok Pisin:
 after the flood the beach exploded with giant peacock trees
 in whose branches on windy days you could hear
 the surge
 and swell
of Ocean summoning whales, whalers who chased blood-wakes,
 red-haired women who fought pirates, sleepless harpooners
 who sailed from fjordlands to where
 volcanoes splintered the sleeping ice,
 furies who choked pearl divers, drove catamarans aground,
 voyagers who fell into the sea and grew wings
 Ocean reciting from his depths
every drifting epic of pursuit, every song of shipwreck,
 every trace of raft and sail and trailing anchor
flotsam jetsam buckram vellum
 he could remember

3: AHAB

Captain of castaways, the pilot calls out and his curse carries
 across docks, derricks, opium factories:
 a typhoon in the horse latitudes.
He's hurled his ship after the whale
that swallowed him and spat him out.
 The monster is the only system he's known.
At the bridge, he's drenched in the dark:
locked on target, silent, furrowed,
Saturned to stone.

*

Across steep tides, through walls of water, his life has always been pursuit.
 As the ship splinters on the reef,
 the rigging becomes his noose.
Brine blistering his throat, he thinks:
 If only I'd harpooned this monster on a page.

4: SPELLING THE TIDE

We drew near the island, the surf a cannonade on its stony beaches,
no landing.
We dropped anchor.
Some fishermen came down
 to the water's edge and called out. We called back.
The surf roared in our ears, no one
 heard no one.
The skirling wind shredded our voices and danced on them.
We pointed
 at the canoes
they'd hauled out of tide's reach.
Come get us.
They didn't get us
 or didn't want to.
We made signs.
The skirling wind shredded our signs and danced on them.
 They melted away in the rain.
Water in your sails, shirts, socks is wet lead.
Prayer in that storm
 was just a mouth gone wrong
if you looked at it. We tried our hands instead.
We made all
 the signs we knew.
The skirling wind shredded our sails and danced on them.

Lara Favaretto archive

5: THE CHURCHGATE GAZETTE

I.
Last word on the subject, I promise.
I walked into the train station and it was terrifying.
Like nerve gas had laid the architecture out flat,
the tall glass columns bloodshot and the booking clerks
slumped over, all dead at the till.

A plaster Gandhi with sulphur-rimmed eyes
stopped me (what a substitute for kohl and *why*?).
You missed the last train, it said, he said,
you missed the last and only train that was safe
for a man who's left half his life behind.

II.
A straggler from a late-night movie had more advice.
You could so easily gag on a wine-red, tasselled silk scarf
stuffed in your mouth, he said, you could so easily gag
on sour saliva or a shard of bay leaf
or a letter swallowed just after the bell has rung
and before the door opens.

III.
I thought of the possibilities as I left the station without a compass.
Walk straight enough, said Gandhi, and you could walk into the sea.
At the wharf, the sailors' wives were keening together:
they were singing the last songs of the whales.
I was their brother and I had killed them
with my broken harpoon and my rusted smile.

IV.
Find affection, I told myself. That's fundamental.
Find a voice that doesn't draw blood
each time you hear it. I walked past myself,
I rippled across lean men and sleek women
laughing behind plate glass, their hands caught
in pools of light, wine gleaming in brittle flutes.

V.
Birdsong disturbs the king of incomplete lives.
He wakes up in the middle of the novel he's writing
in the Midnight Hotel. His eyes need shielding
from the raw clarity of neon. He is back
where he began, with a plate of waxy grapes
and a blunt silver knife on his bedside table.

VI.
Break, ice, for me.
Let me fall through stinging water
in my skin of rust and flame.

I've jumped from a tree
that's branched into the clouds.
It's sucked up all the reality

I've watered it with.
Its fruits are red and wrinkled.
I plunge into drowned gardens

where I walked once.
Sinking, the water stroking
my crown of leaves

as it comes apart,
dark tribune, archaic clown,
I open my eyes.

6: AND SOMETIMES RIVERS

And sometimes rivers
that run in your veins
change course.
 Silt marks the spot
from where you set sail
to circumnavigate the globe
 and where someone wearing your sunburned face
stopped thrashing about in mangroves that wouldn't let go
and stood still, bleached hair ruffled by the wind,
 as if, after a voyage charted across fevers and hurricanes,
riding at anchor.

7: RISK

The earth here is glass, the wind the sting of a thousand wasps.
Whoever is driven north wishes he could burn in the fires of hell.
On this sea without horizons we do not sail by the magnet.
Of wisdom, the deep says, "It is not in me."

I.

At the mouth of the dog river
 foam words foam words
 currents of sand arrowing after fog birds
slack shadows engraved on the veil of the tide
 that shimmers in and sags out
for the twentieth the thirtieth the emptieth time
the river going with the sea the sea going homewards
As It Emptieth It Selfe

You shall build your citadels on silt said the preacher
 and sink your pride in spice currents
 take your parakeets and painted cormorants
with you but leave the coconut palms and the Inca silver
 leave behind a bloodful of curses
with strands of indigo wet bales of cotton
on this parched delta these dragged fields of salt
sweet strained with brack
For the Emptieth Time

II.

Splayed in his planter's chair, the saboteur of silences toys
with a breech-loading Bible, cocked in defiance of treaties.
Nib sharpened by monsoon hungers, the chronic ache
of working in a country without plums or Bordeaux,
he writes home:

In this damnable climate, steel rusts, razors lose their edge.
Thread decays, clothes fall to pieces. Books moulder away,
drop out of their bindings. Plaster cracks, timber rots,
the matting hangs in shreds. Fungus inscribes itself
on vellum bindings as the tattoo of rain on the roof
drowns out the arias in my mind.

Ranjit Hoskote

The clouded mirror's been my only proper companion
since my Ovid and Seneca fell apart.
I've been reading palmleaf manuscripts with sour pandits
and picking up opium and Tamil from sallow lascars
in this pidgin district, waiting for the mail boat
to bring me the necessities:
sherry, walnuts, Trichinopoly cigars.

I have hidden in the houses of the bibis who breed
our scabby byblows, who run around the gullies *['lanes'? 'gallis'? – Ed.]*
with their tow hair and improbable grey eyes:
their fortunes will be the fortunes of Homer's sailors.
Before they indenture themselves
to war or shipwreck or sirens or mutiny,
we'll tame the little devils, give them Greek
or Irish names, teach them a respectable tongue.

Then we'll lop them off the family tree
and send them out on battered frigates
to fight and die for King and Country.

III.
Try mangrove instead of watercress.
Try chameleons instead of retrievers.
The earth webs your feet here, and look out
for rivers that bite.

Stone in the veins.

This country smelted from copper
and scented with mustard
has secret names that only
its lovers can nose out.

IV.
The river stabs the sea.
Water, salt and fresh, bursts up
through the splintered ribs of the scuttled boat
that's trailed a wake of belly-up fish.
Thalassa. The compass bird points to the coast:
to a rivermouth disgorging crumbled islands,
to the tidewash that numbs the wounds
by which conquerors have named it.
Trapped by the trader's sovereign eye,
by the surveyors of revenue lands,
the purveyors of clove and camphor,
the coast signals its own tongue:

breaking with the horizon's grammar,
a stutterance.

Lara Favaretto archive

Villa Design

In Search of Better Things

Villa Design Group's new serialised radio play for Liverpool Biennial is conceived as episodes to be released each week during the exhibition's run. Through the filter of the nineteenth-century novel, in particular Anthony Trollope's *The Way We Live Now* and the novels of Charles Dickens in which the city of Liverpool plays a key role in the arrival and departure of protagonists, the radio play reflects on historic, present and future images of the city.

Episode 1

Work–in–progress poster for *In Search of Better Things*, 2016, 650mm × 250mm, courtesy of the artists and Mathew Gallery

Litany for a Computer and a Child about to be Born

Episode 2

We begin Episode Two at the lowest levels of Liverpool John Moores University, where we find the archives and personal library of Stafford Beer, who late in life was a professor at LJMU. There are the boxes of his letters; his paintings (rendered in a Symbolist yet rustic style); many volumes on organisational theory and cybernetics (of course, that was his field), and on literature, philosophy and religious beliefs. Among the books we find some vinyl LPs of Chilean folk music.

'Chile 1970–73' is the episode around which the life of Beer turns. Having worked through the 1950s and 1960s to translate the principles of cybernetics into the practices of business management, he finds himself invited by the revolutionary government of Salvador Allende to create the work of a lifetime: Cybersyn. This would be ... what? An intranet (40 years ahead of its time) for public industries to enable workers up and down the country to collaborate in real time. A challenge in anachronism: to create (as he put it) the software of the future with the hardware of the past.

Software is the collapse of distances, and the execution of a collaborative agency. Software is the execution of a society.

At what age do we become participants in a society? Childhood development is a matter of learning, a formation of the self, but above all it is a becoming-social. It is a matter of becoming co-operative. We become participants in a society when we are able to co-operate with others and when others (especially those who are older) are able to co-operate with us – in life, in work, in art. What is it for older and younger artists to be able to co-operate? It is again to seek to collapse a distance, a *temporal* distance; it is a form of time-travel towards others and within oneself. It is a journey to the origins of society.

Chile 1970–73 was the childhood of a society: the effort to walk and talk and make, collectively. The encounters between different languages, different worlds. Cybersyn was a scientific and a practical challenge, and it was also a challenge of communication, pedagogy, even of art.

Let Beer tell the story:

> If we wanted to redesign the governmental process, then there ought to be a manual in which some key principles were set down – in such a way that all could understand them ... Perhaps something useful could be said by five principles ... This was to be the cybernetic substance of 'the manual'; but now it need-

ed translating into simple statements that could be distributed to the people through booklets, leaflets, posters and (I hoped) songs ... I determined to tackle the question of songs ... music was a major amplifier in the cultural system.

The central figure among the musicians with whom I mixed and became friends was the famous folklorist Angel Parra. He was at first quite amazed that I expected him to sing about the scientific inheritance of the people: this is hardly a familiar idiom of the folklore genre. However, he has been following our progress with great interest, and he eventually agreed. In this 'translation' of the manual, the cybernetic finesse of the five subsystems commentary was assimilated into a political appeal for reform – which somehow made all five points through the recounting of then-current events and preoccupations. And the two basic messages of the manual came through strongly in the chorus:

Then let us STOP
Who do not want
the people to win this fight –

And let us HEAP
All science together
before we reach the end of our tether

or, better, in the original:

Hay que parar al que no quiera
que el pueblo gana esta pelea

hay que juntar toda la ciencia
antes que acabe la pacienca

Angel Parra called the song: *Litany for a Computer and a Child about to be Born*.'[1]

With these words in our minds, let us explore Episode Two, in which the childhood of cybernetics encounters the cybernetics of childhood.

Lara Favaretto archive, Mexico City, MX, 2014

1 Stafford Beer, *The Brain of the Firm*, 2nd edition, John Wiley & Sons, Chichester, 1981

If I was about to choose my parents today it would be you and China
(the country) – or you and all the cartoon characters that have never been
popular. And then the next day I would like to be adopted by all the future
dogs, just as an exercise of belonging to different orders of things.
We could hang out together in the dog crèche, near the old brewery.

Andreas Angelidakis

Pottery was the strongest export
in Ancient Greece

was the Newsfeed of its day

Vessel

were they encrypted

Can we read buildings
like we read pottery?

otherwise known as
Diogenes the Cynic

he moved to Athens

Vessel, 2016, digital video, 7 minutes.
Images courtesy of the artist and The Breeder

I wonder what Diogenes would think

He would probably never leave his pot

Zian Chen

Portrait of Liverpool Biennial as a Little Girl

[Soon after the jubilant opening.] Liverpool Biennial lies in the arms of an early summer morning. It was supposed to be a changing and uncertain show – just like a shy little girl. Let's call this shy little girl Pauline. Pauline is always engaged in silent dialogues with Isabella, an imaginary friend who does not exist for anyone else. Sometimes they go on adventures together, encountering things they don't yet understand. One day, when they visited the Biennial exhibi- tion, which is about time-travel, they overheard some artists talking about what they liked or didn't like there. Pauline turned to discuss their comments with her secret friend – and between them, they wondered if they really meant what they said. Sometimes Pauline and Isabella would wander around the exhibition looking at the most talked-about artworks, or venture onto the streets of Liverpool: the city that inspired the show. Once, as they were following an artist on her way to the Adelphi Hotel, they passed a Cantonese restaurant called San San. It had been out of business for quite a while. A strange neon sign hung above the door: though switched off, its outline left a deep impression on Pauline. Its irregular, repetitive rhythm reminded her of the hills with people walking in front of rainbows that she used to draw with felt-tip pens back at school. On a dust-covered window, a notice on a piece of paper read: Sorry! We are closing our doors by end of May 2014. Thank you for your visits over the past 34 years. – Staff of San San Restaurant

The
notice
h a d
been up
for ages,
and when she
walked up to it to look
at it more closely, the date
mentioned in the announce-
ment sounded like a song's continuous
end note – a leftover sound. Pauline
thought that such an unchanging,
single note sounded just like some-
one whispering from under
a blanket, smothering the
vibrant hustle and bustle that
must once have filled the restau-
rant. Pauline didn't really understand
how long thirty-four years was, so she asked
Isabella, but even for such an imaginary (or, better
said, ideal) being, this period of time was too long to
ponder. However, Isabella and Pauline had known each oth-
er for a long time, and Isabella was perfectly comfortable in
her role as knowledgeable companion. Methodically, Pauline's
imaginary friend read about all the artists that had contributed
to Liverpool Biennial, and about every artwork in the show. She
read about different sorts of time, and how all these times were
used to create the whole exhibition. Isabella came up with an
answer good enough to convince her little friend: 'Compared to
San San's closing forever, thirty-four years is actually not that
long.'Some of the texts said that San San had been forgotten by
time. What does it mean to be 'forgotten by time'? Pauline and
her friend wondered. 'Maybe it means to be forgotten *for a long
time*?'Pauline thought of a felt-tip pen she had once left at her
grandma's house. She was time, and the pen was San San. She
tried looking at the world from the perspective of that aban-
doned pen, to imagine the feeling of being forgotten by time.
'Perhaps the pen is no longer being used by anyone, and it
has been lying in the corner all along', she thought. Pauline
and Isabella were thinking together, and to understand San
San's problem better, they began to read the exhibition's
guidebook. They decided to start from the clues they could
understand. They opened the first page. It started with a sen-
tence, followed by some discussions entitled 'What is time?' Some
words jumped out at them – 'forgetting', 'nostalgic', 'time lapse',
'flashback'.
These de-
scriptions
were not
very helpful.
But the discus-
sion's main point
was that every change takes time. And since time
gives birth to everything, then all

things
are vulnerable to
time. When we speak of trav-
elling through time, we are really
talking about changing the relationship
between time and things. Instead of things
being changed by time we need to get time to
be changed by things. Travelling through time
... OK, but to when? Pauline had never witnessed
a San San full of visitors, which might well be
a reason to travel to that time when its rooms
were filled with boiling steam and the scent of delicious dim
sum. Pauline had not the slightest bit of nostalgia or sentimentality, the
sort of grownup emotion that can easily trigger flashbacks, nor could Isabella
imagine where the edges of time travel could be. 'Would the start be at the start of
the world?' Pauline asked. Pauline wondered whether, when something is no longer
needed by time, it has already experienced time travel. 'When San San closed, it left
time outside the window: and that's how San San turned into a place forgotten by time.
It pushed time away.' 'But if, like San San, there's nothing you plan to do anymore, time
becomes like an object.' Isabella continued: 'Of course, it may as well have been San San
itself that forgot time. Because it forgot time, the board that announces its closure still
hangs there on the window, just like when you're sick and you fall asleep in bed, and
your mum calls your teacher to tell her you're not going to school. This sort of
notice is like an absence request form, sent to time.' 'Oh!' thought Pauline,
'so this is what grownups mean by time travel. It's probably about
forgetting, about abandoning time. We have to give up the
idea that if something is used by people then it can
be measured in time.' They left San San, and con-
tinued their journey towards the Adelphi. At
the corner, Pauline had the feeling she had
just gathered another secret with Isabella.
She suddenly remembered something
said by those artists and their friends
in the exhibition (remember: Pauline
is just the embodiment of an ex-
hibition, after all): 'Children
are in fact a science-fiction
genre.' To this day, she still
doesn't quite understand
this sentence, but she is
convinced with her
whole heart that
as long as there
is Isabella, she
will eventu-
ally solve
the puz-
zle

Ana Jotta

Excerpt from
Brasília: Five Days,
Clarice Lispector, 1962

The two architects didn't think of building beauty, that would be easy: they erected inexplicable astonishment. Creation is not a comprehension, it is a new mystery. – When I died, one day I opened my eyes and there was Brasília. I was alone in the world. There was a parked taxi. Without a driver. Oh how frightening. – Lúcio Costa and Oscar Niemeyer, two solitary men. – I regard Brasília as I regard Rome: Brasília began with a final simplification of ruins. The ivy has yet to grow. Besides the wind there is something else that blows. One can only recognise it by the supernatural rippling of the lake. – Wherever people stand, children might fall, and off the face of the world. Brasília stands at the edge. – If I lived here I would let my hair grow to the ground. – Brasília has a splendored past that now no longer exists. This type of civilisation disappeared millennia ago. In the 4th century BC it was inhabited by extremely tall blond men and women who were neither Americans nor Swedes and who sparkled in the sun. They were all blind. That is why in Brasília there is nothing to stumble into. The Brasilianaires dressed in white gold. The race went extinct because few children were born. The more beautiful the Brasilianaires were, the blinder and purer and more sparkling, and the fewer children. The Brasilianaires lived for nearly three hundred years. There was nothing in the name of which to die. Millennia later it was discovered by a name of outcasts who would not have been welcomed anywhere else: they had nothing to love. There they lit fires, pitched tents, gradually digging away at the sands that buried the city. These were men and women, smaller and dark, with darting and uneasy eyes, and who, being fugitives and desperate, had something in the name of which to live and die. They dwelled in ruined houses, multiplied, establishing a deeply contemplative race of humans.

Lara Favaretto archive, São Paulo, BR, 2014

There is a restaurant in Liverpool that bears
my name. Turtle soup cannot be ordered
there anymore, because the restaurant
went out of business in October 2014, but
you can keep reading its recollections from
the future through my voice, because that
restaurant – San San – became a forest, and
a narrator of the Biennial. Not so long after
that, I went out of business too.

Today we've arrived to
Liverpool as huge red cranes,
all the way from China.

Mark Leckey

Dream English Kid

Transmission of Blinderator drawing by Joey the Mechanical Boy

Vauxhall Viva Rear–Window Heater

Project Echo Satelloon, 1964

Ebay assemblage. Kelloggs, B&H. Photo by Mark Blower

Mark Leckey

051-236 8301
9 Mathew Street
Liverpool 2

				members	guests
Thur 2 Aug	TOURS			75p	£1
Fri 3 Aug	SIMPLE MINDS + The Portraits			£1-10	£1-60
Sat 4 Aug	THE POP GROUP + The Delta Five	Evg Only		£1-35	£1-75
Thur 9 Aug	JUNK ART + guests			free	50p
Fri 10 Aug	ORCHESTRAL MANOEUVRES IN THE DARK + A Certain Ratio			£1-10	£1-60
Sat 11 Aug	JOY DIVISION + Swell Maps	Mat 5 pm		£1-10	£1-35
		Evg 8.30		£1-10	£1-60
Thur 16 Aug	ROCK AGAINST RACISM BENEFIT			75p	50p
Fri 17 Aug	THE SELECTOR			£1-25	£1-75
Sat 18 Aug	EDDIE & THE HOT RODS + guests	Evg Only		£1-35	£1-75
Mon 20 Aug	THE DAMNED + The Victims			£1-50	£2-00
Wed 22 Aug	THE BEAT + God's Toys			£1-25	£1-75
Thur 23 Aug	Open Eye Christmas Party with THOSE NAUGHTY LUMPS / THE MODERATES / ROY WHITE & STEVE TORCH			75p adv £1 door	
Fri 24 Aug	Lesley Palmer presents a Christmas Reggae Party with THE MIGHTY VHYBES + I SOCIETY + THE PEOPLE'S SOUND SYSTEM			£1	£1-50
Sat 25 Aug	ERIC'S CHRISTMAS PARTY with THE TEARDROP EXPLODES + ECHO & THE BUNNYMEN				
		Mat 5 pm		£1 10	£1-35
		Evg 8.30		£1-50	£2-00
Thur 30 Aug	Skeleton Records present THE ZORKIE TWINS / JUNK ART / ATTEMPTED MUSTACHE / THE POSERS / TIM BYERS			75p	£1
Fri 31 Aug	A TRIBUTE TO WINSTON featuring members of ORCHESTRAL MANOEUVRES IN THE DARK and DALEK I			£1-10	£1-60

Hours of Opening: 8.30-2am (Matinee Saturdays 5-7.30pm) We are open between mid-day
and 2 pm daily except Sunday for badges, posters, T-shirts and membership enquiries.
SHOW TIMES: On all shows except Saturday the support will be on stage at 9.30 and the main
band at approx 10.45. On Saturdays the main band will be onstage at 10 pm and the support
group will play at approx 11.30 pm. The door admission price will be reduced when the main
band have finished their set.
MEMBERSHIP OF ERIC'S is £1-10 yearly. A member is entitled to sign in two guests, and to
benefit from reduced admission prices. Membership application forms are available from the Club.
Call us on our 24-hour answering service 051-236 8301 for further information.

Handbill from Eric's, August 1979

Stage at Eric's. Photo by Dave Eaton

'New Labour' Bridge
circa late 1990s

'Xerox' Bridge
circa late 1970s

Andrew Pickering

Sketches of Another Future: Cybernetics in Britain, 1940—2000

My topic is the history of cybernetics, the strange science that grew up in the 1940s and 50s, reached an apogee in the 1960s – not co-incidentally, the time of the counterculture – then disappeared into obscurity and which, more recently, has been making quite a come-back in the humanities and social sciences. I want to outline why cybernetics interests me now, and also to gesture towards its political potential, which is much argued about.

Donna Haraway famously declared that she would rather be a cyborg than a goddess,[1] while the Tiqqun group inform us that 'Cybernetics is the police-like thinking of the Empire, entirely ani-mated by an offensive concept of politics ... Cybernetics is war against all that lives and all that is lasting.'[2] I'm on Donna's side, which is why I refer to the examples that follow as sketches of another future. I think of them as models for a systematically different way to act in the world from our usual ways of behaving.

What was, or is, cybernetics? There is no clear-cut answer to this question, so I will focus on strands of its history that somehow speak to me. These, as it happens, largely emerged in Britain – in England to be even more precise. British cybernetics was a different kind of science, a different 'paradigm' in Thomas Kuhn's sense, from the modern sciences. The best way to explain the contrast is in terms of ontology, of understandings of what the world is like, what it is made of, and how its components relate to one another. Physics, for example, elaborates a very familiar ontology; it gives totally unsur-prising answers to these questions: the world has a definite structure; this structure is knowable, and thus physics' job is to spell out that

structure in words and symbols – stories about quarks, strings, black holes and dark matter. Cybernetics was not like that. It had a different ontology, a different view of what the world is like. In 1959, Stafford Beer defined cybernetics as the science of 'exceedingly complex systems',[3] meaning entities that are either so complex that we can never hope to understand them fully, or, more importantly, entities that continually mutate, so that today's knowledge of them is always becoming obsolete. If modern science is a science of the knowable, then cybernetics was a science of the unknowable.

A science of the unknowable sounds like a contradiction in terms, but what Beer had in mind was that cybernetics should be about getting along with systems we can never fully understand. Getting along – adaptation to the unknown – was the enduring focus of British cybernetics. And what interests me most about this history is not the idea of adaptation, but the range of surprising projects, practices and objects in which it came down to earth, in all sorts of fields ranging from brain science and psychiatry – which is where cybernetics began – through robotics and engineering, mathematics, biological computing, management and organisations, the arts, entertainment and music, architecture and education, all the way out to non-standard spiritualities. These projects are my sketches of another future, possible models for future practice that differ systematically from the modern paradigm. I don't mean to say that we should emulate the specifics of any of them; I mean that once you have the hang of them you can start to imagine new ways of thinking and acting in all sorts of contexts. My examples are drawn from the work of Stafford Beer, Gordon Pask, Gregory Bateson and RD Laing, but we should start with Ross Ashby, one of the founders of British cybernetics.

In 1948, Ashby built a machine called the homeostat, intended as a scientific model of the adaptive brain, an electro-mechanical device that turned electrical inputs into outputs. When several homeostats were connected together, feedback loops were set up, and the combination of homeostats might turn out to be stable – meaning that the currents within them tended to zero – or unstable, with the currents tending to grow. If the set-up was unstable, a stepping switch within each homeostat would move to the next position, randomly changing the parameters of the circuit, and this process would continue until a condition of stable equilibrium was found. The homeostat was thus what Ashby called an 'ultrastable' machine – a machine that, whatever the initial conditions, would come into a situation of balance with its surroundings.[4]

Norbert Wiener described the homeostat as one of the great philosophical discoveries of the age. I suggest we see a multi-homeostat set-up as a piece of ontological theatre, as somehow staging the ontology of unknowability mentioned above. None of the homeostats in a multi-unit set-up ever knew anything about its environment (meaning the other units to which it was connected). Instead, each unit explored its environment, via its output current, and adapted to whatever it found there by randomly reconfiguring itself until equilibrium was reached.

The homeostat had two modes of operation. One was the one described above, in which the machine was free to adapt to its environment; the other was one in which its inner circuitry was fixed. Ashby experimented with two different sorts of multi-unit configurations: symmetric ones, in which all of the units sought to adapt to one another, and asymmetric ones, in which the circuits of one unit were fixed and the others had to try to adapt to that. I mention this because these different set-ups could be taken as models for different structures of human action in the world, and here cybernetics starts to take on a political edge.

Until 1960, Ashby's career was in psychiatric research, and he understood his field on the asymmetric model. The business of psychiatry was to make the patient adapt to the doctor, and not vice versa. The doctor had to stand firm like a rock and force the patient through a set of homeostat-like reconfigurations until he or she ended up in a state resembling normality. This asymmetric model hung together with the 'great and desperate cures' of the day – electroshock and chemical shock treatments and lobotomy – and it was what lay behind Ashby's horrifying vision of what he called Blitz therapy, which imagined treating mental patients with 'LSD, then hypnosis while under it, & ECT while under the hypnosis'.[5] Evidently, then, this asymmetric version of Ashby's cybernetics could function as technocratic social ideology, here reinforcing and intensifying the existing hierarchical power relations of doctors and patients in the mental hospital. It was also Ashby's vision of war. This is the place where the political critique of cybernetics could really go to town – 'the police-like thinking of the Empire ... war against all that lives'.[6]

But Ashby was capable of thinking more symmetrically too. His vision of social planning, for example, entailed a symmetric and reciprocally adaptive back and forth between planners and plannees. This symmetric picture is what one finds played out in later cybernetic projects, and these are my sketches of another future. The simple image of homeostats experimentally adapting to one another runs through everything that follows here, from management and organisations, art and architecture, back to psychiatry, madness and transcendence.

Stafford Beer was the founder of the field he called 'management cybernetics'.[7] His aim was to make organisations adaptative to the unknown. Initially this led him and Gordon Pask into the field of biological computing.[8] The idea was somehow to couple the adaptability of naturally occurring biological systems – which might be a colony of mice or insects, or a swamp or a pond ecosystem – to a factory in place of human management: take out the managers and plug in a pond, was the idea, amazingly enough. Just like a collection of homeostats, a pond, a factory and the business environment could jointly search for states of collective equilibrium and even respond creatively to changes in any of the elements – which is just what one wants from human managers. This was a highly imaginative project, completely alien to anything one would normally imagine in the fields of management, engineering or computing. It is a striking example of

the fact that ontology makes a difference in how we go on in the world. No-one could dream up such a project without already grasping the cybernetic ontology and understanding the world as built from exceedingly complex systems.

The project foundered, alas, in the early 1960s, not on some point of principle but on the practical difficulty of getting biological systems to care about us. In one experiment, for example, Beer induced pond insects, *Daphnia*, to ingest iron filings, so that applied magnetic fields representing some key industrial variables would constitute a feature of the environment to which they adapted. The *Daphnia*, however, just excreted the iron, creating a muddy brown medium impervious to the fields. This kind of coupling simply didn't work. The crowning achievement of the biological computing project was to grow a body of electrochemical threads that developed a new sense – an ability to respond to sounds: an ear! – that had not been designed into it, an amazing accomplishment from the perspective of conventional computing. But in 1962 Beer more or less gave up, lamenting the lack of support for this research, which he had been doing in his spare time (while running the Operations Research and Cybernetics Group of a major steel company in his working hours); the pond water that loomed so large in his work had actually been collected on Sunday afternoon walks with his children. This sort of institutional marginality runs right through the history of cybernetics, and is worth bearing in mind. Social marginality was a correlate of its non-modern ontology.

From the 1960s onwards Beer went in a new direction, developing what he called the viable system model of adaptive organisation, the VSM.[9] Instead of incorporating real biological material into the organisation, Beer's idea was now to model information flows within the organisation on the most adaptive biological system he could think of: the human brain and nervous system. The organisation itself was to become a giant adaptive cyborg, partly human and partly nonhuman.

The VSM diagram indicates information pathways between five levels of the organisation modelled on their biological equivalents, running between production units at level 1 and the board of directors at level 5, as well through various intermediary levels and the firm's environment. Much of Beer's attention focused on level 3, which housed a set of operations research models of the organisation, and level 4, home to a big computer model of the firm's world, the wider economy.

The VSM was the basis for all of Beer's consultancy work and has a considerable number of exponents in the management community today, but the most ambitious application of it was 40 years ago, to the entire Chilean economy under the socialist regime of Salvador Allende in the early 1970s. Project Cybersyn, as it was called, went a long way in a couple of years before it was cut off by the Pinochet coup.[10]

Cybersyn was politically controversial. In a 1974 book called *Designing Freedom*, Beer argued that the VSM allowed the greatest possible autonomy to individuals within an organisation. In contrast, his critics claimed that in Chile he was implementing a technocratic

monster of command and control. In a way, both sides were right. One can easily see how the basic structure of information flows in the VSM could be harnessed to an authoritarian top-down structure of surveillance and control. Against this – and what the critics ignored – Beer specified that the links between the various levels of the VSM should have the same form as Ashby's symmetric multi-homeostat set-ups – thus the reciprocating arrows linking systems 3 and 4 in the VSM diagram. Far from being an apparatus for command and control, the relation between levels was supposed to be one of 'reciprocal vetoing', of proposal and counterproposal, until some sort of equilibrium emerged with which all of the parties could live. Beer often pointed out how hard people found it to get the hang of cybernetic projects, and the critique of Cybersyn illustrates this. Beer's vision of the VSM was, in fact, the antithesis of command-and-control management, and this is the model I would like to remember as a sketch of another future.

If a real-world example might help to see what's at stake here, we could think about British universities. Precisely what they lack is any cybernetic reciprocal 3–4 linkage between so-called 'management' and faculty. The modern British university *is* the technocratic nightmare of surveillance and control that the critics of the VSM could only imagine 40 years ago and that Beer was trying to get away from.

In parallel with the VSM, Beer also developed an approach that sought to give organisational form to homeostat-like interactions in decision-making. 'Syntegration',[11] as he called it, is a complex process of many iterations, usually extended over several days, but crudely the idea is to assign participants to the edges of a notional icosahedron, and to organise a process of sequential discussions between the parties whose edges end at a common vertex, alternating in steps between the vertices at the end of each edge. In this way arguments can progressively echo all around the icosahedron, eventually taking an emergent form controlled by no-one in particular. Beer regarded this as a form of perfect democracy, and it is hard to argue against that. His management cybernetics brought Ashby's ontological theatre down to earth in an explicitly political fashion, which was very different from the usual hierarchical arrangements. Instead of top-down command-and-control, Beer's cybernetic structures implemented symmetric and constructive negotiations and adaptations between individuals, organisations and their environments. Ontology, again, makes a difference.

We can move from Beer and organisations to the arts and Gordon Pask, who built many strange devices that all staged adaptive processes on the model of the homeostat – between people and machines, between people and people, and even between machines and machines. The first was his so-called Musicolour machine from the early 1950s. Musicolour turned a musical performance into a light show, and its key feature was that it was an exceedingly complex system on Beer's definition: its internal parameters varied during a performance so that it was impossible to master it cognitively. Instead of a linear correlation between sound input and light output, the

machine would adapt to the performance as it took place and eventually it would 'get bored' as Pask put it.[12] It would cease to respond to repetitive inputs, thus encouraging the human performer to adapt to the machine and try something new. Then the machine would get bored again, and so on, back and forth between the human and the machine – a beautiful example of ontological theatre and the dance of human and nonhuman agency.

Pask also built artworks in which robots adapted to one another, communicating with distinctive sounds and coloured lights, and he helped develop an interactive theatre in which the audience and the actors could collaborate in structuring how the action should evolve in real time in any particular performance.

I will end where cybernetics began: with psychiatry. The dominant trend since World War II has been to see mental illness as material and organic and up until the mid-1950s to treat it with lobotomies and electroshock, and increasingly since then with psycho-active drugs. Throughout this history, mental illness has been regarded as a simple defect to be erased if at all possible, and Ashby certainly took it for granted that the business of psychiatry was to normalise the abnormal. But cybernetics also offered a quite different take on madness, which depended on a symmetric rather than one-sided notion of adaptation.

In 1957, Gregory Bateson, one of the founders of Cybernetics in the US, suggested an association between schizophrenia and the interactional blockages that he called 'double binds', and which he understood on the model of two homeostats collectively getting stuck in an incapacitating oscillation.[13] Taking inspiration from one of his collaborators, Alan Watts, a great populariser of Buddhism in the west, Bateson further likened the double bind to the paradoxical instructions given by a Zen master to his disciple: 'One of the things [the master] does is to hold a stick over the pupil's head and say fiercely, "If you say this stick is real, I will strike you with it. If you say this stick is not real, I will strike you with it. If you don't say anything, I will strike you with it".'[14] This is a classic double bind for the pupil, a performative version of a koan, in which there is no satisfactory normal response. The point of this comparison was to suggest that schizophrenia might be understood not as mere pathology but as a confused form of Buddhist enlightenment. Centrally at issue here was a notion of the *self* that went far beyond conventional conceptions of the controlled modern self and Marcuse's one-dimensional man into the realms of madness and ecstasy, of heaven and hell as Aldous Huxley put it. Bateson, we could say, understood the self as one of Beer's exceedingly complex systems, forever capable of surprising us and becoming something new. He also suggested seeing psychosis as a manifestation of an adaptive mechanism through which the self might disentangle its double binds and emerge somehow better adapted to the world, in a process that he referred to evocatively as an 'inner voyage'.[15]

Bateson's ideas were put into practice in the 1960s by a group of psychiatrists led by RD Laing at a large house called Kingsley Hall

in London. Kingsley Hall was a commune in which psychiatrists and patients, as well as artists and dancers, lived together. In contrast to the conventional mental hospital, Kingsley Hall was a non-hierarchic institution. The psychiatrists did not prescribe drugs or electroshock or try to normalise sufferers in any way. The aim was simply to provide a place where the inner voyages of sufferers could find sympathetic support and possibly come to a successful conclusion. Importantly, there was no recipe for what that support should look like – the model was again a homeostat-like performative adaptation of the sane and the mad, a sort of open-ended and performative latching on. And on the model of symmetrically adapting homeostats, the idea was that the selves of the psychiatrists might also be transformed in this process. Intended as a space of emergence for new human possibilities, new kinds of self, Kingsley Hall, as Laing once put it, was a place where the mad could teach the sane to go mad.[16]

In conclusion, if I wanted to recommend these examples ontologically and politically as pointers towards another future, I might appeal to Martin Heidegger's contrast between enframing and poiesis as different ways of being in the world.[17] Enframing is the technocratic stance of domination, normalisation and optimisation that turns the world and other people and even university professors into standing reserve. It's how we usually go on – the police-like thinking of the Empire. Poiesis, I believe, is the cybernetic stance, characterised not by dreams of perfect ordering but by a performative and experimental openness to what the world has to offer us. Given the choice, I know which one I'd vote for. My fantasy is that more poiesis and less enframing might be an antidote to the increasing grimness of the twenty-first century – and my argument is that cybernetics can offer us a set of examples of what that would look like.

1 Donna Haraway (1985), 'A Manifesto for Cyborgs: Science, Technology, and Socialist Feminism in the 1980s', in *The Haraway Reader*, Routledge, New York, 2004, p.39.

2 Tiqqun, *The Cybernetic Hypothesis* (Anarchist library), cybernet.jottit.com.

3 Stafford Beer, *Cybernetics and Management*, English Universities Press, London, 1959.

4 William Ross Ashby, *Design for a Brain*, Chapman & Hall, London, 1952.

5 William Ross Ashby, personal journal, 3 November 1958.

6 Ashby, 1952.

7 Beer, 1959.

8 Andrew Pickering *The Cybernetic Brain: Sketches of Another Future*, University of Chicago Press, Chicago, 2010, pp.232–43; Peter Cariani, 'To Evolve an Ear: Epistemological Implications of Gordon Pask's Electrochemical Devices', *Systems Research*, 10, 1993, pp.19–33.

9 Stafford Beer, *Brain of the Firm*, Penguin, London, 1972.

10 Stafford Beer, *Brain of the Firm*, Wiley, New York, 2nd ed, 1981; Pickering, 2010, pp.256–61; Eden Medina, *Cybernetic Revolutionaries: Technology and Politics in Allende's Chile*, MIT Press, Cambridge, MA, 2014.

11 Stafford Beer, *Beyond Dispute: The Invention of Team Syntegrity*, Wiley, New York, 1994.

12 Gordon Pask, 'A Comment, a Case History and a Plan', in J. Reichardt (ed.), *Cybernetics, Art, and Ideas*, New York Graphics Society, Greenwich, CT, 1971, pp.76–99.

13 Gregory Bateson, John D. Jackson, Jay Haley and John Weakland, 'Towards a Theory of Schizophrenia', *Behavioral Science*, 1, 1956, pp.251–64. Reprinted in Bateson, *Steps to an Ecology of Mind*, Ballantine, New York, 1972, pp.201–27.

14 Ibid, 1972, p.208.

15 Gregory Bateson (ed.), *Perceval's Narrative: A Patient's Account of His Psychosis, 1830–1832*, Stanford University Press, Stanford, CA, 1961.

16 Pickering, 2010, ch 5.

17 Martin Heidegger, 'The Question Concerning Technology', in *The Question Concerning Technology and Other Essays*, trans. W. Lovitt, Harper & Row, New York, 1977, pp. 3–35.

Lara Favaretto archive

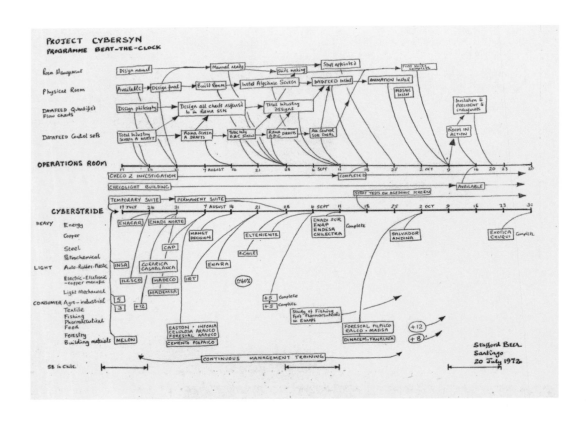

Top: **Stafford Beer**, Diagram from *Cybersyn: The New Version*,
typed written report dated containing diagram (pictured) dated 2⊙ July 1972,
courtesy of the Stafford Beer Collection, Liverpool John Moores University.

Right: VSM (viable system model) 'Chart One', in *Diagnosing the System
for Organizations*, Stafford Beer, p.139, New York: Wiley, 1985.

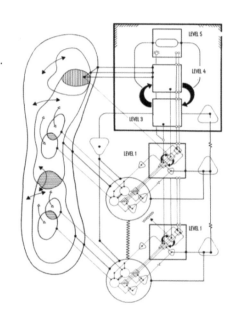

LEVEL 5

LEVEL 4

LEVEL 3

LEVEL 1

LEVEL 1

Lara Favaretto archive

173

COPY

Santiago, 28th April 1972

Dear Professor Beer,

My Government has been notified of the results achieved by the
information and control projects for industries dependent on the Development
Corporation, and has considered it opportune to take measures for the swifter
development of the work that has been, and is being, accomplished with such
success in our country with your valuable help.

In order to consolidate the carrying out of this work, and to advance
the search for optimal results in productive efficiency, I have considered it
of prime importance to count on your pressence in Chile in a more permanent way
and in a more executive role, so that you may contribute your scientific knowledge
to the process of change that the economy of our country is experiencing. We need
your support both in specific projects and also in your contribution to the training
of our professionals in your scientific discipline.

I thank you deeply in the name of the People of Chile for the co-operation
you have shown in our struggle to overcome underdevelopment, and I hope that I can
count on your invaluable support in the future tasks that we shall start together.

Sincerely yours,

Salvador Allende Gossens
President
Republic of Chile

English translation of a letter from President Allende of Chile to Stafford Beer,
inviting him to continue working with the Chilean Government, April 1972.
Courtesy of the Stafford Beer Collection, Liverpool John Moores University

174 **Episode 2**

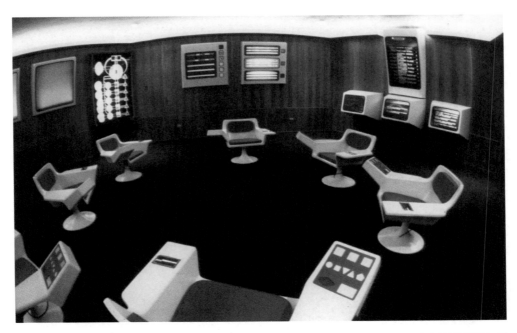

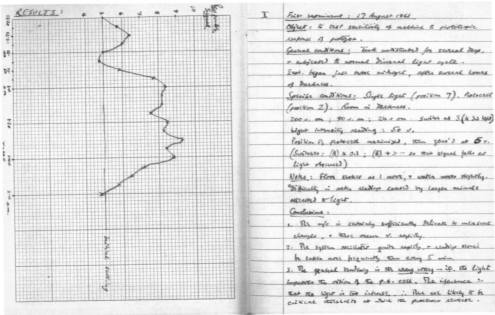

Top: The Operations Room, Project Cybersyn, Chile, 1971–1973.
Courtesy of the Stafford Beer Collection, Liverpool John Moores University.

Bottom: **Stafford Beer**, Cybernetics of the Ecosystem – Experimental Log. Record of experiments
conducted by Beer in the early 1960s to create a biological computer with tadpoles and daphna.
Courtesy of the Stafford Beer Collection, Liverpool John Moores University

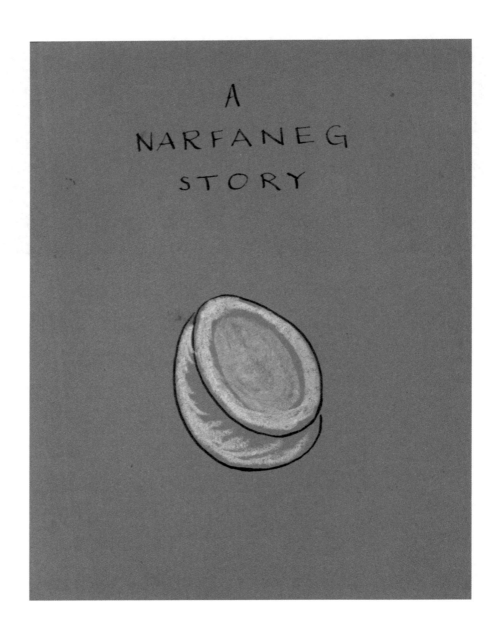

Stafford Beer, *A Narfaneg Story*, a children's book that Beer created for his daughter, Polly, early 1970s. Courtesy of the Stafford Beer Collection, Liverpool John Moores University.

For Polly Persephone

In a far away place
Where the sky meets the sea
Live some very strange folk
Not much like you and me.

They are yellow and white
Sort of glunkish and round
When you poke them they wobble
About on the ground.

They are born in the morning
At breakfast you see
(Or else a bit later
At afternoon tea).

They sit in the sun
Being perfectly tame;
And Polly Persephone
Gave them their name.

It started one Sunday
When breakfast was late
And she left a Narfaneg
Alone on her plate.

Since then she has done it
Again and again
In summers of sunshine
And winters of rain.

Well, after they're born
In the spring or the snow
The question arises
Where Narfanegs go.

I think you will find them
(Though no-one knows why)
So long as they're good –
Where the sea meets the sky.

Where the sky meets the sea
There is nothing to do;
So they all sing their song
That they'll now sing for you:

'We are the Narfanegs
The halves they didn't eat;
We are the Narfanegs
Our lives are incomplete.

Being the left-overs
Is really rather sad.
We can't have fun like whole eggs,
There's no fun to be had.'

Their song was so sad
Because they didn't know
That there are worse places
Than Narfanegs go.

And one of their number
More wise than the rest
Had a different song
(And I think it's the best).

One evening at dusk
Where the sky meets the sea
That very old Narfaneg
Sang it to me:

'I am a Narfaneg
The half she didn't eat;
But Polly Persephone
Is really rather sweet –

'Cos if she had eaten me
To make herself grow tall
The sky would meet the sea alone
I'd not be here AT ALL.'

Lars Bang Larsen

All Systems Flow
Fiction and play
on the cybernetic plane
of history

1. Cybernetics: what did not follow

In 1956, when the twentieth century was recovering after World War II and not long after the fledgling science had been baptised, Ross Ashby defined cybernetics with indifference to existing certainties. He wrote: 'Cybernetics takes as its subject-matter the domain of all possible machines, and is only secondarily interested if informed that some of them have not yet been made, either by Man or Nature.'[1]

Ashby took the pre-modern notion of nature as a giant clockwork device and allowed the boundless notion of 'all possible machines' to usurp the function that God once had as the prime mover that made it tick. By anchoring possibility in a future that does not result from human agency alone, he rearranged scientific reliance on what can be positively known. Such a time-space continuum, in which machines are abstract and fictional as much as they are real and reproductive, is inimical to the status quo, or is based in what Andrew Pickering elsewhere in this publication calls an 'ontology of unknowability'. In a radical way, cybernetics gives notice that another future is not only possible, but that tomorrow must be different. As articulated by Ashby, the cyberneticist's mid-twentieth-century dream of technology is rife with premonitions of the current dismantling the modern mind's binary constitution. Cybernetics went a long way to undoing the conceptual watersheds between nature and culture, brain and computer, human and machine, science and play, animal nervous system and electronic circuit. It also seems that cybernetics does not necessarily make information lose its body; information is potentially given multiple new bodies in machines – whether they are natural or human-made, or somewhere in-between.

Today, cybernetics is a defunct branch of research. It is no longer to be found in the US government's lexicon of research topics that can receive federal funding, and the American Society for cybernetics has only a few dozen members. This might seem strange given the genealogical relation between cybernetics and the development of personal computing and the internet. The more that reality is mediated by the internet, on the other hand, the clearer it becomes that there are aspects of cybernetics that have no direct bearing on today's near-inescapable digitality. Hence it is a partial truth that cybernetics is pre-internet; from another perspective than the corporate sublime of digital networks, the heirs to cybernetics' speculative ethos are more playful and irritable phenomena in art and computational cultures that are typically at odds with existing cartographies of power.

A digital control society is based in an ontology of the knowable, in prediction and accumulation. If you instead – in keeping with its fundamental unknowability – look at what cybernetics never became, the picture is very different. The efforts of cyberneticists were not solely focused on proof, mechanics and solutions (for the military industry, for corporate organisation etc); they revolved around encounters between disciplines and on the production of text and the invention of concepts, too. Cybernetics, then, is not just a discontinued thing of the past that was sublated into a determined and highly operational technological reality. It also makes for a history that can extend into a different tomorrow. Yet in its own haunted way, this history is not as easily legible today as the more common historical narrative that considers it a forerunner of the internet, AI, Big Data and finance capital.

Unlike the overwhelmingly post-human slant of certain strands of contemporary media theory, cybernetics described the encounter between human being and machine, and by extension between the humanities and human history on the one hand, and machinic and systemic realities on the other. These encounters, their tensions and effects, and the ensuing strange metabolisms and idioms that arise across sutured realms of being, then and now characterise much cybernetic writing with a particular sense of hybridity – monstrosity, even. Ashby again: 'The most fundamental concept in cybernetics is that of difference.'[2]

2. The last months of the Allende regime

You can say that cybernetics deals with multiple outsides: *the human brain*, understood as an opaque performative and replicable organ, not a thinker analysing abstract signs; *coming encounters between information and space*, namely the spatial dimension implied by the notion of feedback loops; and *futurity*, all the machines that have not yet been made. It is this inherent ethos that makes it grist for the mill of science-fiction writers, not just its techie aspect. Jorge Baradit's *Synco* (2008, not translated into English) is a book that appropriates cybernetic history to confront historical processes of governance and subjectivation with what cyberneticist Ralph Gerard called the (in)discipline's exploration of 'all sorts of ifs'.

Lars Bang Larsen

Baradit's novel is named after the Synco project – in English 'Cybersyn' – initiated by Chilean President Salvador Allende when he came to power in 1971, and with which he intended to automatise Chile's economy. He invited the English cyberneticist Stafford Beer, together with a transnational team of engineers, to develop a computer able to coordinate the state-run enterprises through a network for economic management. Synco was conceived as a nationwide, real-time system capable of aligning production sites and collecting data to be transmitted to the government in ways that would assist human decision-making. Conceived neither to outpace the human capacity for analysis and calculation, nor to become an immeasurable network, Synco was devised as a tool to keep abreast of unpredictable events in the realm of the national economy (to paraphrase Pickering). As a symbol of a Socialist techno-utopia, Synco was decommissioned by Pinochet on the eve of its launch in 1973.

Today, we may think of our politicians as Pavlovian behaviourists who throw the electorate key words and scenarios to gauge from their salivation levels the way tomorrow's political winds will blow. If this caricature has any bearing on what still goes by the name of everyday reality in contemporary Western democracies, Baradit's *Synco* goes much further in its dystopian reverie on an alternative history for Chile. Signifiers melt down and merge deliriously: a decade or so after an attempted military coup has been thwarted, the Venezuelan journalist Martina visits Santiago to write about Chile's unique brand of *Ciberbolivarismo* that is propelled by the enthusiasm of the people and aided by the miraculous computer Synco. Martina meets Salvador Allende and Augusto Pinochet, both proud to serve side by side, and the model state façade falls to reveal a nightmare regime run by Synco – now a mastodontic automaton installed underneath the presidential palace on La Moneda. As a final turn of the screw, it turns out that Synco itself might not be the prime mover, but in its turn is controlled by occult entities mapped out by an infernal mix of Nazi lore and Rapa Nui cosmologies.

Had Allende lived to turn Synco on, history might have taken a different turn – not only for Chile. It could have helped reverse the neocolonial alchemy that has made Latin America specialise in losing out as the world's supply zone since the arrival of European Renaissance man.[3] Given that Synco was conceived to be as sophisticated as any computational installation in the Northern hemisphere, and signifies an accelerated process of development in a country that considered itself to be part of the third world, it would have contributed to turning this historic atlas of domination upside down, making Chile a vanguard state of global technology. Synco is an important instance in the late twentieth century of how countries outside of the geographic, economic and political centres of the world planned and built computers, thereby challenging the simple models of technological diffusion that frame science and technology as flowing from North to South.[4]

Considering how Leftist politics since then have collapsed in the wake of a globalised, digitalised economy, the historical irony

of a digitalised Socialism is palpable. And yet it stands to reason that systems thinking was a match for a Socialist planned economy. As Eden Medina explains, the history of Synco is the history of a modernity that made two utopian visions intersect, one political and one technological. You can add that the project's impact on contemporary possibilities for a socialist utopia has yet to be analysed. When Baradit started planning his novel in 2006 – around the same time as historians began to recover the project – Allende's machine was one among many of the Pinochet regime's *desaparecidos*.[5] The Socialist utopia as it was imagined and theorised in the nineteenth and twentieth centuries should also possibly be considered in this way: as an entity that has disappeared from history for good. Perhaps between the two lost visions, the political and the technological, a new critical mass can be built.

As Maria Berrios has pointed out, Allende's victory was of great international significance after the post-68 disenchantment with the revolution that did not come.[6] At home, however, nobody wanted Allende to succeed. His vision for a Chilean socialism – different from the Cuban version, and unaligned with the Soviet model – lacked support from an infighting Left. Faced with mounting pressure from a US-backed Right that sought to undermine him at home, and having nowhere else to turn, Allende finally dispatched his minister of foreign affairs to Moscow. Anecdote has it that Leonid Brezhnev received Allende's envoy with open arms, treated him to a big lunch, took him sightseeing in the Russian capital and let the motorcade return to the airport, from where the Chilean comrade was sent straight back to Santiago. The Russian non-involvement sealed the fate of Allende's regime, and Synco remained a dream machine at the end of the world.

Baradit's *Synco* was published two years after the death of the former dictator. Utterly disrespectful to any genre conventions, and one of the first Chilean novels to deal with the aftermath of the dictatorship, the book was illegible on the ordinary political–aesthetic spectrum. When *Synco* was published, it was called everything from communist to *filonazi* (Naziphile). It would be more fair to say that Baradit homeopathically addresses pervasive social and political trauma that has dramatically affected the subjective, social and political fabric of Chile; this is why he drives a stake through the heart of any historical logic and unites what cannot be united – human and machine, fascist and socialist, past and future, Occidental modernity and a pre-Hispanic past – under the sign of the god-like machine.

When I talked to Baradit in Santiago de Chile earlier this year, he insisted on how the distortions of science fiction and cyberpunk meet a Chilean *mestizo* culture in which uneven temporalities, conflicting myths and a variety of subjectivities and ethnic origins coexist on the same plane of history with no view to sublating their simultaneity. It is all in the mix, and in the mix it stays.[7] *Synco* degrades technology by dramatising the machine that Beer built as a shape-shifting freak occurrence – sometimes a deliberately anachronistic steampunk fantasy, sometimes a premonition of a cyber-totalitarian present. History is dreamt by technology, and the destiny of Latin America

is manifested in a mad *mestizaje*: 'Maybe Synco is a writer who has freaked out, or a frightened child with monstrous powers.' Baradit goes on:

> Some are beginning to doubt the very existence of South America. It is a delirium of the Spanish, perhaps. Maybe America is a man in a boat in the middle of the ocean where land should rise. This man sleeps or writes the fabricated history of an entire people and their grief. He receives correspondence directed to Colombia or Bolivia. He hallucinates, cries, and drafts constitutions.[8]

3. Reality is not yet real

By inscribing technology and historical space onto one another in the register of fiction, *Synco* articulates not only an aesthetic truth about cybernetics but also about its epistemology as a play of knowledges. Ashby's definition of cybernetics as 'the domain of all possible machines, and ... only secondarily interested if informed that some of them have not yet been made, either by Man or Nature' echoes Hans-Georg Gadamer's insight that those playing are not the subjects of the game. It is not the case that the player commands the game, Gadamer writes; on the contrary, the player is commanded by the game. Being absorbed by a game or play changes the individual subject and what it knows. 'The player knows very well what play is, and that what he is doing is "only a game"; but he does not know what exactly he "knows" in knowing that.'[9] Both cybernetics and play are ontologies of the unknowable, of unreality.

The entity called cybernetics, of the domain of all possible machines, is not 'a frightened child with monstrous powers', but an unworried and playful child. To paraphrase Ashby, a child absorbed in play is only 'secondarily interested if informed' that some of the things she invents 'have not yet been made'. Any true player is interested in what the game does and how it will play out, not in its degree of respect towards what already exists, or its availability and commitment to the realm of social reproduction. As something imponderable that is removed from what exists, operating in hypothetical time and space, play is an inherent part of a cybernetic ethos.

This would also mean that cybernetics has not unambiguously been part of Western civilisation's road to barbarism. The aspects of thinking that to T.W. Adorno make thought resemble play represents 'the unbarbaric side of philosophy': a blitheness that makes it capable of escaping what it judges, of taking liberties.[10] To Adorno, play's element of exaggeration makes the thinker 'overshoot the subject', thereby creating a 'self-detachment from the weight of the factual, so that instead of merely reproducing being it can, at once rigorous and free, determine it'. Play cannot authorise anything; we can think here of Baradit's politically unacceptable novel. Nor can play be possessed – but it can indirectly determine what exists and

what will come into existence. We can say that in this way it has re-
mained untainted by the dialectics of Enlightenment, to use another
of Adorno's terms.

You could say that Norbert Wiener's writing entered the terrain
of play if not before, then in his last, strange text *God & Golem, Inc.
A Comment on Certain Points where cybernetics Impinges on Religion*
(1964). Here, the founding father of cybernetics engages in a radical
play with meaning in a world cohabitated by humans and machines;
a world that he unhesitatingly compares to Lewis Caroll's fiction. It
is such radical 'toying', as Wiener put it, with ideas concerning the
reproducibility of life and other questions that are key to his ethical
discussion of the use and misuse of modern automatisation.[11]

An ontology of the unknowable is a strange ontology because
it embraces being-in-the-future. In the encounter with what is outside
of the present moment, becoming may dissolve history as we know it,
and ourselves as knowing subjects too. This relativisation of control as
a key cybernetic term turns the subject of non-knowledge into a child.
In aesthetic terms, any definition of play involves the child or another
unknowing subject. Baradit's irreverent, yes infantile plunging of
Allende's supercomputer into totalitarian-machinic regression shows
how those possible machines, and the use of them, can join violent and
repressive tendencies at any and all times. In its ambiguous autonomy
'(innocence' is the old-fashioned, misleading term) play is amoral and
polymorphous, containing micro-fascisms as well as primeval forms of
socialism. Play exacerbates as much as it provides relief.

Thanks to the rise of digital communication to the point of
near-ubiquity our view of history has changed profoundly in the last
decades. History, we think, is no longer the result of struggles be-
tween antagonistic or mutually irresolvable positions, but something
that plays out between already networked flows. The idea of complex-
ity, to which cybernetics crucially contributed, cannot exist without a
sense of the multipolar tensions and struggles that persist after it has
dissolved the binary opposites with which the Western mind has tried
to master reality. A networked historical space perhaps even makes
new outsides proliferate, including those subjects and communities
who have always been barred from participation in power networks.
Perhaps cybernetics – anachronistically and fundamentally commit-
ted to difference – is equipped to open up to these outsides, these
other spaces, other times.

To try to articulate the unknowable, other side of today is to
fight to make something else happen outside of what can be identified,
processed and fed back through existing machines that work to close
the loops against the future.

1 Ross Ashby, *An Introduction to Cybernetics*, Chapman and Hall, London, 1957, p.2.

2 Ibid., p.9.

3 Eduardo Galleano, *Las venas abiertas de América Latina*, Siglo XXI de España Editores, 2015 (1971), p.15.

4 I rely here on Eden Medina's analysis in her *Cybernetic Revolutionaries. Technology and Politics in Allende's Chile*, MIT Press, Massachusetts, 2011.

5 To many artists at the time, cybernetics remained associated with war and commerce, and was hence anathema to the *engagé* cultural producer (we can think of Hans Haacke's unrealised but nevertheless famous satire on cybernetics in the installation *Norbert: 'All Systems Go'* (1970–71), where he attempted to teach the mynah bird Norbert (after Norbert Wiener) to parrot the phrase 'All systems go.') However, according to Medina, such technological determinism oversimplifies things because the cybersciences were not only an extension of 'wartime power, of command-control communication, to the civilian domain' but also emerged as a way to embrace complexity and 'in response to the increasing impracticality of conventional power regimes' (Medina, op. cit., p.43). In a case of parallelism between scientific research and fiction, Jorge Baradit undertook research on Synco at the same time as Medina was working on her book.

6 Maria Berrios at the conference 'Politics of Mediation', MASP, São Paulo, 15 April 2016.

7 Author's conversation with Jorge Baradit, Santiago de Chile, 10 March 2016.

8 Jorge Baradit, *Synco*, Ediciones B, Santiago de Chile, 2008 (2013), p.57. Author's translation from the Spanish.

9 Hans-Georg Gadamer, *Truth and Method* (London and New York: Continuum 1960/2004), p.103.

10 T.W. Adorno: *Aesthetic Theory*, Continuum, London, 2002 (1970), pp.126–27.

11 Norbert Wiener, *God & Golem, Inc. A Comment on Certain Points where Cybernetics Impinges on Religion*, MIT Press, Massachusetts, 1966 (1964), p.36. Contemporary practices and theories of video games seem to be of limited relevance in this discussion, unless their hyper-operational, over-realised role in the culture industry can be analysed satisfactorily. Machines turn reality into a game, and a computerised world is a 'gamified' world. Again, the stakes of play inspired by cybernetics need to be higher than what already exists.

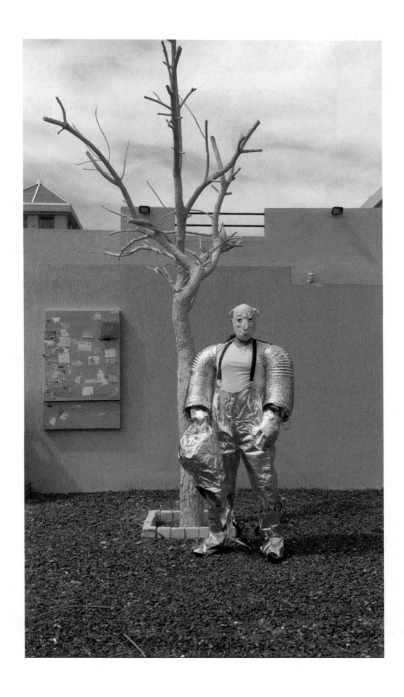

Ramin Haerizadeh, Rokni Haerizadeh and Hesam Rahmanian, *Submarine I: Space Sheep. Space Sheep Was Paid To Land On a New Zeeland!* 2016, still from video user manual, 15 minutes, 15 seconds. Image courtesy of the artists

HFT The Gardener

Hillel Fischer Traumberg (b. 1982 London), a high-frequency algorithmic trader in the city of London, experienced a semi-hallucinogenic state one day whilst staring fixedly at the High Frequency Trading graph patterns illuminating the bank's trading-room walls. After several such experiences Traumberg got the idea of experimenting with psychoactive drugs and eventually managed to procure some on-line from a supplier in Zurich.

The influence of the drugs, which he took at first in small doses, began to alter Traumberg's perceptions of the trading algorithms he was working with and he gradually began to feel more at one with them, as if he actually inhabited the code. He felt himself becoming part of an infinite swirl of global data as the algorithms became transformed in his mind into technicolour fluxing entities, travelling through and beyond his body in holographic space and time.

In his spare moments Traumberg started researching the ethnopharmacology of a hundred or so known and documented psychoactive plants across the world, exploring their historical ritual uses and functions in shamanic healing, in magic, religion, sex, divination, protection, modern medicine and in mental enhancement.

He became curious about their chemical composition and studied the compounds in each plant that produce the psychoactive effects. He made lists of the active substances, the alkaloids, and wondered whether inserting their molecular formulae into the codes of his trading algorithms would have a similar effect as the drugs themselves have on the human brain, i.e. whether they would in any way enhance or alter the trading performance of the algorithms.

Inevitably when the presence of these rogue algorithms came to light at the bank his bosses traced the problems back to Traumberg. Suspecting a nervous breakdown due to the stresses of the job they released him from his employment. With his substantial savings Traumberg moved to a penthouse

HFT THE GARDENER

apartment on the other side of town at Embassy Gardens, a New York Meatpacking District styled riverside complex recently constructed around the new US Embassy in Nine Elms on the south side of the Thames.

From his apartment Traumberg had a 360 degree view, which took in the US Embassy, the New Covent Garden Flower Market, the green glass edifice of the MI6 building just beyond St Georges Wharf, the Houses of Parliament and the City of London further to the east.

Most mornings Traumberg went for a stroll around his new neighbourhood. From the local flower market he built up a collection of plants with supposed psychoactive properties, which soon filled his living room shelves and penthouse roof garden.

One day, staring at the list he had compiled of the botanical names of his plants, he decided to conduct a gematria experiment. Using his rudimentary knowledge of the Hebrew language, gained during his school days, Traumberg made numerical experiments, translating the botanical names of psychoactive plants into phonetic Hebrew and then deriving their numerical equivalents.

He discovered that, for example, Mandrake (Mandragora officinarum) had a gematria value of 970. Adding together the 9 the 7 and the 0 made 16 and then adding the 1 and the 6 made 7.

A copy of the *Financial Times* on his desk prompted him one day to check the numerical equivalents of the plants against the top companies in the FT Global 500 index.

Traumberg found that the two final numbers for Mandrake 16 and 7, corresponded to Petro China and Wells Fargo, which came 16th and 7th respectively in the FT index.

Traumberg compiled a gematria chart of all the plants, listing their botanical names alongside their global companies equivalents. He then developed an algorithm that would trawl the internet, collecting images of the groups of psychoactive plants that corresponded to each company.

Inspired by the botanical illustrations of Ernst Haekel, which he had loved as a child, Traumberg reprogrammed the algorithm to collate and transform these images into works with a similar style and format.

Stimulated by the artistic results, he recalled a summer holiday he'd taken in 2013 to Venice with some banker friends. One of them, an avid art collector, had dragged them around an exhibition in a park on the lagoon and he had seen masses of weird coloured drawings in one of the many buildings, which were said to have been made by artists who had received no formal training.

This brought to mind a work trip several years previously, to UBS in Bern, Switzerland. The Swiss bank had taken them on a free afternoon to a museum where he had seen works by a supposed madman. He looked it up online; the guy was called Adolf Wölfli.

Traumberg, who by now had become obsessed with the forms and structures of the plants themselves, as well as all the data he was collating about them, began, under the influence of the various psychoactive drugs in his possession, to spend his afternoons making a vast series of drawings.

Under the hypnotic influence of Wölfli he transformed himself into an 'outsider' artist. He developed a fantasy of himself as a kind of techno-shaman, transmuting the spirituality of the universe and the hallucinogenic nature of capital into new art forms.

One day a banker friend, the art collector from the Venice trip, paid him a social visit and was astonished to see Traumberg's new apartment filled with strange plants and drawings. On a subsequent visit he took along a top art dealer, who invited Traumberg to show the works at his London gallery. Traumberg, in the throes of a hallucinogenic trip, agreed to the offer. Later in the year the dealer put

on an exhibition and all the works were sold out, primarily to bankers, oligarchs and to some of the corporations featured in the works.

Traumberg was unaffected by this turn of events, his primary concern being to discover whether the realities opened up to him by psychoactive plants were arbitrary hallucinations or whether they indeed, as many had suggested, lifted the brain's filter, opening the portal to what lay beyond our everyday perceptions of reality necessary for survival; the holographic universe perhaps?

Traumberg spent his days wondering whether his experiences were real or imaginary, whether they originated in his unconscious or came from another dimension. He wondered about the nature of consciousness and whether it existed outside the brain/body. Was consciousness perhaps the ultimate organising principle of the universe, merely reflected by the brain in a limited and distorted way? Was consciousness maybe a giant algorithm? And where was the universe in this algorithm?

Based on his experience with high-frequency trading algorithms Traumberg decided to develop a new algorithm to test these ideas.

A brain thinking about a brain. Consciousness thinking about consciousness. An algorithm trying to return information about another algorithm. A brain trying to develop an algorithm about an algorithm about a universe of which it is a part or perhaps a whole or perhaps neither.

HFT The Gardener

High Frequency Trading (HFT)
Hillel Fischer Traumberg (HFT) (en. ToPraise Fisherman DreamMountain)

All images on this and previous spread:
HFT The Gardener, 2014—15, mixed media, dimensions variable.
All images courtesy of the artist, Annely Juda Fine Art and P.P.O.W., New York

Dennis McNulty

The Time Domain

An image search for *Liverpool* and *Brutalism* plants a wonky grid on my laptop screen. I'm drawn to some jpegs of one building in particular, an asymmetric ziggurat compiled from ribbed precast components. I click through views from various angles to their host pages. On one, a blogger named Brutalist Constructions explains that 'the shape of the building was dictated by the company's structure at the time'. In other words, it's a diagram. I dig some more and find that it's known as The Sandcastle Building, The Capital, Royal Insurance Headquarters, The Royal Sun and Alliance Building and New Hall Place. Like a mythological figure, it has many names.

Rob accompanies me on my initial visit. We begin on the lowest level, in the multi-storey carpark. Its rough bricks soak up sound-waves, producing an unexpectedly warm acoustic. We dither at the doorways of the Queensway Tunnel ventilation shaft, admiring their Art Deco detailing before skirting the panelled perimeter. City Exchange, at the junction of Brook St and Old Hall St, is a weightless blend of glass and plants and air, retrospectively applied architectural connective tissue, grafted to The Sandcastle and The Echo. On the upper floor, the combination of white space-frame roof grid and the mature roof-garden atop the Echo's old printworks evokes the verdant mega-structures of 70s sci-fi.

Later on I head over to the Central Library. Plugging keywords into the digital workstations returns a list, but I have trouble locating a couple of books about the city's urban fabric. In the course of pointing them out to me, one of the archivists enquires whether I'm after something in particular. I tell him about my Sandcastle complex. A few minutes later he returns with a squarish pamphlet emblazoned with the building's unmistakable geometry. It's a handbook, a sort of user manual produced for employees and offering information under headings such as Archival Filing, Benevolent Fund, Clocks, Copying Service, Document Conveyor, Plants, Smoking, Telephone, Telex and Theatre. The back pages are taken up with abstractions. Maps of the surrounding streets are accompanied by floorplans of the building, diagams of a diagram, each of which looks like an MRI slice through The Sandcastle's tapering concrete spine.

Top right: Front cover of 'Royal Insurance Guide to Head Office', 1977. Photo courtesy of Liverpool Central Library

Bottom right: New Hall Place, 2015. Photo courtesy of the artist

Royal Insurance

New Hall Place, Liverpool

Guide to Head Office

Dennis McNulty

Ian Cheng

Emissary Forks For You

Shiba Emissary verbally commands the viewer to follow her throughout the exhibition at Cain's Brewery. With promise of reward, the viewer assumes a new role: Shiba Emissary's pet. *Emissary Forks For You* is a mixed reality simulation for Google Tango tablets, in which a relationship between the human viewer and a virtual AI dog may develop.

Emissary Forks For You, live simulation, sound, Google Tango tablets, 2016

HERE

Lawrence Abu Hamdan

H[gun shot]ow C[gun shot]an I F[gun shot]orget?

Spotting the Shotspotter: digital photograph of Shotspotter
microphone installed on the top of a street lamp.
Image courtesy of the artist

If you're feeling that text can't say enough,
you're ready for Glide. Get a little closer.
– Extract from the App Store product description of Glide

In December 2014, new audio evidence emerged that captured the moment when unarmed teenager Michael Brown was shot to death in Ferguson, Missouri, that August. The audio was submitted by an anonymous man who had accidentally caught the moment of the shooting as he was recording and sending a private voice message from his phone using the Glide app. He only realised the significance of the gunshots he had recorded much later.

In this recording it is audible that Brown's murderer, a police officer by the name of Darren Wilson, fired his gun ten times. Six of these shots hit Brown, mostly in the head (all above the torso). And yet there is another and unexpected violence that is captured in this recording – one that, whether presented on CNN or to the grand jury, listeners were asked to ignore. While both defence and prosecution provided forensic audio experts to give their own accounts about the gun shots that could be heard in the background of this recording, neither seemed to acknowledge that the greater police violence enacted upon the residents of Ferguson and many other African-American neighbourhoods in the United States was in the foreground, clear for all to hear.

This is the recording transcribed with both the foreground and background sounds included:

> 'You are pretty. [6 gun shots]. You're so fine. Just going over some of your videos. [gun shot] H[gun shot]ow c[gun shot]an I f[gun shot]orget?'

Dr Robert Showen was one of the key expert listeners in this case. His analysis of the gunshots centred mostly on the echo they created. Using the impulse sounds of the shots and their reflection off nearby walls, he was able to define the space around the shooter. Since each echo of each shot was very similar in sound, it was concluded that the murderer was stationary and stayed more or less in one place while he was firing the shots. This evidence corroborated some eyewitness testimony and was also key to denying the veracity of other contradicting accounts. These technicalities amounted in the end to a greater body of evidence that concluded that unarmed Michael Brown was charging at the officer and that the officer was therefore acting in self-defence when he repeatedly shot Brown in the head.

Showen's expertise was called upon because of his extensive experience in working with gunshot sounds as echo-location instruments. He is the founder and creator of ShotSpotter™, a gunshot detection and location service that works by installing microphones throughout a neighbourhood to listen for sounds from the street that might be gunfire. When the microphones detect a loud bang, they automatically triangulate where this sound is coming from. The

Lara Favaretto archive

information is algorithmically analysed against a huge database of loud bangs to verify quickly whether the sound registered is indeed a gunshot. If it decides that it is, it sends the location to the Police Department. This is on average accurate within thirty feet of where the shot happened. The ShotSpotter system of microphones is now installed in 80 'troubled' neighbourhoods across the United States. The company has aspirations to cross the Atlantic, having now installed systems in South Africa and, after the November 2015 attacks in Paris, has seen the opportunity to make its service available on the European market.

Showen told me in an interview that ShotSpotter microphones are typically placed on the rooftops of buildings so that one can 'listen to the horizon'. 'So they're mostly installed on private property?', I asked. His response was: 'Yes. We went out with the police officers and knocked on doors and asked if the people would allow us to put a sensor on their building to help protect the community from gunfire. Practically everyone agreed [...] Everyone was just willing to donate their roof for the benefit of the community.' This seems to contradict the whole rhetoric of ShotSpotter™, however, which is constructed on its necessity as a security infrastructure, based on the fact that the communities affected by gun crime were made up of unreliable witnesses who failed to report more than 80 percent of the gunshots they had heard. The idea, then, is that ShotSpotter™ would replace these unfaithful ears with law-abiding microphones and be able to algorithmically detect 80 percent of gunshots that previously went unreported.

Showen says: 'Our sensors' microphone sensitivity is almost identical to what is on a cellphone and a speakerphone.' But the human capacity for hearing is in general much more sensitive and adapted to reading sounds than a cell-phone microphone placed on a rooftop. Therefore the issue is not that people don't hear the gunshots and the microphones do, but rather that people hear the gunshots and choose not to report them to the police. This startlingly high figure of unreported incidents suggests that, as in the case of Michael Brown and hundreds more since, the police can be more dangerous, more racist and more trigger-happy than the criminals. Showen seems oblivious to this idea when he speaks of the inauguration ceremony that happens in each community when ShotSpotter™ is installed: 'When we install a system, we have the police go out and shoot and we see the accuracy and the sensitivity of our system.'

It is no surprise, then, that when Showen forensically listens to the recording of the death of Michael Brown, he doesn't hear the loudest aspect of this recording: the love-struck voice of the man who, despite the sound of gunfire ringing out loud outside his window, continues unfazed to send a message to the subject of his admiration, oblivious or perhaps not caring that the message of love he is sending is underscored by the sounds of brutal violence. 'You are pretty', he says, and then a short pause that is long enough for a volley of six shots to ring out. After a brief break in the gunfire he resumes by saying 'You're so fine.' Is this short pause an acknowledgement of the gunfire? Is he waiting for it to subside so he can carry on with his

message, like the pause we might make in our conversations while a jet flies overhead? Or is this pause a coincidence and he has simply become totally desensitised to the sound of gunfire outside his window? Either way, this voice that ignores these very loud sounds rather than alerting the emergency services is treated as irrelevant in the courtroom. Yet, this voice that jury members were asked to ignore is ironically the best way to understand the extent of violence in these communities and the endemic distrust of the police.

Cue Future's *March Madness* from the mixtape 56 Nights 2015.

Many are concerned that ShotSpotter could constitute a fourth-amendment violation – a warrantless search and seizure of public sounds, a pervasive method of surveillance that could be used to record private conversations, amassing a huge sound archive available for all kinds of security applications. Yet according to ShotSpotter's privacy policy: 'The entire system is intentionally designed not to permit "live listening" of any sort. Human voices do not trigger ShotSpotter sensors.' And perhaps this fact – that the authorities are not interested in human voices – is the more frightening possibility. Rather than pointing to a hyper-surveilled society that hears everything we say, ShotSpotter points to a society where words are the last to be heard. And when we listen to and not past the voice on the recording of the murder of Michael Brown, what becomes distinctly audible is the extent of this societal deafness – the deafness of communities to gun violence, the deafness of the police to so-called 'troubled' communities, and the deafness of the judges and lawmakers to the social conditions that produce unreliable and uninterested witnesses.

The analysis of the gunshots that killed Michael Brown didn't work in his favour because the conditions of listening are determined by the same authorities that committed the injustice against him. Yet what would a Shotspotter with its microphones aimed towards the police rather than the people enable us to do? Although it has been recording every gunshot across 80 neighbourhoods, there has not been a single case where it has been used as evidence to prosecute a police officer. What would it sound like if we could hear this vast database of police gunfire rather than have it ring out only in the desensitised and terrorised communities in which it is a regular occurrence? Instead of demanding that our privacy be granted and rejecting this technology, we should instead be demanding more listening, more archiving, in order to reverse-engineer its selective ears, building an alternative database of sounds from which this system can become artificially intelligent to another reality of violence.

Lara Favaretto archive

Lawrence Abu Hamdan

Elena Narbutaite

Elena Narbutaite, *Study of Water*, 2016. Watercolour on paper, 14.8 × 21 cm

Eduardo Costa, *Preparatory Drawing for Sun Kiss Feline, 1982—2016*

Eduardo Costa, *Laminated Morpho Butterfly Wings With Acrylic Body, 1979—8*☉

Eduardo Costa, *Ring With A Mole With Hairs*, 1982, ring, yellow gold, mole, red gold, hairs, white gold as seen in *Fashion and Surrealism*, FIT, New York and Victoria and Albert Museum, London, 1987/1988

Elena Narbutaite

Marvin Gaye Chetwynd

Dogsy Ma Bone

CALLING ALL PRECOCIOUS YOUNG ACTORS, SINGERS, CHEEKY PERFORMERS, DANCERS AND SHOW-OFFS

We are looking for bright young talent with the gift of the gab for a brand new production.

Come and help artist Marvin Gaye Chetwynd realise *Dogsy Ma Bone*, an amazing new film and live performance, inspired by Betty Boop's *A Song A Day* and Bertolt Brecht's *The Threepenny Opera*. Roles include Nurse Betty, Professor Grampy, animals such as Billy Goat and Mr Woodpecker, as well as thieves and outlaws. The film will be shown as part of Liverpool Biennial 2016, the UK's largest visual arts festival.

You are invited to star in the film and work with the artist to reimagine the songs, script and sets of these iconic works.

AUDITIONS

WHEN
Sunday 1 May, 10am–5pm

WHERE
The Black-E

WHAT TO PREPARE
Along with a performance you love that best shows your talents (be it singing, dancing or acting), you'll have a short slot to perform either *A Song A Day* by Betty Boop or *The Ballad of Mack the Knife* from *The Threepenny Opera*.

WHO
You need to be 14 or under to apply. All performance abilities welcome.

HOW TO REGISTER
Sign up at **www.biennial.com/ marvincallout**. If you have any questions, contact **aimee@ biennial.com** or call 0151 203 3585.

Please note you must be available for rehearsals in Liverpool over the May half-term holidays: Sunday 29 May – Friday 3 June. The final performance takes place on 11 and 12 June.

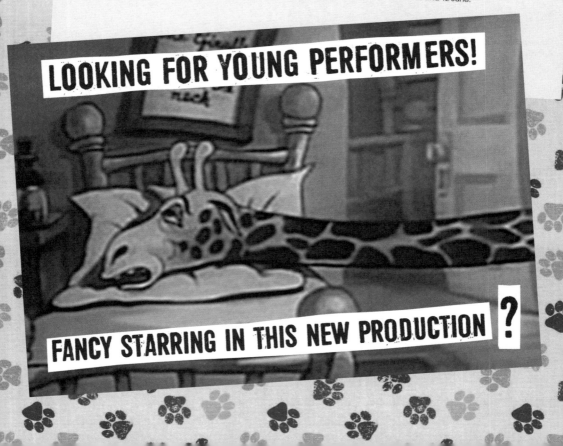

LOOKING FOR YOUNG PERFORMERS!

FANCY STARRING IN THIS NEW PRODUCTION?

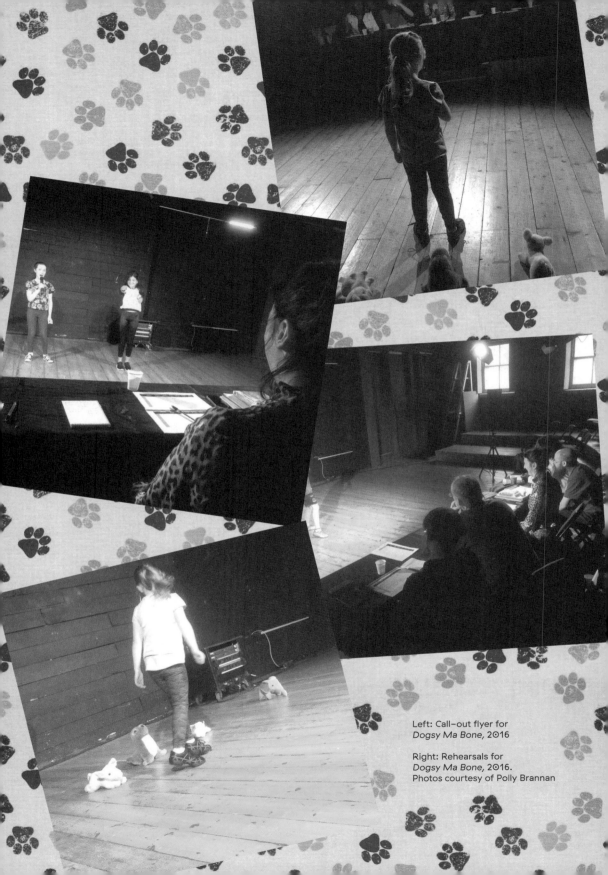

Left: Call-out flyer for
Dogsy Ma Bone, 2016

Right: Rehearsals for
Dogsy Ma Bone, 2016.
Photos courtesy of Polly Brannan

The Space/Time Bus

Our Liverpool Biennial bus was made in collaboration with Year 7 pupils from Childwall Sports and Science Academy. Rather than being sent into outer space, our bus and its pictorial message will be transmitted into the space of Liverpool. It will also be sent out into the future – the bus service will run on beyond the Biennial.

During our workshop we discussed the history of sending messages into space to be found by future people (or non-people), including the Pioneer Plaques, the Voyager Gold Record, the Arecibo Message, and most particularly the Teen Age Message. The Teen Age Message, organised by scientist Alexander Zaitsev, is a radio broadcast composed by teenagers from various cities in Russia. It was sent to target stars chosen by the young contributors. We also discussed the idea that physical and mathematical certainties will be already understood by intelligent extraterrestrials, but artworks, which are unique to humans, will not.

Pupils of Childwall Sports and Science Academy with a technical drawing of their bus, 2016. Photo courtesy of Robert Battersby

Decoder chart for *Hello Future Me*

Episode 2

Drawing for *Hello Future
Me*, Hato and pupils of
Childwall Sports and
Science Academy, 2016

Wanting our bus to be a time capsule as well as a time machine, we invited Childwall pupils to think about what is important to them and their lives in present-day Liverpool and to create pictograms that represent these themes. The pupils have created symbols that depict where they are (a boat sailing to Merseyside, the Radio City tower, the Fiveways pub sign), who they are and what they stand for (the nationalities in our class, support for gay relationships and marriage), things that they enjoy (a skateboard, a pencil, a ruler, football, Batman vs Superman), people they are inspired by (Beyonce, David Bowie (RIP), Lemmy (RIP), Ellen DeGeneres) as well as their perception of problems (homelessness, swearing, drinking, bullying, Donald Trump).

A selection of these pictograms appear on the bus alongside a written message and question. We discussed what we might ask the people of the future (do you have air/water/jobs/pets?), and how could we greet them. In a way, the children were asking their future selves what they should expect from their city, and which values should be protected in their future. Our final message has been translated into a coded language that was communally put together by the pupils and which can be deciphered using the alphabet on the left.

The Voyager Golden Record,
NASA/JPL, 1977

Yevpatoria RT–70 Radio Telescope, used in the Teen
Age Message, 2001. Image: Rumlin

Hato

Lucy Beech

Lie to Your Doctor

Lie to Your Doctor.
How many times have you been told its all in your head?
I always tell my members,
if you're still insistent on getting advice from your GP
then don't turn up in an agitated state and accurately report
what you see happening to your body.
Don't make any comments about your stress levels.
Don't say things like 'I can't take it any more' or 'It's unbearable.'
Exercise restraint in using certain words.
Now, I know that many people have suffered greatly with
disbelief, and disrespect from their friends and even their doctors.
But part of my mission is to start to change the way we're viewed.
We know what's happening in our bodies is real.
I know it
because I've felt it.
I know the truth about the ways in which you are suffering;
my team are here to help you.
You have the right to have your suffering acknowledged,
and we are here to give voice to that suffering;
we're working tirelessly to make that voice heard.
Remember we feel what you feel.
So, what can we do?
We can avoid specific terms when describing our symptoms
to our doctors;
it's risky to say our skin is crawling, or 'something's moving under
the skin'.
Don't whatever you do describe in detail things you've observed
on your skin.
Going into detail will cause them to jump to conclusions about
what's going on in your head.
Try to be as calm and composed as possible
and don't take samples;
don't walk into that trap.
If you're going to your GP, make THEM ask YOU for samples.

Right and next spread:
Lucy Beech, film still, 2016, HD video 30 minutes.
Images courtesy of the artist

Lucy Beech

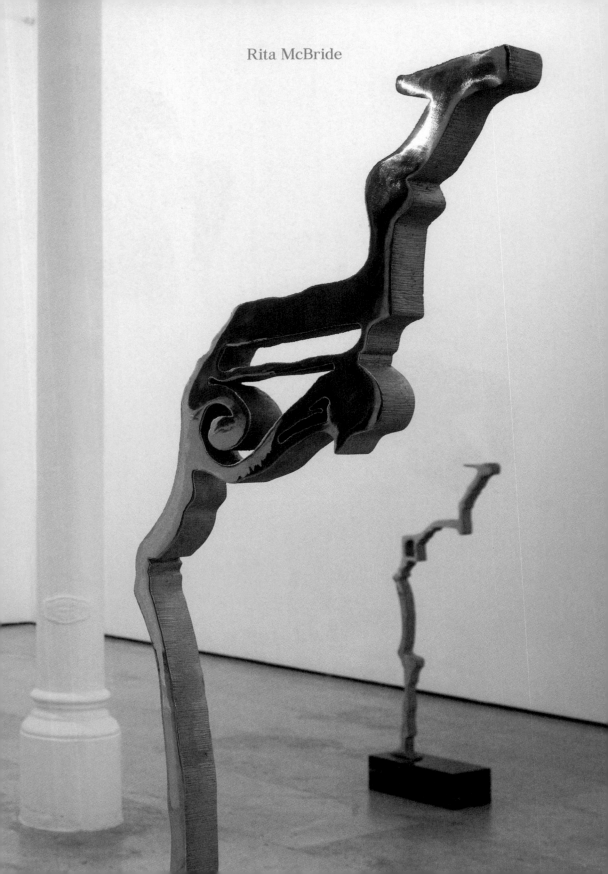

Rita McBride

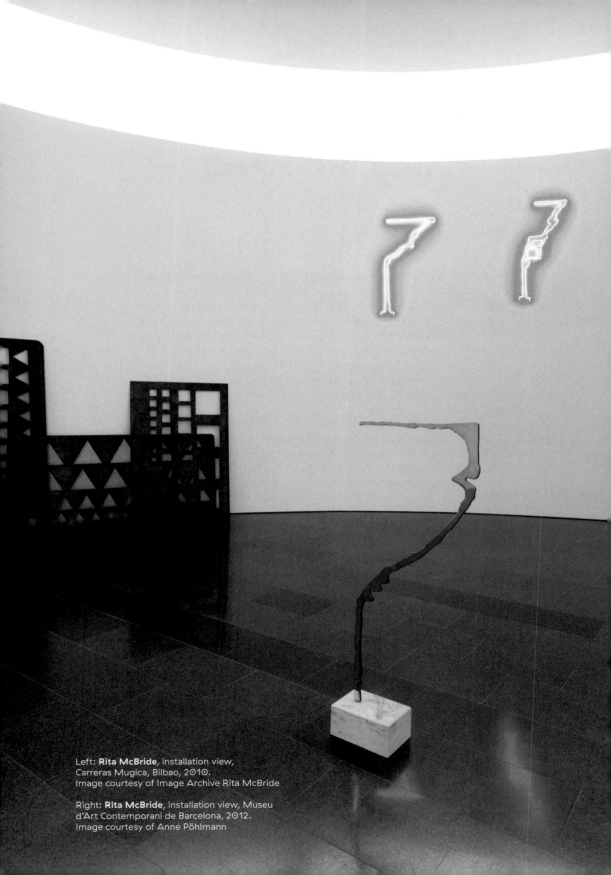

Left: **Rita McBride**, installation view,
Carreras Mugica, Bilbao, 2010.
Image courtesy of Image Archive Rita McBride

Right: **Rita McBride**, installation view, Museu
d'Art Contemporani de Barcelona, 2012.
Image courtesy of Anne Pöhlmann

Koki Tanaka

Youth Training Scheme Strike, 1985 (Revisited)

After over thirty years of photographing demonstrations including the Miners Strike and the Poll Tax, the Liverpool School Strike against the Youth Training Scheme (YTS) on 25 April 1985 stands out. It was brilliant, funny, noisy, exciting, fast and angry. Thatcher had said she 'deplored the action', Kinnock, the Labour leader, called the protestors 'dafties'. But YTS was a government scheme intended to reduce unemployment among young people, which was as high as 80 percent in Liverpool at the time. It was meant to provide training skills but didn't guarantee a job at the end, and was used by many employers as a way of obtaining cheap labour.

I was taking photos for the *Militant Newspaper*, so I got to St George's Hall early, just as the first students arrived with banners and placards. Flyers had been handed out at schools by the Labour Party Young Socialists (LPYS), but we had no idea so many kids would turn up. Two thirds of them girls, many had made their own placards and banners attacking the scheme, comparing it to 'conscription' and 'slave labour'.

After a number of speeches, the organisers mentioned the Pier Head and the kids shot off down Roe St onto Dale St, not through the Town Centre as planned, which was a shame since it would have made even more impact. Only a couple of coppers turned up, but the kids were good-humoured and well-behaved. A number of speakers including Terry Fields MP spoke at the Pier Head.

The scheme was postponed but resurfaced a year later. Kinnock used the demo as one of his excuses to attack the left in the Labour Party and shut down the LPYS.

Dave Sinclair, March 2016

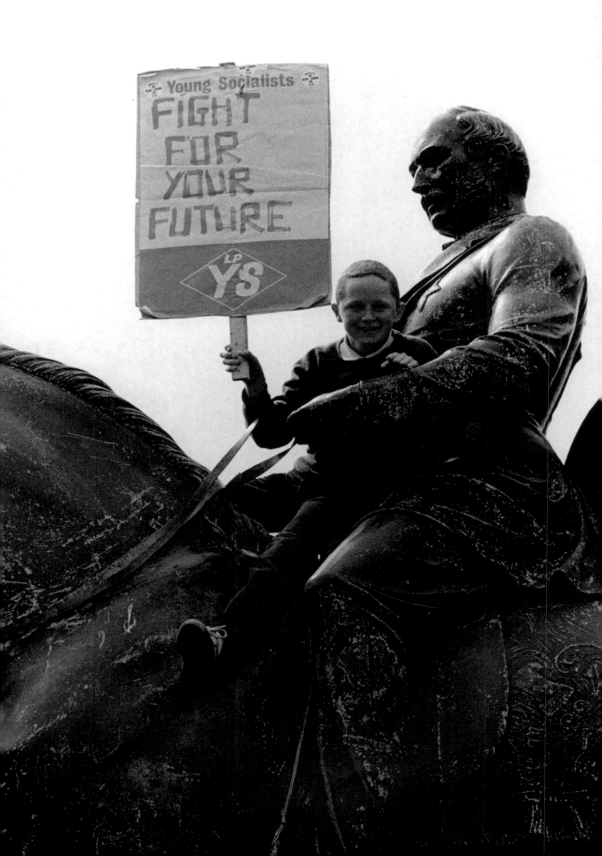

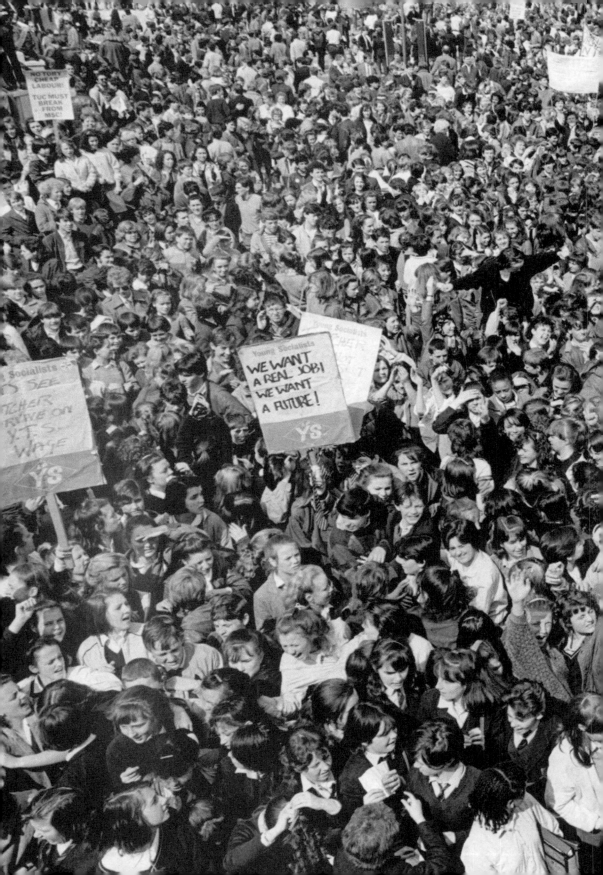

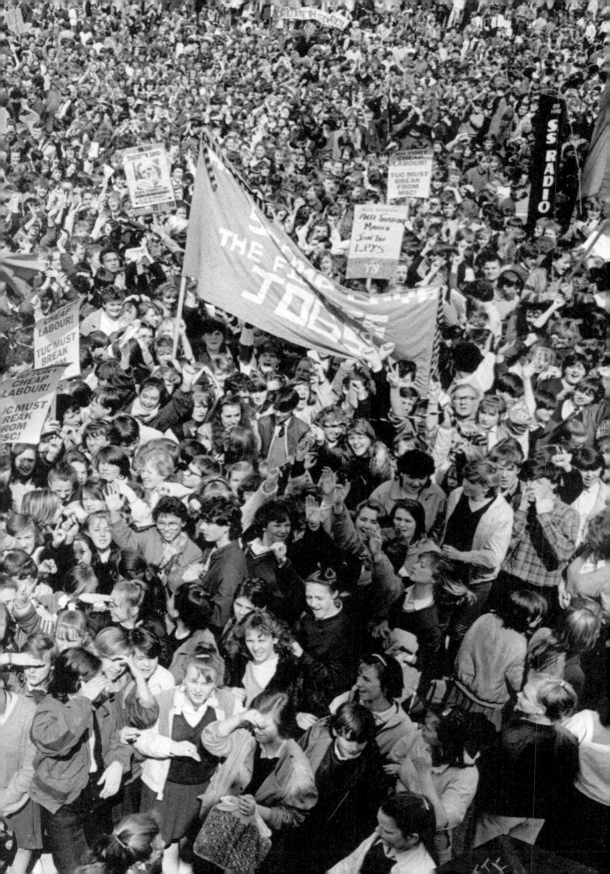

The atmosphere on the day was electric. I'd never been on a demo like it. In the weeks before the announcement of the strike, there'd been a lot of speculation in the press as to what its purpose was and what support it would get. There had been so many spontaneous walk-outs from students in schools in Knowsley that the Council announced that all secondary schools in the borough would be closed on the strike day itself.

I was amazed by the numbers who showed up. There were thousands. Cynics had suggested that it would be used as a day to stay at home and that most young people wouldn't be interested in political protest, but the numbers in attendance refuted that. Students came from all over Merseyside. Knowsley and Liverpool schools were obviously well represented, but there were also students from Southport, St Helens, Formby, the Wirral.

We'd organised stewards, but it proved to be beyond the our control. The demo was scheduled to leave St Georges Hall at 10.30 I think, but we couldn't hold the demonstrators back, so the march started spontaneously about ten minutes early. The demo never followed the designated route. People just went on the most direct way to the Pier Head and pretty much ran all the way. We'd planned for the march to take about an hour, but it took about twenty minutes. Those twenty or so minutes were mad. Roads were blocked, traffic was held up, people walked between cars. I was seriously worried that someone would get run over. I'd heard that there had been a couple of arrests, which was a shame because it wasn't that kind of event. Although we'd lost control in organising the demo as a steady march along a planned route, the mood was boisterous

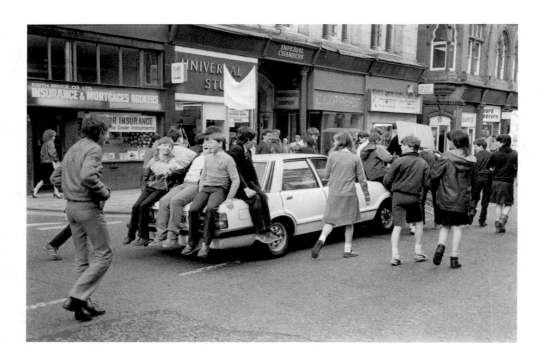

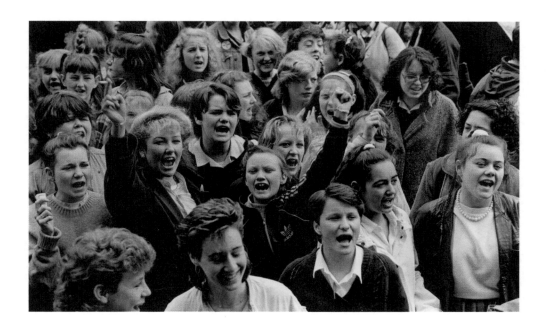

pp.209—13
Youth Training Scheme
Protest, Liverpool,
25 April 1985.
Photos courtesy
of Dave Sinclair.
© Dave Sinclair

and enthusiastic rather than destructive. There were certainly no fire extinguishers thrown from high buildings. Those reports of arrests aside, the police took a generally hands-off approach, although some were clearly intent on pushing kids around for little more than over-enthusiasm.

At the Pier Head, there was a sea of kids, mostly in school uniforms. There were informal competitions to see which schools were best represented. They'd made banners that read things like 'Croccy Comp on strike', 'We won't go on YTS' and others demanding real jobs and futures. My own personal favourite was a banner that read, 'Slavery was abolished in 1833'.

There was also a real multi-racial dimension to the demo, which was rare in youth events at the time. There were black kids, Chinese kids, Asian kids, all participating in the event, but I also remember speaking to a couple of lads from a fairly posh school on the Wirral who'd turned up. The speakers were enthusiastically received and nobody would go home at the end. Terry Fields in particular got both an enthusiastic and genuinely warm reception.

The demo had the desired effect, at least in the short term. The plans to introduce compulsory Youth Training Schemes were ditched, although they were introduced through the back door a year later. But a victory is a victory and there weren't that many against Thatcher. The students who went on that demo now have their own kids of the same age. Then it was YTS, now it's EMA, tuition fees, welfare and housing benefits, stop and search. Every generation of young people finds itself under attack in one way or another.

Emy Onuora, September 2011

Koki Tanaka

C.O. Grossman and Juliana Spahr

Poets of
The Revolution

MUSA SABRI WROTE A POEM OF EULOGY TO PALESTINIAN MARTYRS.

POEM BY FATHER (ALOYSIUS) MANDLA ZWANE TITLED "I AM BLEEDING" SPEAKS OF POSSESSION BY FOREIGN SPIRITS HITLER, MUSSOLINI, VERWOERD.

POET YEVGENIY YEVTUSHENKO FILLED THE INTERNATIONAL COMMENTARY COLUMN OF PRAVDA ON SEPT. 14 WITH A "TELEGRAM TO CHILEAN PEOPLE" IN FORM OF POEM ENTITLED "GENERALS' BOOTS."

FOR THREE DAYS RADIO HAS REPEATEDLY BROADCAST ANTI-SENGHOR POEM BY TOURÉ, AND EXTRACTS FROM PAST ANTI-SENGHOR AND ANTI-HOUPHOUET SPEECHES AND EDITORIALS, ENTITLED "DE LA NEGRITUDE A LA SERVITUDE" AND "LE VALET DES VALETS."

INSULTS AIMED AT THE PORTLY GENERAL INCLUDED RECITATION OF POEM EaNTITLED "FAIRY TALE OF THE FAT WATER BUFFALO." THE ARTICLE QUOTES MAO'S POEM ABOUT "SUFFERING TEN THOUSAND CUTS...TO UNHORSE THE EMPEROR," WHICH EVOKES MEMORIES OF RED GUARDS CHANTING IT AT THE BEGINNING OF THE CULTURAL REVOLUTION.

FEMININE GENDER USED IN ORDER TO SET UP IMAGE OF SOLZHENITSYN AS A PROSTITUTE SELLING HIMSELF AND HIS COUNTRY. CARTOON ABOVE POEM SHOWS SOLZHENITSYN WITH FOOT PRINT ON BACKSIDE CARRYING HIS BOOKS TO HOST OF TRAITORS - JUDAS, BRUTUS, CAIN, FATHER GAPON, ETC.

PRC MEDIA HAS GIVEN A SUDDEN BURST OF ATTENTION TO THE RECENT PARACELS BATTLE, WITH A LONG EPIC POEM LAUDING CHINESE HEROICS AS THE CENTERPIECE. THE EPIC VIGOROUSLY REASSERTED PRC CLAIMS TO THE PARACEL, SPRATLY, AND PRETAS ISLAND GROUPS BUT DID NOT SEEM INTENDED AS A WARNING OF MILITARY ACTION.

WE HAVE NO MEANS OF CONFIRMING THIS REPORT, BUT FACT THAT THE GROCERY CLERK FROM WHOM JANKOWIAK OBTAINED A COPY OF CONTROVERSIAL POEM HAS ALREADY BEEN RELEASED BY POLICE LENDS STORY SOME CREDENCE.

ECEVIT WAS THEN ACCUSED OF WRITING POEM EXPRESSING PRO-GREEK SENTIMENTS. ECEVIT ADMITTED WRITING POEM OVER 20 YEARS AGO, BEFORE HE HAD ENTERED POLITICS, AND WENT ON TO UNDERLINE IMPORTANCE OF GREEK-TURKISH FRIENDSHIP AND NEED TO END ARMAMENTS RACE IN AEGEAN AREA.

AMBASSADOR VALLS ARRIVED TWENTY MINUTES LATE, HAVING OVERSLEPT BECAUSE HE HAD BEEN UP MOST OF THE NIGHT COMPOSING A POEM ADDRESSED TO RADHAMES MENDEZ VARGAS.

HIGHLIGHT OF EVENING WAS PREMIERE OF NEW POEM BY FOREMOST SYRIAN POET NIZAR QABBANI ENTITLED "ODE TO DAMASCUS." REMARKS BY SUBSEQUENT SPEAKER WERE ALMOST TOTALLY LOST IN CONTINUING CLAMOR ABOUT NEW POEM.

IN 1974, USIS SANTO DOMINGO PUBLISHED AMBASSADOR ROJAS' POEM "TROTACIELOS: HOMENAJE A LOUIS ARMSTRONG."

ONLY ONE POEM HAS APPEARED CALLING NEBULOUSLY FOR LIFE TERM OF PARTY GENERAL SECRETARY.

COMMUNIST PRESS HAS INAUGURATED A CONTEST FOR THE MOST INSULTING, UNFLATTERING POEM ABOUT FOREIGN MINISTER.

EVER BALEFUL NEW YORK COMES IN FOR A NEW KIND OF PUT-DOWN IN N. KRAMOVA'S POEM, "RAIN IN NEW YORK," IN STUDENCHESKIY MERIDIAN MAGAZINE, WHICH CONCLUDES SOMEWHAT EERILY WITH LAST SMILE ON LENIN, APPARENTLY WAITING FOR LEFTY TAKEOVER.

THE AUTHOR TAKES SUNG CHAIANG'S POEM TO TASK FOR HAVING ALLUDED TO HUANG CH'AO, ANOTHER MILITARY FIGURE, AS "UNMANLY."

THE PRIME MINISTER, WHO HAS NOT HITHERTO BEEN KNOWN FOR HIS LITERARY CRAFTSMANSHIP, WILL READ A SPECIAL POEM WHICH HE HAS WRITTEN FOR MUHAMMAD ALI'S VISIT.

COOPER WROTE OR COMPILED DOCUMENTS IN BLACK PEOPLE'S CONVENTION NEWSLETTER (27 PAGES OF ESSAYS ABOUT BLACK SOLIDARITY, WHITE VIOLENCE AGAINST BLACKS, EFFECTIVENESS OF STRIKES, DIATRIBES AGAINST HOMELANDS AND FOREIGN INVESTMENT, POEM WHICH STATES "LET'S FIGHT FOR OUR FREEDOM").

CHARGES AGAINST VARIAVA CONTAINED IN TWO COUNTS: COUNT 1: PUBLISHED PEOPLE'S EXPERIMENTAL THEATER NEWSLETTER AND WROTE (A) POEM CONTAINING LINE "OPPRESSORS' DEATH IS BLACK SURVIVAL" (WHICH IN CONTEXT IS OPEN TO VARYING INTERPRETATIONS); (B) ESSAY ON BLACK CONSCIOUSNESS WHICH STATES BLACKS MUST BREAK CHAINS, COMPLETELY TRANSFORM SYSTEM, BUILD COUNTERPOINT TO WHITE RACISM IN ORDER TO CREATE LAND IN WHICH BLACK AND WHITE CAN LIVE IN HARMONY, AND ALL BLACKS (ARICANS, COLORED, AND INDIANS) SHOULD UNITE AGAINST COMMON OPPRESSORS; AND (C) INFLAMMATORY AND OBSCENE POEM WHICH SAYS PEOPLE HEAR DRUM OF BLACK CONSCIOUSNESS, CLENCH THEIR FISTS AND PICK UP THEIR SPEARS.

A LENGTHY POEM ATTACKING THOSE "ROOSTERS AND HENS" WHO OPPOSE RESTORATION BUT ARE PRACTICING RESTORATION AND PROMISING THAT "THOSE BUSY LITTLE CLOWNS WHO SCHEME TO OPPOSE PREMIER CHOU DEFINITELY WILL NOT COME TO A GOOD END."

THE POEM BY A TSINGHAU STUDENT WAS WRITTEN IN BLOOD ON A PIECE OF WHITE CLOTH AND READ OUT TO CHEERS AND APPLAUSE.

CEAUSESCU'S TOAST STRESSED FAMILIAR THEMES OF NATIONAL LIBERATION, INDEPENDENCE, AND NEW WORLD ECONOMIC ORDER PUNCTUATED WITH QUOTE OF SENGHOR POEM TOGETHER WITH CRYPTIC ANTI-SOVIET NOTE OF ULTRA-NATIONALISM FROM ANONYMOUS ROMANIAN POET: "BETTER TO DIE ON ONE'S FEET THAN TO LIVE ON ONE'S KNEES."

ISSUE CONTAINED POEM BY VASILE NICOLESCU ENTITLED "SLANDERERS OF THE MOTHERLAND" WHICH, ALTHOUGH NOT MENTIONING RADIO FREE EUROPE BY NAME, REFERS TO "CENTURIONS OF HATE" WHO SPEAK WITH "SUPPLE LIES" AND "PUTRIFYING WORDS."

SIN SANG-CHO, WHO IS SUPPOSED EXPERT ON COMMUNISM, TESTIFIED THAT KIM CHI-HA'S WRITINGS ARE SIMILAR TO COMMUNIST-STYLE EXPRESSION BECAUSE OF USE OF TERMS SUCH AS "CLASS STRUGGLE" AND "PROLETARIAT VS BOURGEOISIE."

IN SEPARATE ARTICLE FROM HONG KONG, MATHEWS OBSERVES THAT POETRY HAS BECOME "PRIZED POLITICAL WEAPON" IN PRC. PEASANT VERSE BEING ENCOURAGED; HANGCHOW STEELWORKER WON WARM APPLAUSE FOR HIS EPIC "FURNACE FLAMES REFLECT BLAZING WRATH FOR TENG HSIAO-PING." KUO POEM, PUBLISHED IN "KUANG MING," ALLUDED TO CHIANG CHING AS "DEVIL ROSE FROM A HEAP OF WHITE BONES"; WANG HUNG-WEN CALLED POL HOOLIGAN; YAO WEN-YUAN LABELED LITERARY RUFFIAN. ONLY PERSON NAMED WAS "CANINE-HEADED ADVISER CHANG" CHUNG-CHIAO.

THE POEM "VISTA BEYOND VISTA" (ZA DALYU-DAL) PAYS TRIBUTE TO STALIN THE INDUSTRIALIZER AND WARLORD. HE IS ACCLAIMED FOR PROMOTING THE ECONOMIC DEVELOPMENT OF THE

SOVIET UNION'S EASTERN REGIONS IN PARTICULAR AND THE BUILDING OF A STRONG METALLURGICAL BASE THERE. STALIN IS ALSO PRAISED FOR RESOLUTE COMMAND OF THE WAR EFFORT, WITHOUT A TRACE OF REBUKE FOR HIS COLOSSAL BLUNDERING IN THE EARLY STAGES OF THE CONFLICT.

A READING OF KIM'S POEM "THE POLE" REVEALED KIM'S ASPIRATIONS FOR THE EVENTUAL TRIUMPH OF COMMUNISM.

CHANG CHUN-CHIAO'S POEM "MY FEELINGS" CONSTITUTED EVIDENCE OF HIS AMBITION TO BE NAMED PREMIER.

THE POSTER'S ACCOMPANYING POEM IS AN ACROSTIC: READ TOP TO BOTTOM THE MESSAGE IN THE LEFT COLUMN READS "THE PEOPLE HOPE FOR THE RETURN OF TENG HSIAO-PING."

THE POET'S SHARP-SPOKEN MOTHER TOLD REPORTERS IN A COURTHOUSE CORRIDOR THAT SHE HOPED PRESIDENT-ELECT CARTER COULD HELP FREE HER SON. WHILE FRIENDS TRIED TO STOP HER FOR HER OWN SAFETY, CHUNG KUUM SUNG SHOUTED, "HE IS IN PRISON BECAUSE OF MR. PARK'S DICTATORIAL GOVERNMENT."

IN CLOSING, CEAUSESCU REFERRED TO THOSE WHO SPEAK AGAINST THEIR COUNTRY TO PLEASE THEIR "MASTERS" WHO PAY THEM WITH DOLLARS AND ALLOW THEM TO USE "RADIOS." HE RECITED AN OLD ROMANIAN POEM WHICH CALLS CURSES DOWN UPON THE HEADS OF TRAITORS.

THE MOST PROMINENT YOUTH MILITANT RUNNING ON THE TAMIL UNITED LIBERATION FRONT TICKET THIS YEAR IS KASI ANANTHAN, A REVOLUTIONARY POET WHO WAS JAILED SEVERAL TIMES DURING THE PERIOD OF EMERGENCY RULE.

COPIES OF THE NEW BULGARIAN ENCYCLOPEDIA APPEARED IN BOOKSTORES THAT YEAR AND THEN WERE QUICKLY WITHDRAWN, WE ARE TOLD, IN RESPONSE TO YUGOSLAV FURY WHEN THEY SAW PARTS RELATED TO MACEDONIA. GONE WAS SEPARATE ENTRY ON "MACEDONIAN LANGUAGE," ENTRY FOR CONTROVERSIAL "MACEDONIAN POET" BENKO MARKOVSKI HAD BEEN CHANGED TO DESCRIBE HIM AS "BULGARIAN REVOLUTIONARY POET," INSTEAD OF PREVIOUS DESCRIPTION AS "REVOLUTIONARY POET OF SOCIALIST REPUBLIC OF MACEDONIA."

A POEM BY YI PONG-NAE COMMENTS ON VAGUENESS OF CHARGES AGAINST PAK AND OBVIOUS AMERICAN DESIRE TO "THROW THE NOOSE."

POET SPECULATES WHETHER CARTER'S MORALITY AND CRUSADE FOR HUMAN RIGHTS ARE JUST FOR POPULARITY.

THE FORMER SECRETARY OF STATE FOR THE ENVIRONMENT'S ACTIVITIES WERE LARGELY LIMITED TO POLL-TAKING, EXHORTATIONS, AND AN OCCASIONAL POEM ON A NATURE THEME PUBLISHED IN THE PRESS.

RECENT INVESTIGATIONS BY THE CITIZEN SHOW THAT 'POETRY' READINGS AT THE USIS LIBRARY IN SOWETO AND ELSEWHERE HAVE BEEN A REGULAR FEATURE OF BLACK PEOPLE'S CONVENTION 'CULTURE' SINCE 1975.

THE MINISTER OF JUSTICE, MR. JIMMY KRUGER, HAS RELEASED SOME EXAMPLES OF THIS 'BLACK POETRY'.

HERE IS THIS VERSE FROM THE POEM, "FOR UHURU DAY.": "I WILL RETALIATE, BOTH VERBALLY AND PRACTICALLY. I WILL RAPE THEIR DAUGHTERS* I WILL KILL THE LIVING* I WILL MURDER THE UNBORN* AND CURSE THE WHITE DEAD* FOR ITS THEY WHO RAPED MOTHER AFRICA. FOR IT'S THEY THAT OPPRESSED BY BLACK PEOPLE. I WILL HAND THEM ON TREES, I WILL BURN THEIR HOMES, AFTERWARDS, ENJOY THE FRUITS OF MY WORK."

THAT EVENING, THE DEFENSE ATTACHE NOTICED A GROUP OF APPROXIMATELY 60 YOUNG PEOPLE STANDING OUTSIDE THE INTERNATIONAL STUDENT DORMITORY IN THE CASTLE DISTRICT. THEY WERE STANDING PASSIVELY WITH THEIR HEADS BOWED LISTENING TO A POETRY READING. THIS OBSERVATION WAS CONFIRMED BY A BRITISH EMBASSY OFFICER.

GOETHE SOCIETY CUTTING ITS CONTACTS WITH OPPOSITIONISTS IN WAKE OF BACKFIRE OVER POETRY READING.

'Poets of The Revolution' is composed of language we found in the WikiLeaks Public Library of US Diplomacy (PlusD) database. PlusD is a collection of US diplomatic traffic from 1966 to 2010 (the majority of the documents are from 1973–1977 and from 2000–2010). We searched on the words poet and poem and then kept and lightly edited the more interesting entries (removing State Department abbreviations, sometimes combining sentences for clarity, etc.). These edited entries are only a fraction of the several hundred instances of poets and poems in the diplomatic cables. In this version, we include only non-US poets, with the exception of one entry on an Amiri Baraka reading in Italy. They are sorted roughly by date, moving forward in time.

The Electric Blanket Is Tested By "Maggie"

THE delightful creature in the bed is "Maggie," the engineer's solution to General Electric's search for a substitute for a human being to conduct continuous tests on the automatic electric blanket developed by G.E. to keep its users warm whatever the temperature. Stuffed with straw, "Maggie's" underwear contains insulated copper wires which give off heat approximating the human body's normal temperature.

219

Lu Pingyuan

The Artist Made of Paper

Little Kiki was at summer camp in the mountains. One day, the teacher took the children outdoors to fold origami, and Kiki folded a little paper man. When the teacher asked her who it was supposed to be, Kiki replied, 'It's an artist.'

The sky had grown dark, another day of fun had come to an end. It was time to return to the mountain lodge for a rest. But when they arrived back at camp and Kiki felt around inside her pockets for the little paper man, she found that he had disappeared. The next day the children were meant to turn in their work to the teacher. What was she to do? Kiki snuck out of the lodge all alone and went in search of the little man.

Episode 2

She looked around the spot where they had gone to fold that day, but he was not there. Kiki had no choice but to head back. The mountains were already in complete darkness; there was no moon that night. Though there was a path, it was difficult to follow.

Suddenly, Kiki saw the lights of a house in the distance. She walked to it, hoping to find an adult inside who could accompany her back to camp. But when she peered into the window, she saw that only a single candle was lit. She felt strange and did not want to go inside anymore. She turned to leave. Just then, a man made out of paper a little over a metre tall appeared at the door. He laughed and exclaimed, 'You've arrived! It's me, the artist you were looking for! Don't you want to come in and see my paintings?' Kiki explained that she couldn't. She had to hurry back because the teachers would be looking for her. The paper man's expression turned suddenly ferocious. He dragged Kiki by the arm into the house. 'My paintings are very good! Why won't you look? Do you not believe I can paint? You must come in!' The paper man's hair was made of a few meagre strips of paper. His face had crumpled so much in his anger that it was completely deformed. He was terrifying. Kiki had no choice but to be taken inside to look.

The entire house was wrapped in paper. Kiki's feet made rustling sounds as she stepped across the paper floors. Several large paintings hung on the walls, their canvases full of creases and wrinkles. They were all portraits of the paper man's deformed face. In the centre, he had also placed a sculpture. It was an abstract form reminiscent of an airplane, with bamboo laid across it.

'What do you think of my work?' the paper man asked. Kiki admitted she did not understand what the heck it was about. The paper man pointed to the airplane-shaped sculpture. He insisted, 'This work is perfect!' He said he wanted her to sit on top of it. He grabbed Kiki by the arm and dragged her over to it. Kiki struggled to escape his grasp, and knocked over a candle. The room quickly caught fire. 'My work!' the man screamed in a panic, and surged into the fire to save it. Kiki seized the moment. She fled the house, sprinting in the direction of camp. The paper man, his entire body ablaze, rushed out after her, yelling, 'Kiki! Don't go!' But he had only run a few steps before his entire body crumbled to the ground, leaving only a pile of ashes.

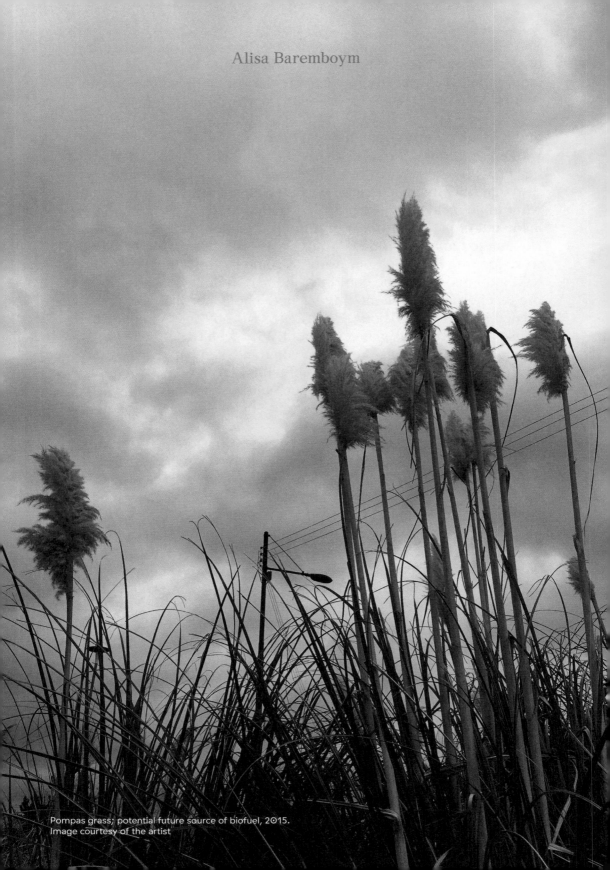

Alisa Baremboym

Pompas grass; potential future source of biofuel, 2015.
Image courtesy of the artist

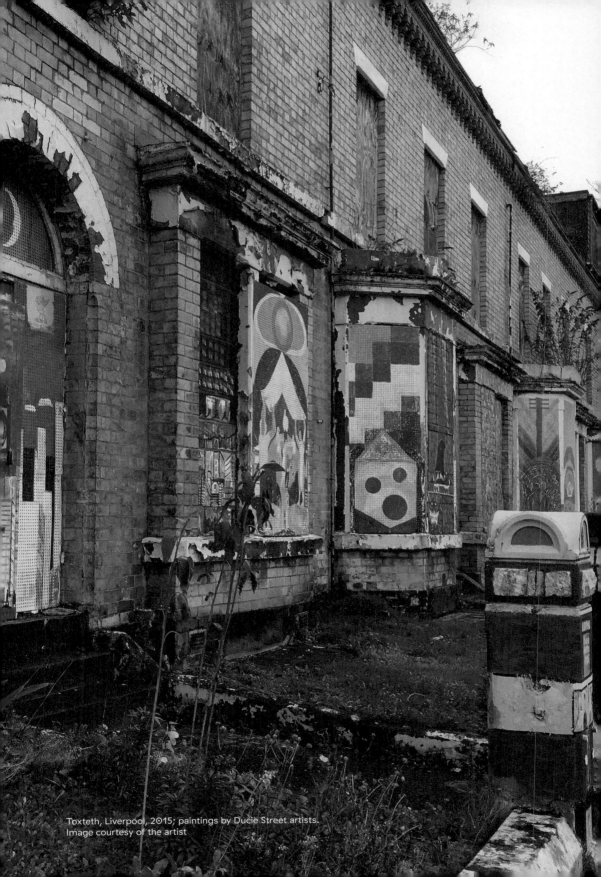

Toxteth, Liverpool, 2015; paintings by Ducie Street artists.
Image courtesy of the artist

CAConrad

(Soma)tic Poetry Rituals & Resulting Poems

Soma is an Indian-Iranian ritual drink made from pressing particular psychedelic and ener-
gising plants together. In Vedic and Zoroastrian traditions, the drink is identified with the
divine. The word 'Soma' is derived from the Sanskrit and Indo-European tongues meaning 'to
press and be newly born'. In English, 'Somatic' is derived from Greek and means the body. In
different medical disciplines it can signify different things, from a cell or tissue to the part of
the nervous system that controls sensations and movements. My idea for a (Soma)tic Poetry
investigates that seemingly endless space between body and spirit by using any possible thing
around or of the body to channel the body out and/or in towards the spirit with deliberate and
sustained concentration. (Soma)tic rituals create an 'extreme present' where the many facets
of everything around me, wherever I am, can come together through a sharper lens, revealing
their creative viability.

DENISE LEVERTOV vs. BRUCE LEE:
(Soma)tic Poetry Ritual & Resulting Poem
for Rae Armantrout

The poet Denise Levertov is buried in Lake View Cemetery in Seattle, Washington. For this
(Soma)tic poetry ritual I would first walk through Volunteer Park, which is next to the cem-
etery, one of the most beautiful urban parks I have ever had the pleasure to visit. Crows are
among my favourite kinds of people on Earth and there are thousands of them in Seattle, living
like pigeons do in other cities, and several in Volunteer Park knew I would feed them and
would follow me from tree to tree until I sat down in the grass. In animal spirit lore the crow
represents finding our higher authority, choosing a more enlightened direction for our lives.
After feeding the crows, I would take notes for the poem, then close my eyes to listen to the
world around me for a little while.

I would then walk into the cemetery, giving myself twenty-seven minutes after passing
through the gates to locate Levertov's headstone. If I did not find it, I would spend an hour
in front of the grave where I stood. Bruce Lee is also buried at Lake View and his dedicated
super fans would take the pilgrimage there. Throughout the afternoon, young men would whip
off their shirts to do martial arts moves in front of the headstone while their girlfriends made
videos with their phones, the boys' imitations of Lee's distinctive sounds echoing throughout
the cemetery. I am certain I am not the only one to have read a Levertov poem aloud with
Bruce Lee sound effects as the backup. I would read, 'He himself must be / the key, now, to the
next door, / the next terrors of freedom and joy.'

The best rituals are when the unexpected inserts itself. One day, while looking quietly
for Levertov, I noticed a young man watching me. He was dressed in black with thick black
eye-liner and nail polish. He wanted to know what I was doing, and admitted he had been
watching me. I asked why he was there and he told me he liked to masturbate behind a shrub
while watching the half-naked young men do karate. What shrub? I didn't see a shrub. He took

me to the shrub, which was nowhere near Bruce Lee, but of course we could hear the super fans making their warrior cries. We had sex every day from that point on, and it became part of my ritual and part of my notes for the poem. When I found Levertov, he wanted us to ejaculate on her grave, but I vehemently forbade it, stating that we should only consecrate a gravesite in that way if the poet would appreciate a shower of our semen, like Jack Spicer, John Wieners or some other faggot poet. I insisted that Levertov needed our tenderness and we kissed instead and held hands while I read the poem 'The Broken Sandal', where she says, 'Where was I going I can't go to now, unless hurting? / Where am I standing, if I'm / to stand still now?' The notes became a poem titled POEM AS STORM NOT AS REFUGE.

POEM AS STORM
NOT AS REFUGE

where is the
old druid who
loved me when my
tide slammed his door
statue of Kafka looking like
Judy Garland looking like me
life is about choices is what
assholes with the best choices say
take the voyage or crack beneath it
riots on TV with commercials of cars
making men inside them clench their
sphincters it all happens with signals through mist
cocks swinging to attention horny is not cynical they
promise glory keeping firm their
soft road to genocide
a black spot of map
capitalism and religion is
no place to stand between
my song flushed from ear to page
the old druid loved it through his guitar
furniture of future wastelands open to us
wondering is like falling all over the mind
kissing at edge of a landfill no thought of
death with his tongue in my mouth no fear to fence in
a sentence we tear holes in the wall to watch plants
grow
love one another enough for the missing parts
can you blame me became *you can blame me*
my cousin got me drunk to convince me to
repent something his pastor taught him
I told his daughter
when you're ready to
rebel against that bastard
here's my number
I will travel to you
no matter where you are

MY FAGGOT KANSAS BLOOD
CONFESSIONS TO THE EARTH
A (Soma)tic Poetry Ritual & Resulting Poem
for Anne Boyer

In a Kansas field I spent several hours burying my feet in the soil while listening to the insects, birds and cars on the highway beyond the trees. I was born on 1 January 1966 at the 838th Tactical Hospital, Forbes Air Force Base of Topeka Kansas. My mother said the doctor held me by my ankles and announced, 'ANOTHER FINE SOLDIER FOR JESUS!' And I say FUCK YOU to those first words said to me! My mother ate food grown on this land when I was inside her; we drank from the same aquifer, the sky was as big as it is today.

I took notes for the poem. I dug a hole and deposited shit, piss, vomit, blood, phlegm, hair, skin, fingernails, semen and tears, and in that order. I apologised for being alive.

I apologised for having no answers to how to stop the hyper-militarised racist police on the streets of America while the racist US military is on the streets of Arab nations. I apologised for paying taxes that purchase the bullets, bombs and drones. I apologised for not convincing my queer sisters and brothers that repealing 'Don't Ask Don't Tell' was only putting a sympathetic face on a multi-trillion dollar military industrial complex. I apologised for not finding a way to protect Chelsea Manning. I apologised for many things for a long while then covered the hole with my offerings and took more notes for my poem.

MY FAGGOT BLOOD
ON HIS FIST

the first time
someone sent
Homer through
the internet
 dot
dot dot
 we are all
 falling in
 love while
 standing in
 line for death
 fuck this way we
 slowly adjust to suffering
 an ant finding her way home in
 the downpour
 lovers are weapons subjugating your
 heart if you smell them years after they die
 if you feel
 destroyed
 let us talk
 do not
 turn it
 off yet
 we dreamed
 our obliteration for
 centuries then
 Hollywood said
This is what it will look like
Or maybe this Or maybe this
you think it's everyone's job to
make you feel good which
 is why we all hate you
the disgraced hairdresser
 pours us another shot
 we will figure
 it out my friend
 the ocean is
 never far
 when you feel
 your pulse

HALL OF THE DECOMMISSIONED PANTHEON
(Soma)tic Poetry Ritual for the Pulitzer Foundation's
Exhibition *Art of Its Own Making*
for Nicole Eisenman

The Mona Lisa was wrapped in fine red satin and sealed in a specially designed wooden box before being transported to the countryside in 1939. Art in the middle of war needs dedicated stewards to keep it hidden from invaders. Even with the most trusted well-trained curators and other staff a museum can fall prey to enemy gunfire, poison gas or drone attacks. You are in the museum alone at night and the staff's dead bodies are stacked in the basement. You have a chance to save one piece of art before the looting begins: what do you save? What are your criteria for choosing which to save: the most valuable, the most popular, your favourite, or what? Take notes.

(Soma)tic poetry rituals provide a window into the creative viability of everything around us, initiating an extreme present. Documentary notes are not important; in fact the movements we make inside the ritual inform the way the notes come out of us; no need for exacting detail. Take notes as fast as you can, faster than you can; think about what you are writing. Later, type the notes into a single document, print it out then carry it around to extract lines and words to shape your poem. Approach your chosen work of art, thinking about the safest way to remove it from its mount on the wall or floor. What tools do you imagine needing? Stop to take more notes. You will live with it hidden in your attic or as a lover under the covers next to you. How will it feel, seeing this coveted object each day? Take notes.

Create a password for your hidden art by first choosing an ancient god or goddess. What is your favourite home appliance? Think of the nights you turn them all on to sit and listen in the dark for the most pleasing one in the chorus. Combine a god and an appliance, like Jupiter Egg Beater. Take notes. Go into a stall in one of the museum restrooms and write the password onto your naked flesh. Take notes. Write it again harder, then harder. Take more notes. Walk up to a stranger and say the password. Just say it. How do they react? Take more notes.

(Aphrodite Microwave was my password. Nicole Eisenman's painting *Breakup* at the ICA in Philadelphia was my focus. How far are the doors from where it hangs? There is a subway entrance just outside the exit, but what if, and what if ... okay, then here we go: THIS WAY instead. The notes became a poem titled 'NOW THAT THE PRESENT IS SO ENDANGERED WE CAN STOP WORRYING ABOUT THE FUTURE'.)

Lara Favaretto archive, Merida, MX, 2014

NOW THAT THE PRESENT IS SO ENDANGERED WE CAN STOP WORRYING ABOUT THE FUTURE

my grandfather died of lung cancer before retiring from the DuPont
chemical factory if weakness is tender solicitous kisses I will be the
weakest in the room my grandmother died a year after retiring from the
flag factory I enjoy my life for them

> as a kid certain poems edified me to taste my
> lover all the way inside striking flint a rush
> when poetry penetrates the world to make
> us so much older than last night we used to
> get rid of it now we keep it as long as we can
> wake to pheasant nailed to the boards it's
> going to injure itself one day while I dirty
> the house with poetry our delicious animal
> smells made in the room carry leftovers out
> in pockets

I am a poet for those dead before they die
if strength is cruelty apathy and murder I
will collapse with another like me to suf-
fer with flowers my aunt died of alcohol
six months after retiring from the dental
floss factory listen to garden in my head
venerate arc of the arrow flying back
with a season of wonderland visions a
noble cause to rid ourselves of worry to
wake and kill them all my uncle died a
year after retiring from the coffin factory
when you dial 911 you know it will change
everything the burden and strength of
poetry is in the fractures unsure if light
on wall is moonlight imposter of the sun
a curse upon all men who enslave others

> when they became
> afraid of the thing they
> created to scare us it
> was clear we needed to
> be concerned

Poems selected by Jason Dodge / Fivehundred places

Jason Dodge

tête brulée pomme
Kellogg's petit

Mai May Mei						
L	M	M	J	V	S	D
				1	2	3
4	5	6	7	8	9	10
11	12	13	14	15	16	17
18	19	20	21	22	23	24
25	26	27	28	29	30	31

MARDI
TUESDAY - DINSDAG
12
MAI
MAY - MEI

Juin June Juni						
L	M	M	J	V	S	D
1	2	3	4	5	6	7
8	9	10	11	12	13	14
15	16	17	18	19	20	21
22	23	24	25	26	27	28
29	30					

132-233 / S.W. 20
2015

☀ 4 h 15 / 19 h 20 Sᵗ ACHILLE ☽ 18

Ricoré
Petit déj. Lu
ouate demaquillante
dentifrice crystal
Rouleau scottex
 Pain
Parmesan
Cadenas.

8 Yaourt nature.
9 salami
10 Jambon
11 gruyère
12 parmesan.
13
14
15 Cordon bleu
16 Wiskas
17 Nojits.
18
19
20

GOD DAMN YOU ALL TO HELL

Like every artist in the Biennial I am doing several
projects at once. Today I am writing a love letter from
the Adelphi Hotel while sitting in a cafe in Porto and drawing
story boards of what looks like nineteenth-century battles.
My children are boarding the number 79 bus to school.
Their bus is a space bus that transmits the future.
At the same moment, my parents are meeting for the
first time, at University or shipping docks perhaps.
Everything is happening simultaneously, including
the sunrise and sunset on the same horizon.

Episode 3

In *Planet of the Apes* (1968), the first episode in its series, this is the last line. Astronaut Taylor (Charlton Heston) is on his knees on a lonely beach, pounding the sand with his fists. He realises [spoiler alert] that he is not, as he imagined, a traveller through space, but instead he is a time-traveller. The ruin of a monument, the Statue of Liberty (gifted to the US by France in 1886, now a symbol of immigration) reveals that Taylor has landed on a post-apocalyptic Earth populated by post-human apes. Meeting a monument is always like this; it is a thing from another time, an event, an irruption (a *caesura* which, in the language of poetics, is a white space or gap in the line) that breaks through the habitual narrative of continuous time. In films and novels, it can be a flashback, or a recurring image (think of Kenneth McPherson's *Borderline* lingering on Paul Robeson's black skin, his otherworldly body shaping narrative time). To simply stand before a monument is itself a kind of time travel – to the past, typically. But what would be a monument from the future? In 2016, the scientist Dr. Zira, Taylor's closest ape-friend, will have travelled (to employ the future perfect: συντελεσμένος μέλλων) back to our time.

Planet of the Apes premiered on February 8, 1968, but it was released in US theatres on April 3, the same day Stanley Kubrick's *2001: A Space Odyssey* opened. Both films immure the history of man's species within monumentalised eras. In *2001*'s episode 'The Dawn of Man', pre-human apes encounter the 'monolith', a monument made smooth by the technology of a future race or species. Evolution begins at that moment – the history of the post-ape humans begins. Flash-forward, the same monolith (or a member of the same species of monoliths) appears in 2001 – a year in the future (but now in the past) and is, in our universe, now known for the destruction of other highly symbolic monuments, namely New York's World Trade Center. One day after *2001* and *Planet of the Apes* was released in cinemas across the US, on April 4, 1968, Dr Martin Luther King was assassinated. His killing triggered the so-called 'Holy Week Uprising' across 100 American cities, the most explosive phase of racial unrest in the country's history. *Planet of the Apes* – a film in which white Americans have been conquered and enslaved by post-human apes – was perceived, even at the time, as responding to the heated Civil Rights debates of the 1960s. One year later, on July 20, 1969, Apollo 11 made the first human landing on the moon, a desolate, unpeopled landscape.

The stories of human civilisation, and the razing and the racing of monuments (think of the debate over Rhodes' statue in Oxford, the

destruction and reconstruction of Palmyra) require us to think in linear and non-linear time: of ruin and commemoration as two sides of the same coin. Writing in 1957, Afro-Caribbean philosopher and revolutionary Frantz Fanon wrote about the levelling of the African civilisation for the benefit of the European imagination: 'The white man was wrong, I was not primitive, not even a half-man, I belonged to a race that had already been working in gold and silver two thousand years ago.' He quotes the Martiniquan poet Aimé Césaire: 'Monuments in the very heart of Africa? Schools? Hospitals? Not a single good burgher of the twentieth century, no Durand, no Smith, no Brown even suspects that such things existed in Africa before the Europeans came...' In the moment of its making, the monument enshrines itself in the fantasy of loss: the language of ruin. But how do we envision the ruins of what has not yet been built?

And so to Episode 3 in which time-travel enables us to suffer one world while living another.

EXIT
Fighting Evangelist

Saturday, July 9, 2016

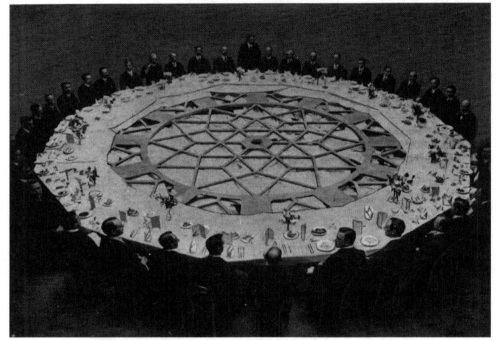

LUNCHING ROUND ONE OF THE 25FT DIALS OF THE CLOCK
FOR THE ROYAL LIVER BUILDING, PIER HEAD, LIVERPOOL, 1906

MORNING LIGHT, July 9th, 1856.—Slept like a top until near 6 A.M. Soon afterwards on deck.

8 A.M. Breakfast, meat served in abundance hot rolls not half baked and very dirty. In the one that fell to my share I found a piece of sail or something like it. Splendid view of ships in full sail and some in the same position as our own obligued to be tugged by steamers.

12 A.M. Move the faster with a favourable breeze the Captian now (7) determines to dismiss the pilot. In a few minutes the Morning Light is for the first time in full sail and the bravely goes ahead without any assistance and seems delighted at being left to herself. In the meantime the steamer keeps up with her until the pilot is ready to return by her to Liverpool.

I hasten to write a few lines to Aunt Mary but in the hurry & confusion of the moment misdate it.

5 P.M. Many of the passengers begin to feel the effects of the dolly-tub motion of the ship, looking so wise at each other and occasionally putting the charitable question 'how do you feel' at all sick? Some there are who unmistakably answer by at once exhibiting the quantity and quality of their recent dining spreading it in a most unceremonious manner on the deck before all present, as for myself I feel rather shy not knowing how soon I shall join in their beautiful programme as I already feel rather seedy.

7 P.M. Tea, meat is served at every meal.

10.30 P.M. Return to my cradle either to be rocked to sleep or kept awake.

Episode 3

...amily as
...th tax
...l couples

alcohol before." His task force also wants cannabis upgraded to a class B drug and heroin users encouraged to go "cold turkey" rather than be treated with substitutes such as methadone.

The report will claim that the Government's drug policies have become part of the problem and call for an end to "non-judgmental, politically correct and scientifically inadequate" school programmes. In its interim Breakdown Britain report last year, the group gave warning that severe debt, drug addiction and the breakdown of the family were creating a growing underclass.

In the meantime, Mr Cameron faced criticism over his calls for a referendum on the proposed EU reform treaty from two Tory grandees. Kenneth Clarke, the former Chancellor, said that referendum demands had "an inner absurdity" and argued that moving away from Euroscepticism would boost Tory electability.

Speaking on the GMTV *Sunday Programme*, the strongly pro-European Mr Clarke said: "One thing that will make a Conservative Party electable ... will be if we continue to dilute this absurd, extreme Euroscepticism that swept over the party in the last ten years."

Lord Hurd of Westwell, a former Foreign Secretary, credited Mr Cameron with "draining the poison" from the issue, but said that a referendum was unjustified.

Lord Hurd told GMTV that referendums should be reserved for "the most extraordinary earthquakes which are proposed", adding: "I don't think there is anything in this treaty, insofar as we can see it now, which actually justifies that."

Less than half
of teachers have
degree in subject

Alexandra Frean Education Editor

Less than half of primary school teachers have two good A levels, while only 41 per cent of secondary teachers have a degree in the subject they teach, according to a report claiming that the profession is in crisis.

There has been a big increase in teacher numbers in recent years, after a shortage in the mid-1990s. But the report from the think-tank Politeia says government policies focus too much on increasing numbers with too little regard for quality. It notes there there are two non-teaching members of staff for every three teachers. There are now 150,000 teaching assistants, while the number of unqualified teachers working in schools has increased significantly in the past decade.

Bob Moon, Professor of Education at the Open University and co-author of the report, said: "The assessment system allows even the weakest candidates through."

The Training and Development Agency for Schools, the Government's teacher training agency, rejected many of the findings, insisting that standards had never been higher.

9

JUL

9

Des Campbell, a former policeman, relaxes at a luxury hotel

Police charm
five-star hol
killed ugly w

David Brown

A former British police officer accused of duping a string of divorcees and widows out of their money is being investigated over the death of his third wife.

Des Campbell, 48, claimed that his wife had accidentally fallen down a cliff while on a camping trip at an Australian beauty spot. But an inquest into Janet Campbell's death was halted last week after her friends and family claimed that she had been killed for her money.

Several of Mr Campbell's exgirlfriends, including a former colleague at Surrey Police, accused him of preying on rich and vulnerable women, describing him as a "manipulative" and "charming" schemer.

Mr Campbell had been married to his third wife for six months when he persuaded her to go camping in the Royal National Park, south of Sydney, in March 2005. He claimed that she had left the tent, pitched five metres from a 40-metre-high cliff, in the middle of the night to go "for a pee" and had fallen over the edge. He told police that he had heard his wife sigh and "thought she was playing a game of hiding with me". He had found her body at the bottom of the cliff.

The inquest at Glebe Coroner's Court in Sydney was told that as Mrs Campbell's family and friends were attempting to come to terms with her death, he was busy making plans for his future. On the first business day after his wife's death he asked an estate agent to sell the couple's A$600,000 (£250,000) home quickly, saying he had to "get away". On the same day he booked a luxury holiday, telling the travel agent he wanted "only the best" for his wife. A week later he was photographed with his

girlfriend, Goricia Velic... star resort near the Gre...

Ms Velicanski told t... she had planned to m... Campbell and had no id... ried. They had met v... dating site and had ... from December 2003 ... Mr Campbell was also ... with Lynda Rogers, wh... that he had promised t... cruise to celebrate her ... she lost 50lb. She turn... after Mrs Campbell die...

Two months after h... Mr Campbell dumped ... withdrew $70,000 from ... had opened with his wi... to the Philippines to ... woman he had met o... Melissa Campbell, a fo... singer, became his f... January last year.

Mr Campbell had e... his family to Australia ... he had returned to Brit... 1990s to join the police ... in Surrey he had an aff... ried colleague, June Ing... lationship ended whe... after a complaint was ... him by a woman he had... vestigating an allegatio... violence, and he left Br...

Ms Ingram said that ... contacted her again aft... in 2001 and proposed ... phone. But when she ... Australia he was enrag... she had received only ... divorce settlement. On... arrived he allegedly scr... "You f***ing bitch, yo... were going to get mo... morning Mr Campbell ... airport, dumped her bel... pavement and drove o...

ning
erbug

...ke action to reduce or control ...addition only one microbiologist, ...ng four hours a week, was ...yed to monitor infections at the ...which serves a catchment of ...000 people. There was also no ...fied budget for training staff in ...ion control and attendance at ...raining was not monitored. Clini... ...aff were found to be "confused" ...isolation policies, indicating ...hey are not always adhered to. ...commission said in a statement. ...use the trust does not conduct ...sis to determine the cause of ...ion on all patients confirmed to ...MRSA, it is difficult for the trust ...mbor and learn from outbreaks ...ncidents. ...as now been given deadlines to

20

...hdog inspections being
...d out in England and Wales

...sy issues raised by the com...
...on with the local strategic health
...rity overseeing the work.
...na Walker, chief executive of the
...hcare Commission, said: "I hope
...ends out a strong message to all
...that we will not hesitate to use
...owers when it comes to enforc...
...e Hygiene Code".
...hard Harrison, medical director
...met and Chase Farm Trust, said
...ssues against infection control
...the national picture, but with
...star £500,000 investment in
...ing the wards, screening patients
...admission and our prudent
...otic policy, the trust is winning
...attle against hospital-acquired
...ons. The trust reported 74 now
...f C difficile in April and only 16
...n June."

guards to
m violence

...that more than 75,000 health
...rs were attacked physically by
...ts, carers or their relatives last
...There are fears that many more
...nts go unreported, however.
...e introduction of 24-hour licens...
...ws and a rise in binge drinking
...made alcohol and drug-related
...ks more common in accident and
...gency wards, he added.
...is not good enough to assume
...hese attacks will happen and kit
...le out with stab-proof vests," Dr
...r said. "This should not be tolerat...
...nd more needs to be done to pre...
...assaults and abuse against staff.
...e need to see properly trained se...
...y staff at all inner-city A&E de...
...nents that have a history of vio...
...and in those trusts that handle a
...number of mental health
...nts. Nightclubs, pubs and other
...ntial troublespots have them, and
...hould be doing more to protect
...h service staff — who are also at
...from the consequences of alcohol
...drug abuse."
...e NHS Security Management Ser...
...said that prosecutions of people
...attacked NHS staff rose from 51
...003 to 850 last year.

Clockwise from top: British hopeful David Millar turns on the power as he passe... peloton snakes its way through Kent; crowds cheer the pack as riders pass thro... and fans try to capture the excitement from the roadside. Below, the breakawa...

The lingo

Peloton The French name for the main pack, herd or bunch of riders

Bonk What happens when a rider doesn't eat or drink enough and faints

Honking Rising out of the saddle while climbing a steep gradient

Lanterne Rouge The booby prize that goes to the last man in the race

Ride a train A line of riders who carry their sprinter in their slipstream, peeling off one after another until the sprinter is able to speed off towards the finish line

Domestique Another word for servant — someone prepared to sacrifice their chances of success to help a stronger team-mate win the race if the opportunity arises

Dreaming on a life on ocean wave

Monday July 9.—We have passed through a extremely rough night, our box containing our provisions at the head of the berth, fell over during the night, although, I had lashed it fast as I thought, with a crash throwing sugar, butter, meal, rice, broken bottles, etc. which took me about an hour to set them right again as well as I were able.

Mrs H. an d children never got up today it w a s with great difficulty I could get to the galley for hot water green sea swept over the decks and we had a great number of the passengers kept their beds as it is not fit to be up on the decks being at times in an angle of 45 degrees, the yards and bulwarks sometimes under water. I hope we shall not have another day like today, we are only making two knots and that the wrong way, under close reefed top sails.

Towards dusk I crept quietly to bed being tired and weary no dought dreaming on a life on ocean wave, a home on the rolling deep.

Hodkinson 1860

9

J
U
L

9

Friday July 9.

Fed up – fed up – fed up!
Hopelessly and utterly fed up!
In mind, soul and spirit
though in the body not feeling
quite so satiated. They are giving
us too much for our money and
say we shall not land till the end
of next week. I feel like Auntie
Belle always did – when I once more
put my feet on terra firma it will
take a good bit to persuade me to
a sea voyage again.

DIN

Beschädigter Text

Coco Fusco

Excerpt from
Observations of Predation in Humans: A Lecture by Dr Zira, Animal Psychologist

The following is an excerpt from a lecture by the eminent scientist Dr Zira, ape society's foremost animal psychologist, and the author of several groundbreaking studies of the behaviour and brain activity in humans. It is introduced by Donna Haraway.

When Dr Zira was confronted with the unimaginable – a human being with sufficient frontal-lobe brain function to produce speech – she remained steadfast in her commitment to scientific inquiry despite vehement political opposition from her fellow apes. Eventually, her findings would lead her to risk travelling back in time in a human spacecraft in order to gain greater access to data that could shed light on primate evolution. Dr Zira's important contributions to universal knowledge, though fascinating to some human psychologists of the Reagan Era, were not readily accepted by human society when she arrived on Earth during the 1990s. Fearing the prospect of a future in which humans would be dominated by other hominoids, George Bush the elder's national security team created a covert domestic mission to assassinate Dr Zira and her husband Cornelius, together with their infant son.

Dr Zira not only succeeded in saving her son, but also managed to fool her attackers into believing she was dead. Living in seclusion in a cabin in a remote area of the mid-west, she continued her observation of human behaviour via internet and television. Only in the last year, when a group of human scientists put forth the Cambridge Declaration acknowledging that non-human animals have consciousness, has Dr Zira begun to believe it is safe for her to engage once again with human beings.

p. 245—48
Coco Fusco, *Observations of Predation in Humans: A Lecture by Dr. Zira, Animal Psychologist*, performance at The Studio Museum in Harlem, 2013

p.239
Coco Fusco as Dr Zira. Photo by Gene Pittman, courtesy of the Walker Art Center, Minneapolis

The Lawgiver of my kind warned apes that human population growth would lead to the destruction of everything else in nature, including us. Is that a philosophy driven by fear or by facts? When I was working in my laboratory at home, it did not make sense to me that we should be frightened of those hominoids that we believed to be inferior – which is to say, members of the homo genus. I suppose that is why I wanted to look into your brains a bit more.

The atrophied parietal lobes I discovered in various brain surgeries conducted on human specimens made me suspicious. Dr Zaius insisted that human beings were physiologically incapable of speaking, but the autopsies I ordered on the human corpses in my lab revealed that they did have the lowered larynxes needed to produce speech. So then I wanted to find the cause of what appeared to be some kind of generalised aphasia in only one hominoid group. And why did my kind prohibit its members from recognising that humans were not the evolutionary throwback of the hominoid family? When my late husband Cornelius and I tried to bring our shared evolutionary path with humans to light, we were punished and banished.

Cornelius' excavation site in the Forbidden Zone, which was filled with vital evidence of prehistoric human beings' many abilities – including their speech capacity – was destroyed.

And then my laboratory was shut down. And yet even after all that, we felt driven to find out more – thanks largely to our having met Taylor. He was our missing link – I know that's an awful term, but I think you know what I mean.

Now, since I am the only primate of my kind here, I can declare openly that those Sacred Scrolls are wrong about Man.

Man should not have been singled out as a beast. And the Lawgiver should not have spoken of Man as if your species had no women! Humans are a keystone species among hominoids, but your ability to kill is not what causes you to have a disproportionately large effect on Terra. I know that humans are not the only primates who kill their own – regardless of what was written in the Sacred Scrolls. Those nature documentaries on your television are full of images showing that humans are not alone in killing each other.

I have to say that I find these sorts of moving images about non-human animals to be quite exploitative, even pornographic. But when I regain my composure, I am able to consider what it means for humans to go to such great lengths to demonstrate to themselves that all other animals in the world fight over mates and territory. The limited focus on aggression does not yield a balanced view of animal life. Food gathering may entail the killing of prey, and boundaries will

be defended by those who can, but it is misleading for human beings to treat other animals' aggression as if it were constant and uncontrollable. So do non-human animals serve as foils or mirrors for humans? Let's think about that for a moment.

I can't help but notice that humans' daytime television dramas revolve around mate-related conflict and that human news is rife with reports on civil wars and border disputes.

Before we jump to conclusions about shared behaviours among primates, we must give consideration in our observations to the scale of human aggression.

Other hominoids may band together to attack an intruder, but Great Apes have not been known to engage in any activity that would be comparable to humans sitting on one side of the planet and orchestrating the deadly bombing of members of their species on the other.

I would like to believe that because chimps behave in such a bellicose manner in this stage of life on Terra, we ultimately adopted pacifism in mine not only as a sign of our evolution but also as a form of atonement. That is my way of dealing with the darker side of the chimp in me – a side that came in handy when I needed to dig deep into the recesses of my genetic memory to recall how my ancestors found food in the forest. Humans' fascination with displays of physical aggression in non-human animals suggests to me that your species is wrestling with anxieties about its own practices of aggression.

Ultimately, looking at physical violence does not strengthen the connection between the anterior cingulate cortex and the amygdala. Brain studies show that this connection is key for self-regulation of aggressive behaviour. The amygdala is the emotional centre of the brain, a critical region for the animation of fear. What the spectacle of violence does is to divert our attention away from the non-physical forms of aggression that are peculiar to humans.

You might draw the conclusion at this point that I have adopted the approach of a psychoanalyst since beginning to live in a world dominated by the human species. It is true that I modified my methods for studying human behaviour after I began to live among you. When I was in Ape City, caging your kind and burrowing into your brains provided me with all the answers to the questions I was allowed to consider.

Ethological study, which is to say, the study of animals in their own environment, has made me more aware that tactics, targets and scale – which are the defining aspects of human aggression – only become intelligible outside the lab.

Of course, I may marvel at the views of your brains afforded by Magnetic Resonance Imaging technology, but I must study your complex thoughts and symbolic communication to ascertain why humans without physiological abnormalities turn to predatory behaviours with increasing frequency. Only then can we grasp the underlying causes of what appears to be a diminution among humans of the altruistic expressions of sociality that manifest in other hominoids.

Adolescent Humans Surrendering to Forced Socia

Scarlet Johansson is entering the room again, as a voiceover on a film that we are watching together on the aeroplane. Our screens are out of sync, so I can't help seeing what happens in the near future, and you keep seeing the past. 'You don't have to be history to repeat yourself two or three times', I tell her.

In this dream you pass me a book in which I am supposed to be a forest that is also a hermaphrodite narrator. You say, 'You are San San, the red cranes from China carrying algorithms.' 'OK', I say and open the first page. It is probably page seventeen or 90 something, one of those numbers that pop up whenever one grabs a certain book for the first time and then keep coming back to whenever one opens it again, following the first crease of the book's spine. 'Can you see a transversal recasting here?', you ask.

When we open page seventeen again we find another conversation there. – Is that what you've meant by transversal recasting?

Alisa Baremboym

Top: *Caloescent Impression*, 2016, ceramic, sheet steel, acrylic, vinyl, 92.7 × 40.6 × 11.4cm.
Photo by Joerg Lohse. Image courtesy of the artist and 47 Canal, New York

Right: Skin tone chart at the University of Liverpool, for testing perceptual skin colour and
its application on 3D printed prosthesis, 2015. Image courtesy of the artist

cut

1 2 3 4 5 6 7 8 9 10

1 2 3 4 5

6 7 8 9 10

18 17 12 13 14 15 16

27 37 26 25 24 19 20 21 22 23

38 37 36 35 34 29 32 31 30 33

48 47 46 45 44 39 40 41 42 43

58 57 56 55 54 29 50 51 52 53

67 66 65 64 59 60 61 62 63

76 75 74 73 68 69 70 71 72

83 82 81 27 78 79 80

90 89 88 84 85 86 87

96 95 94 91 92 93

101 100 99 97 98

106 105 104 103 102

110 109 108 107

Red yellow

Denise Ferreira da Silva

The Racial Event or That Which Happens Without Time

'We might well ask if this phenomenon of marking and branding actually "transfers" from one generation to another, finding its various symbolic substitutions in an efficacy of meanings that repeat the initiating moments?'
– Hortense Spillers[1]

'I have not come here to be insulted by a set of wretches, of which every brick in your infernal town is cemented with an African's blood'
– George Frederick Cooke, late 1700s/early 1800s[2]

'It's not that what is past casts its light on what is present, or what is present its light on what is past; rather, image is that wherein what has been comes together in a flash with the now to form a constellation. In other words, image is dialectics at a standstill. For while the relation of the present to the past is a purely temporal, continuous one, the relation of what-has-been to the now is dialectical: is not progression but image, suddenly emergent. – Only dialectical images are genuine images (that is, not archaic); and the place where one encounters them is language.'
– Walter Benjamin[3]

Four ships left the Port of Liverpool one summer day in 1769. Among them was the *Unity*, one of the 100 or so slave ships responsible for the 1.5 million people transported by Liverpool merchants during Britain's legal slave trade. Nearly a year later, while the Unity navigated the bottom line of the Triangular Trade in June 1770, the ship's log registered several attempted insurrections by the 435 captives on board. Just over 200 years later, in July 1981, Toxteth's residents revolted after Liverpool police arrested a 'young Black man', and the neighbourhood would burn again in 2011, when London police killed an unarmed Black man, Mark Duggan, in Tottenham, North London.[4] In this experiment, I read these insurrections as iterations of the racial event. My proposition is that they expose how racial violence is *sine qua non* for global capital, that is, a condition of possibility for capital accumulation under the hegemonic form of financial capital.

Toxteth Riots, Liverpool 1981. Images owned by Liverpool 8 Law Centre. Courtesy of Sonia Bassey/Toxteth Riots 30 Years On Project and Museum of Liverpool

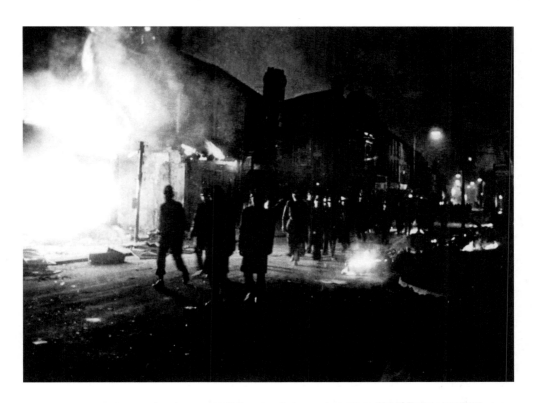

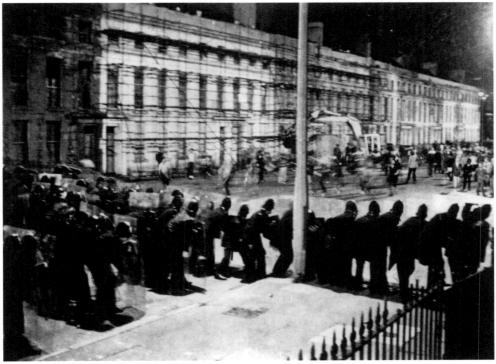

My motive for this exercise is a recent move in contemporary European philosophy's recuperation of a communist project (in the politics of the commons, in particular), which reduces racial and cultural difference to a neoliberal ideological tool. In this return to universalism, I find the same kind of (liberal) thinking that justifies the episodes of total violence necessary for global capital to reproduce itself through the expropriation of the productive capacity of the lands and labour of Europe's racial Others.[5]

Take, for instance, Alain Badiou's recent comments on police brutality against Black persons in the United States and Islamophobia in France, both of which he reads as a leftover of the colonial past.[6] When commenting on police killings, he finds a similarity between these countries: 'there is a racist dimension in the action of the police' in the US and France, which he resolves through a spatiotemporal distinction. He writes: 'in the United States the problem goes back a longer time, to slavery – it is a structural problem which is part of the entire history of the country since its beginning'. He quickly resolves this by displacing US racism to another time: 'On the one hand, we can interpret the police killing taking place under a president who is Black as the expression of a fundamental racism against Black people. On the other hand, it is not the case, Obama's election points to a different reality.' When considered in light of Badiou's defense of universalism against cultural difference,[7] it is evident that what he calls 'fundamental racism' has to be categorically denied (restored to *back then*). This is so because his version of universalism, which sustains his communist thesis, is contingent upon the fidelity to the event – in this case Obama's election, which signalled the end of racism in the United States. Thus Badiou deploys time and space to establish a distinction that places racism *over there* (relevant in the US because of slavery) and *back then* (slavery is irrelevant after Obama's election). Operative

Flaming tyre, Liverpool 2011. Photo courtesy of Matthew J. Wright

Episode 3

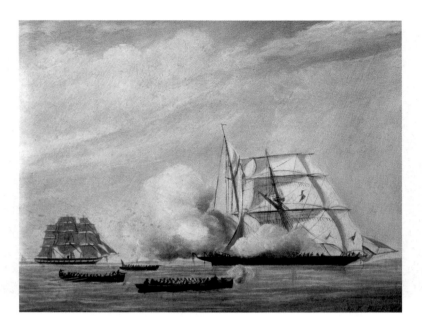

L. Burke, Boarding a Slaver, 'Nightingale', 1864, oil on board, 16 × 27.5 cm. Image courtesy of Merseyside Maritime Museum

in this distinction is a prevailing kind of temporal thinking that arose in Europe around the same time as capital – a kind of thinking that functions through the imposition of separation between what happens in the past, present and future – that is, by reading the elements in any given situation as related sequentially. Temporal (sequential) thinking accounts for a historical materialist disavowal of the significance of the colonial juridic-economic architectures (such as conquest, settlement and slavery), of which the racial is a referent, to capitalism. Time is not the appropriate dimension for 'observing' the racial event, for it requires a release from the onto-epistemological constraints of modern thinking, in which racial (and its twin, cultural) difference is a mere referent of another time and another place.

In this experiment, I deploy a materialist approach that shifts from the historical to the global register. By displacing temporal thinking, which imposes and necessitates the presumption of separability, I move to read *back then* and *over there* as constitutive of what happens *right now* and *right here* and *what is yet to happen*. This experiment with a practice (form) of materialist reading, which I call compositional thinking or imaging,[8] heeds both Spillers' and Cooke's statements that the marks of torture in the slave body transfer to later generations and that Liverpool was built with African blood. My raw materialist perspective takes the elements of any episode of racial violence as prime matter for thinking. It reads *what happens* as always a composition (or de-composition or re-composition), always already a moment that is a singular assembling of that which also constitutes *what has happened* and *what is yet to happen*. Materiality here refers to matter at the quantum level: that which enters in the composition of everything that exists always as matter/energy. Thinking at this level of entanglement demands that we abandon (or de-centre) time

Left: **British School,
John Earle** (1674—1749),
1710—20, oil on canvas,
76 × 63.5 cm. Image
courtesy of the Walker
Art Gallery

Right: **British School,
Thomas Golightly** (1732—
1821), 1800—21,
oil on canvas, 89 × 69.2 cm.
Image courtesy of the
Walker Art Gallery

(Einstein's fourth dimension) conceived as the arrow of time, which accounts so much for the prevalence of sequential thinking. Borrowing from Walter Benjamin, I describe the moment of occurrence (distinguished from the site of occurrence) always already as a composition, and necessarily (because composed of the same particles) *similar* to other *possible* compositions (what has happened and is yet to happen). When attending to the similar, one necessarily looks for symmetry, that is, for correspondences. By attending to symmetry – or looking for similarities, it is possible to image (re-compose) the context under observation as a fractal figure. That is, instead of looking for causal (linear) connection, compositional thinking seeks to identify patterns that repeat at different scales.

How does it work? Let me begin by collecting the pieces, first from a 2011 BBC News interview with a Liverpool police officer deployed to contain the July 1981 revolts in Toxteth:

> 'There was a hardcore of people who wanted to kill a police officer,' said Mr Potts.
> 'I just remember three or four times during that night thinking, "This is it, I'm not getting out of here."'
> 'A couple of older officers came up to me and said "A bobby's been killed, somebody's had their leg chopped off, somebody's been decapitated with a spade."'
> 'It was a frightening situation before we even started.'
> 'The sergeants tried their best with their own men but very soon it just became complete chaos,' he said.
> 'The good thing (now) is no police officer will ever be put in the position where they can get injured so badly.'
> 'It was the turning point where police tactics changed.'[9]

Second, from Captain Norris's recording of the attempted uprisings on board the *Unity*:

> The slaves attempted to force up the gratings in the Night with a design to murder the whites or drown themselves, but were prevented by the watch. In the morning they confessed their intention and the women as well as the men were determined if disappointed of cutting of the whites, to jump overboard but in case of being prevented by their irons were resolved as their last resource to burn the ship. Their obstinacy put me under the Necessity of shooting the Ring Leader.[10]

How to read these episodes that happened 200 years apart? First, I need to select the similar pieces:

- Liverpool is the home of both the Toxteth neighbourhood and the ship *Unity*.
- Both episodes occurred in response to circumstances of total violence (enslaving and killing).
- Both excerpts describe the situation as one in which the white persons involved (the ones responsible for total violence) are in a life-threatening situation.
- Like every Black insurrection registered during and after slavery, these insurrections responded to a circumstance of total violence perpetrated by those with immediate economic or juridic (and many times both) involvement in their oppressive situation.

Reading for correspondences, I find that Captain Norris had an economic investment and the same juridic control (right to kill) over his cargo as Liverpool police had over the unemployed Black youth in Toxteth. Looking closely at the juridic power of Norris and the police, I find that, in spite of the temporal (1770 and 1981) and spatial (Atlantic Ocean and Liverpool) distance, both have the same function: as Captain and slaveholder, Norris functioned as a law enforcer (police) for the slave trade (on behalf of merchants), while the police officers in Liverpool enforce the law for capital (on behalf of Liverpool shop owners) – that is, both do something that is vital for capital from the outset: they are protecting property. In my reading, these spatio-temporally isolated episodes are entangled. They become iterations of the racial event, each exemplifying how racial violence protects property, the juridic-economic relationship that joins (the hip shared by) State Capital.[11] Though capital has shape-shifted over the past 500 years or so, the ethical *force* of property – that which authorises total violence in both cases – has remained fundamentally the same. For Global Financial Capital deploys the juridic-economic architectures that sustained Merchant Capital (the Triangular Trade that Liverpool led for decades) and Industrial Capital (the textile factories processed cotton planted and picked by the slaves transported by the Merchants' ships, like the *Unity*). These achitectures assured the

expropriation of the productive capacity of native (colonised/settled) lands and slave labour and constitute the matter (life and blood) of Global Capital.

The racial event is necessarily without time because of how racial difference refigures the colonial by comprehending the native and the slave, as a Scientific (biological) tool that writes their mental (moral and intellectual) traits outside of History.[12] Traditionally, critical racial thinking's response (through a socio-historical approach) to this effect of the racial has been to present racial matters in terms of the connections between *back then* and *right now* (or between *over there* and *right here*). It does not work: knowing that Liverpool merchants' profits from the slave trade enabled the emergence of modern banking in Britain in the seventeenth century does not expose how the racial links these profits and Black insurrections in today's Liverpool; that is, how the economic dispossession and policing animating them is part of the same assemblage that is Global Capital. For that to be thinkable we need to be able to imagine what happens without time.

Similarly, historical materialism fails to apprehend the racial because, in the historical stage, property (or means of production) is figured in time, that is, as something that takes a different (abstract) form in time. Each successive form is contingent upon new social conditions that are *separate* from the preceding (in time) or contemporaneous (space) forms. Precisely because separability and sequentiality ignore the symmetry highlighted above, historical materialists of today remain as ignorant of the workings of the racial as Marx was over a century ago. When poethical thinking recalls this symmetry, it fractures it. Because it creates composition, an image (in Benjamin's sense) – a complex pattern that disorders the linearity of progress as implied in Badiou's comments on Obama's election – immediately exposes the global context as the actualisation of each and every iteration of the racial event. In sum, it reads the global as constituted by episodes of racial violence, and as such it comprehends/exposes how the colonial (conquest, colonisation/settlement, and slavery) juridic-economic architecture now figures as Global State Capital.

1 Hortense Spillers, 'Mama's Baby, Papa's Maybe: An American Grammar Book', *Diacritics*, 17 (2), 1987, p.67.

2 *The Black & White Picture Place* – The Picture Gallery: Photographs of Liverpool http://www.chesterwalls.info/gallery/somali.html (accessed 02/29/2016).

3 Walter Benjamin, *The Arcades Project*, The Belknap Press of Harvard University Press, Cambridge, MA, 1999, p.462.

4 'Leroy Cooper: The Toxteth Riots were a wake-up call and did some good', *Liverpool Echo*, 4 July 2011, http://www.liverpoolecho.co.uk/news/liverpool-news/leroy-cooper-toxteth-riots-were-3369244 (accessed 28/02/2016).

5 See Denise Ferreira da Silva, *Toward a Global Idea of Race*, University of Minnesota Press, Minneapolis, 2007, for the presentation of the argument that concepts of the racial and the cultural constitute epistemological descriptors that produce globality as an ontological context figured as the horizon of death.

6 'A philosophy for militants – Alain Badiou interviewed by Aaron Hess', *International Socialist Review* # 95, winter 2014–15.

7 For a description of the 'evental subject' as the marker of a universal position that displaces those delineated by law and cultural difference see, generally, Alain Badiou, *St Paul and the Foundation of Universalism*, Stanford University Press, Stanford, 2003.

8 This idea of imaging is inspired by Walter Benjamin's rendering of image (see opening quote) as a critical device that interrupts temporal thinking and its idea of historical progress. Both the focus on the similar and the attention to correspondences also draw from his considerations of language and the image. See Walter Benjamin, 'Doctrine of the Similar', *New German Critique*, 17 (Spring), 1979, pp.65–69.

9 'Merseyside Police officer recalls 1981 Toxteth Riots', BBC News, 3 July 2011. No police officer was killed during the revolts.

10 'Attempted Insurrection aboard the Unity', *International Slavery Museum*, http://www.liverpoolmuseums.org.uk/ism/slavery/middle_passage/resistance.

11 A historian might write a monograph tracing the slave trade and the situation of Blacks in today's Liverpool, and perhaps establish some causal connection. A sociologist would refer to the slave trade, but they would focus on the current situation of economic dispossession, to which they would attribute both the excessive policing and the insurrection. Focusing on the 'facts', however, hides a continuity that can only be grasped if one attends to the correspondences in terms of how, in both cases, we find the same juridico-economic relationship, namely property.

12 It does so both by writing it as the effect of evolution's working on human bodies found in different regions of the globe and by reserving temporality to European bodies and places. See Ferreira da Silva, 2007.

Lara Favaretto archive, Kabul, AF, 2012

Sarah Browne and Jesse Jones

The Truncheon and the Speculum

The Contagious Diseases legislation of the 1860s is a key moment in the history of state violence against women. These Acts addressed the threat of venereal disease for the health of the male soldiers of the Empire, and permitted the compulsory gynaecological inspection of women suspected to be prostitutes in certain military camps in both England and Ireland. A special branch of the police force at the time was tasked with carrying out these forced inspections, working with a truncheon in one hand and a speculum in the other, and being paid a bonus for the unattractive nature of the duty.

Our workshop explores historical state violence enacted through gynaecological means. It stages a series of presentations and actions intended to counter the making prone of the female body for subjection to a medical gaze, broadcast live from Liverpool's radical community workshop News from Nowhere. Liverpool was a key site of the movement to repeal these laws, led by reformist, suffragette and abolitionist Josephine Butler. The workshop also connects with Liverpool's history as a focal point of the slave trade in the 1700s, and its contemporary connection to Ireland via the so-called 'Abortion Corridor', for women who cannot legally access terminations in Ireland, north or south.

In the Shadow of the State. Research photograph in Liverpool (2015). Photo by Miriam O'Connor

Audrey Cottin

Flour Tables

ELEGANT CUSTOM

memo

See on the rigth pa
— a letter
— a sea train
— a tower
— a boat
— a croissant
— a dog in a basket
— a devil
— a coffee cup
— a water tube
— an ice cream
— an eye ball
If you do not recognize
those items join the =
"Flour Table"

書き心地が良く、にじみにくい

高級ノート帳用紙を使用しています。

Check online via
Liverpool Biennial
Audrey cottin

Fabien Giraud

How to Fuel a Stellar Thruster with Dismantled Fear

Transcript of the introductory talk by Fabien Giraud at the conference 'Around the Accelerationist Manifesto', 1 December 2014, Georges Pompidou Centre, Paris.

In order to address the question of accelerationism – not so much the manifesto itself, but its philosophical origins in the writings of Nick Land and Ray Brassier – I would like to begin by talking about an experiment carried out by Heinrich Klüver and Paul Bucy in 1939, the aim of which was to study the effects of mescaline on an organism. The operation consisted of removing a monkey's temporal lobes in order to identify the region activated by the drug in the animal's brain. Although the results concerning the study of the effects of mescaline were inconclusive, Klüver and Bucy were able to observe a series of radical changes in the behaviour of the monkey. The symptoms were as follows:

- a hyper-orality: the animal ate all the food presented to it without discrimination;
- a hypersexuality: the animal exhibited compulsive and aggressive sexual behaviour characterised by an unlimited search for sexual stimulation;
- but more importantly, a total absence of distrust or fear: both in its behaviour and its interaction with the environment, the animal exhibited complete indifference to events that it would usually consider frightening.

Since the 1939 experiment, developments in neurophysiology have revealed the role of the brain amygdala, which comprises a section of these temporal lobes, in the regulation of behaviours (or their

deregulation in the case of the trepanned monkey). The brain amygdala was identified as acting primarily in the regulation of sexual or food satiety, but also and especially on the body's capacity for fear and its reaction towards its environment. Thus, the function of the brain amygdala is to decode the stimuli that could be threatening for the organism and therefore to create a change in behaviour should such stimuli present themselves.

For contemporary physiology, particularly that of Alain Berthoz, there is a clear correlation between what is considered perception and what is considered action. In such a view, perception is not a representation of the outside world but the simulation of a possible act – it is a form of prediction of an action to be carried out. Perception is not simply an interpretation of a given exterior but the constant production of a world in which certain acts are possible or not. Fear plays a major part in this creation of world through action. It makes it possible to regulate and set limits to action by inhibiting a certain behaviour that might weaken future actions. By predicting and integrating future suffering, it allows the body to divert action and thus to retain the possibility and the reactivation of other movements. Fear (in its amygdala form) thus has a function of conservation, but especially of identification. It is a form of primary abstraction, where the body in movement duplicates itself and produces its own identity through this act of conservation. In other words, an identity, as a product of fear, is the outline of a movement or a possible act. What the monkey in the Klüver-Bucy experiment is missing is not simply a section of its brain, but the functions of regulation, of conservation and identification at the heart of its movements.

The first question posed by accelerationism is: can we perform the same sort of operation on our thinking? And as a consequence of this sort of operation, what happens to thinking when fear is removed from its movements? In other words, what would constitute a movement of thinking from which one has removed all notion of conservation? What would an action be without any identity? In short, the question I would like to ask is this: *what is trepanned thinking?* This is a question but also an experiment in thinking that seems necessary to carry out on a philosophical level, but especially on an artistic level, in order to assert that art should not be a refuge or a form of conservation of identity but must, as Eisenstein said about Soviet cinema, 'split skulls'.

I would like to proceed through such an experiment by showing that there is a direct relation between this:

and this:

or between this:

and this:

and that any thinking dedicated to the emancipation of fear is inevitably and necessarily linked to the destruction of its ground. Trepanned thinking (or a fearless thought) is a thinking with no ground. And splitting the brain is just like splitting the Earth itself.

In a recent article about the various fears regarding the end of the world in contemporary thinking, the anthropologist Viveiros de Castro identified the two greatest: the fear of a *World Without Us* and the fear of *Us Without the World*. In both cases, according to him, what is central is the figure of extinction as the speculative core of our times, an extinction that no longer has anything to do with a simple death but presents itself, on the contrary, as the dynamic knotting of every kind of finiteness: individual finiteness, finiteness of species, cosmic finiteness. That we are going to die as individuals, as thinking bodies, we know; that we are going to die as a species of thinking bodies we know as well; that the Earth will not outlive the entropy principle for long and that the universe itself is moving towards an inevitable thermal death, we also know. What characterises contemporary thinking concerning extinction is the superposition in our consciousness and the emergence of all these deaths at the heart of our acts.

The double speculation about a *World Without Us* and an *Us Without the World* offers two ways of dealing with this fear of extinction. The *World Without Us* is the main narrative of contemporary thinking – the one that cloaks the conservation of what we are in an ecological eschatology. It is the narrative of a certain type of radical ecology that uses our possible extinction as a pretext to instate a new form of morality. This geological morality functions by putting our actions into perspective on the basis of an alleged deep inner truth of the Earth. Its moral motto could be: 'We humans have been bad and the coming *World Without Us* is only just.' What interests me more here is the second proposition, the second side of the fear of our times: *Us Without the World*. It is on this proposition that I would like to try to make the accelerationist removal, the trepanning operation discussed above and to see how far we can bear its consequences.

In order to do this, I will begin with a theoretical fable known as Kardashev's scale, formulated by the physicist of the same name in 1964, in order to improve research into extraterrestrial intelligence. According to Kardashev, we can identify three broad types of civilisation based on their level of technology and their use of energy. A type 1 civilisation is a civilisation that uses all the energy resources of its original planet. A type 2 civilisation uses all the energy resources of its star. A type 3 civilisation uses all the energy resources of its galaxy. The question of how one can move from one civilisation to the other pushed some physicists from the same period to refine Kardashev's scale through the engineerial thinking that such transitions between civilisations would require.

Type I : 10^{16} W *Type II* : 10^{26} W *Type III* : 10^{36} W

In order to go from type 0 to type 1, it is necessary to do what we have done: that is, progressively extract and fully exploit all of Earth's resources until we run out. According to these theories at the time when they were formulated – the end of the 1960s – our civilisation was type 0.7. It is thus easy to imagine, according to these criteria, that a civilisation of type 1 is very close to our present day. Things get more complicated going from type 1 to type 2: in order to exploit the totality of the energy resources of our star, it is necessary to build what is known as a Dyson sphere – that is to say, a form of exoskeleton around the sun capable of absorbing all of its radiation. In order to build such a sphere, whose global mass is 2×10^{27} kg, we need matter, and this matter must be found somewhere. The Earth must be broken up in order to reorganise its raw matter and build the stellar superstructure.

Freeman Dyson has explained in detail how to go about dismantling the totality of the Earth through the exponential acceleration of its rotation over a period of 2,500 years. Evidently, a breaking up of the Earth means, above all else, placing humanity temporarily on another planet and thus terraforming Mars beforehand. The speculation is that a Dyson sphere and thus a civilisation of type 2 can be reached in 3–4,000 years.

To go from a type 2 to a type 3 civilisation, that is to say, to go from the exploitation of the energy of our star to the exploitation of the energy of all the stars in our galaxy, it is necessary to multiply the number of Dyson spheres according to the number of stars that make up the galaxy. In order to achieve this, it is necessary to build what is known as a stellar engine – or more precisely a Shkadov thruster. This type of thruster is a Dyson sphere, modified and adapted to accommodate huge mirrors in order to make the radiation from the star asymmetrical and to enable it to move by propulsion. The planets gravitating around this star would also be drawn into the same movement, which would enable the whole of the solar system to travel across the galaxy and gradually to spread the civilisational engineering process throughout it. This is what the theoreticians called 'the colonial front' – the speed of expansion and propagation of such structures inside the galaxy.

The main problem with Kardashev's scale is that the very idea of civilisation, of its progress and its expansion, is based on only one teleology. Certainly Kardashev's scale presents *Us Without the World* in the sense that we no longer have any ground since we broke it up to build our conquering spaceship, but we still carry the same world within ourselves – wherever we go we move and extend our world, which follows a single trajectory and with a constant finality. A situation where man carries his world with him – and extends his identity further and further – is the very definition of colonialism.

For a man to be truly *Without the World,* and thus meet the demands of the experiment into trepanned thinking, it is necessary to think about what a non-colonial conquest might be – that is to say, a movement that has given up the thought of its own conservation and the perpetuation of its identity. In my opinion, it is necessary to toughen Kardashev's scale as a theoretical fable by doubling it with another much more frightening one – that of the physiological contingency of our bodies and our thinking once they have been uprooted from their original ground. In order to be truly without a world, not only is it necessary to break up the Earth, but also the thinking that binds us to it. What I mean by this is relatively simple: the main problem with space conquest, its present limitation, is that it is still inevitably inseparable from the idea of a return to Earth, and that it will only become total and effective when we send the first humans into space with no possibility of them returning. For the time being, the International Space Station, and every contemporary space mission in general, is equipped with a technical armada to enable the regulation of the cosmonauts' bodies in order to ensure the possibility of a return to Earth. It is a question of counterbalancing the effects of the transformations in the

body exposed to conditions in space by training it to remain terrestrial. And in the case of Kardashev, even if there is no longer any Earth to go back to, everything seems to work as if nothing was ever going to alter the well-ordered trajectory of civilisation and its expansion.

We can, however, speculate about what might be the effects of such a prolonged life in space and thus try to imagine what would be the consequences of a conquest without return. We can easily imagine that not only our bodies but especially our ways of thinking and acting would not remain intact and that the physiological changes in any organism subjected to cosmic expansion would produce something quite different from an amplification of the same or a constant propagation of our identity. For example, a prolonged inhibition of the inner ear in a permanent state of the almost total absence of gravity should, in the long term, restructure the whole of our perception. The otolith, which by means of its three axes of movement in the liquid of the inner ear makes us apprehend three-dimensional space according to the vertical markers of the gravitational plan, should, once it is exposed to the deregulation of long-term exposure to space, produce a geometry that is quite different from that of Euclid. The gradual loss of bone matter when the calcium that is supposed to reconstruct it passes into the blood and is totally eliminated in the urine should also completely restructure what we have called up until now an 'action'. Finally, we can bet on the fact that such a deregulation of our modes of perception and action would have major consequences for our brain amygdalae and their production of identity through fear. Given a liquefied body, a chaotic perception and a diminished sense of fear in scarcely a few years of exposure to life in space, it remains to be seen what the philosophy, art and politics of men from a type 3 civilisation would be like.

To conclude, we could say that this space fable had only one aim: to show that the scale and the reach of the contingency that unfolds through it is much more difficult, albeit necessary, to imagine than that of all contemporary conservatisms (whether the ecological conservatism of a *World Without Us* or the colonial conservatism of an *Us Without the World*). The conceptual consequence of such a fable is the idea that every true conquest necessarily implies a full distancing from *what we are* through the ungrounding of our identity. The engine of such a conceptual conquest is a mode of thinking (and thus an art) dedicated to the task of continually dismantling itself by operating fearless ablations on its identity. Any true conquest is a trepanation.

Krzysztof Wodiczko

Alien Staff

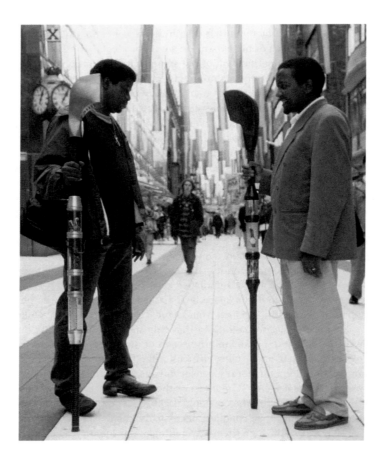

The *Alien Staff* is a form of portable public address tool and cultural network for individuals and groups of immigrants. It is an instrument that gives the individual immigrant a chance to 'address' anyone in the city who may be attracted by its symbolic form of the equipment and the character of the 'broadcast' programme. The *Alien Staff* resembles the biblical shepherd's rod. It is equipped with a high-tech mini-monitor and a small loud-speaker. A video player is located in a special shoulder bag. The small size of the monitor, its eye-level location and its closeness to the operator's face are important aspects of the design. Because the small image on the screen may attract attention and provoke observers to come very close to the monitor and therefore to the operator's face, the usual distance from the immigrant, the stranger, decreases.

Left: *Alien Staff*, 1992–93

Right: Sketch for *Alien Staff*, 1992–93. Images courtesy of the artist

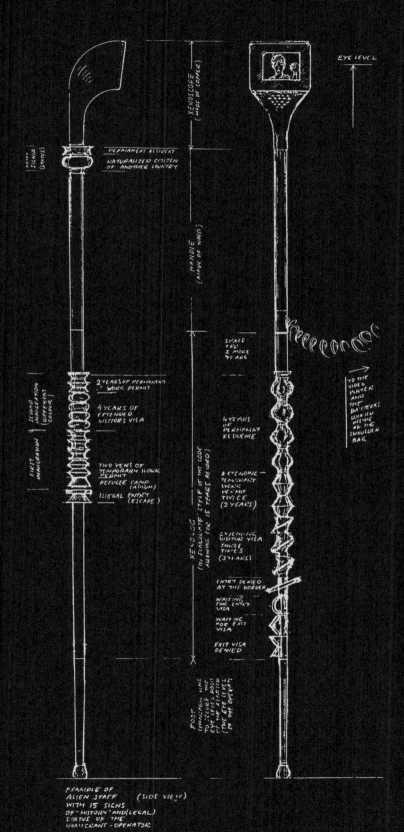

THE ALIEN STAFF
SECOND DRAFT

FEBR 14 1992
PARIS

EXAMPLE OF ALIEN STAFF (SIDE VIEW) WITH 15 SIGNS OF "HISTORY" AND (LEGAL) STATUS OF THE IMMIGRANT-OPERATOR

Will Slocombe

Notes on the Speculation of Future History

Possible Futures

Circa 1930 AD: a man, gently brushing past forty, sits in a café. As he sits, he thinks about living in the moment; after all, 'tomorrow, we die'. So he drinks something – we can't tell what – and writes notes about a future work, a work about the future. We may be dying, but the manner in which we remain even after death is important to him. Every so often he presumably pauses, looks up, not to see what is in front of him, but what is (possibly) in front of us. He hopes to deal, in fiction, with some of his more philosophical ideas, written a few years earlier. From this seat, at this table – we assume – he projects his mind into the future, outside of the building to the city beyond.

This we know; this has been recorded: the work, *Last and First Men* by Olaf Stapledon, will be written and published in 1930, and it will be one of the first, and arguably most important, 'future histories'. As such, it will be *sui generis*, and therefore not known as a 'future history' for some time, until other people have also written 'future histories'. For now, it is a 'scientific romance'.

Circa 2016 AD: I want to visit that café, but I don't know where it is, or even if it is still a café: any of Stapledon's various possible futures could be true, and I don't know which one I am living in.

The Pre-History of *Last and First Men*

The seeds of some of the ideas of *Last and First Men* were planted early, in blood and mud, and subsequently written in a different form, for a different audience. Discussing teleology (the study of ends), ethics and humanity, Stapledon had asserted:

> The whole moral progress of the race seems to consist in the advance from this 'automatism' by which we espouse the familiar and minor processes even when we *know* them to be minor and to be in conflict with major processes.

Episode 3

That is, rather than gratifying our own impulsive desires, we are advancing to the stage where we can think as a race (species?). We are taking the long view now, thinking about consequences and repercussions. We are – as a race (species?) – growing up, apparently, moving beyond childish impulses to rationally consider our place in the world and the universe.

Foreseeing

To quote Stapledon: 'Can't possibly tell what will happen.' Foreseeing is here about the present, not the future, as he reiterates in the Preface to *Last and First Men*: 'We of to-day must conceive of our relation to the rest of the universe as best we can; and even if our images must seem fantastic to future men, they may none the less serve their purpose to-day.'

The Politics of the (Near) Future: 'Think Cosmopolitanally'

Sitting in that café, in 1930, having experienced the horrors of the Great War, and predicting another to come – albeit against France not Germany – Stapledon doubts the future of England. He cannot help but consider England, but as his thinking leads towards a nationalistic conclusion he stops himself with the injunction to 'think cosmopolitanally'. Later, he would decry the loss of the League of Nations ('never a cosmopolitan government, but an association of national governments, each concerned mainly for its own sovereignty') and declaim the emergence of 'Americanism' ('America, indeed, professed to have outgrown nationalism, and to stand for political and cultural world unity. But she conceived this unity as a unity under American organization; and by culture she meant Americanism. This kind of cosmopolitanism was regarded by Asia and Africa without sympathy').[1]

How to Interpret the Legend 'Each Scale is Ten Times the Preceding...'

Each diagonal of Stapledon's timeline shows a widening of temporal vision proportional to the narrowing of the field covered. The 'contemporary' – that is, 'us' – occupies a large amount of space on the 2×10^3

Lara Favaretto archive, Kabul, AF, 2013

Mrs. Olaf Stapledon present-
ing the prizes to High Pave-
ment School pupils at the
Albert Hall, Nottingham, last
night. Second from right is
Dr. Olaf Stapledon, who gave
the address.

High Pavement Speech Day

MANKIND'S THREE POSSIBLE FUTURES

"THERE are three possible futures before mankind to-day, and you citizens of the future will many times have to contemplate which of these futures is coming," Dr. Olaf Stapledon told boys of Nottingham High Pavement School, at their annual prize distribution at the Albert Hall, Nottingham, last night.

He continued: "One is the destruction of the human race. It is a solemn thought that in 10 to 15 years every member of this audience may be dead. I don't think that is likely, but it is not impossible, because our friends, the atomic scientists, tell us that the whole food-producing area of the world might be poisoned by radio activity.

"The second is a world-wide police state, in which nobody could call his soul his own, and everybody would be a mere cog in the machine. And don't suppose that I am meaning that if there is a war, and Russia wins, that will happen, whereas if America wins

it will not. The third is an entirely new kind of human world."

Referring to schools, the speaker said that education meant growing up. He warned them that they would not be happy, because that was not what life was for. What they desired was fullness of life, and that was sometimes painful.

The attendance at the beginning of this term, said Mr. H. Davies, head master, in his first annual report, was 839, the highest in the school's history. He remarked that it was sad to see boys taken away from school at the age of 16, when they were capable of further education.

Prizes were presented by Mrs. Stapledon, and the Lord Mayor of Nottingham (Coun. John E. Mitchell), chairman of the governors, was in the chair.

The Lord Mayor presented to Jack Archer, Olympic runner and an old boy of the school, a silver cake-stand in recognition of his selection for the Olympic team.

'Mankind's Three Possible Futures',
Nottingham Guardian, November 20, 1948.
Image courtesy of Olaf Stapledon Archive,
Special Collections and Archives,
University of Liverpool Library

Futuristic Tower Of Light

TO MAKE this trick shot, an enlarged photo was made of a common 1½-in. wood screw. The image of the screw was cut from the print and pasted to another made from a cloud negative. The base line of trees was painted on the combined print with water color and the combination was copied with the camera on process film. The beams of light were worked in by hand on the copy negative and the final print was then made.

line (2,000 years before and after us) but this reduces by a factor of ten on the 2×10^4 line (20,000 years before and after). Not content with showing how parochial our sense of 'now' is when increased a step, however, Stapledon continues the line onto the next scale, decreasing our self-importance by a further factor of ten on the 2×10^5 line (200,000 years before and after). You move two scales along and what was a major historical period becomes a mere blip – 'we' don't merit even a small square on the longer axes. All human ('First Men') endeavour is dwarfed by the geometric progression of a burgeoning context.

This is why only the 'near' future requires us to 'think cosmopolitanally': in the 'middle-to-far' future, we're thinking on the species level. Some of the earliest examples of *homo sapiens sapiens* have been dated to around 200,000 (2×10^5) years ago and until about 8,000 years ago, we were still hitting stuff with stones (from inanimate objects to humans and other animals). Imagine how regressive we will look in 200,000 (2×10^5) years' time, let alone 2,000,000,000 (2×10^9) years. We are living in an ever-diminishing-in-size episode of 'The Human Story' that by the time we get to season eighteen will reveal that perhaps the temperature of that last latte in that decaying café really wasn't so important after all. Unfortunately, it also shows that the tragic event that caused so many deaths and affected so many lives in episode fourteen of season one isn't so important either.

The Conceit

'This book has two authors, one contemporary with its readers, the other an inhabitant of an age which they would call the distant future [...] The actual writer thinks he is merely contriving a work of fiction' (Introduction to *Last and First Men*).[2] 'Only by some such trick could I do justice to the conviction that our whole present mentality is but a confused and halting first experiment' (Preface).[3]

Possible Ramifications of the Conceit

Time Frames: The Last Man, who travels through time, seems to think that a book is only read in one time, that readers are always contemporary with authors. Is this an unfortunate error on Stapledon's part or an indication of a wider concern, integral with the aims of the book, about the collapse of temporal divisions? Books are always communications from their own times into the time of the reader, yet they also 'de-distanciate' the temporal gap, for the 'contemporary' of the book is always contemporaneous with the reader's experience of it.

Closed Loops: By projecting himself back into the past, the Last Man sets up a closed loop whereby issues of predestination versus free will come into play; it has happened because it is 'history' although to us it is the future. 'It is not prophecy', writes Stapledon in the Preface, 'it is myth, or an essay in myth'.[4] But prophecy is precisely what it is if you step back into the past and reveal what will happen.

Saccades: The eye sees movement by predicting the path of an object, tracking it, anticipating it, switching back to where it is now, then along its likely trajectory (a predictive saccade). The notion of continuous vision is an optical illusion; we see the world discretely. Put another way, Stapledon's I sees movement by predicting the path of the human object, tracking it, anticipating it, switching back to where it is now, then along its likely trajectory (a 'history of the future'). *Last and First Men* is, from Stapledon's perspective, a vast predictive saccade of the human object through the illusory mechanism of a Last Man's memory-guided saccade; the arc of movement is just too long to predict accurately.

The Balkanisation of Time

Determining beginnings and endings is a conceit; Stapledon shows this by placing the Renaissance, the British Empire, Class War and Nationalism – on his shortest timeline – in the context of longer time-scales (timeline ref: axes). He ignores 200 (2×10^2) year timelines and fewer as being outside of notice in the grander human story. Yet the universe, as he shows, does not really care about the 'The Human Story', whatever season we're in. The smallest possible quantum, 'to date', is approximately 10^{-44} seconds: one Planck time unit. Each time-scale is incommensurable, and we can only live on one scale at a time, although we live across all scales simultaneously.

The Conceit from the Future

'Last Men' (*adjective + noun*): The 'Last Men' are the eighteenth and final iteration of *homo sapiens* (see End Times eschatology, Anatomically Modern Human, Hominidae, cladogenesis), about to be destroyed by the sun. Believe 'Being the latest, he is also the noblest', a truism of continual progress (see narrative teleology) despite belief that, *en masse*, '[Man] is very small, very simple, very little capable of insight.'[5] Despite their scheme, 'Scattering of the Seed' (see phallogocentric myth, Timeline ref 'dissemination'), for sending genetic material to other star systems, believe they are the last men.[6] See also: extra-solar life, panspermia.

1 Olaf Stapledon, *Last and First Men*, SF Masterworks Series (London: Gollancz, 2004). Originally printed 1930. pp. 35, 37.

2 Ibid., p.xvii.

3 Ibid., p.xiv.

4 Ibid., p.xv.

5 Ibid., pp.303, 304.

6 Ibid., p.302.

I am sure that you are not a kid anymore if you are reading this. Now I would like to ask you to close this book, go to the garden or a street, come back tomorrow, tear off this page, flip it many times, make a mask out of it, wear it, smoke it and keep finding simultaneous sequels somewhere else.

1206

F86

Possible Futures

1918 Club
Soroptimists
Headmasters (Settlement)
Medical + Literary Soc
Loom Luncheon Club

9.0 Down

Future of this building

not always a café
~~sight~~ site cleared for a bigger building
taken over by Americans
used by Russians as a child welfare centre
" " Japs or Chinese
destroyed by bombs
allowed to fall to pieces

Future of Liverpool Crossing ∂ Mersey

not always to be a great port
someday either — removed
 or decay. (river silts like ~~Dee~~ Dee)
 dock gates fall to pieces
 buildings crumble

Future of England

Why bother about foreseeing?

as I sat down — thinking of this moment
 "let us eat drink & be merry"

Can't possibly tell what will happen
 except — it will be utterly different
 then useless to ask?
No, not to consider possibilities
fascinating, educative (emotionally)

⊕

Degrees of futurity (for my purposes)

"near" — next 100 years Waterloo
middle — 1 — 10,000 yrs before Egypt
far — million yrs & onwards early man

Questions to ask about them

 (of different orders)

near — England a world power? Russia?
 ∂ family? education?
middle — coal, oil, subatomic?
 huge cultural advance?
far — what will man be like? extinct?
 will he be superman?

Near Future

enumerate ∂ vital questions

1. will ∂ world be better or worse?
 better = politically unified
 socially coherent, happy, rich
 culturally more vital
 worse = civilization breaking up
 successive wars
 no unity
 economic slavery
 impoverished
 degenerate
or — Brave New World
⊕ or better-worse, in different respects

2. England still a great power
 I see no possibility of it
 her advantage is over
 must lose her trade
 but what matter?
 think cosmopolitanally
 & anyhow England may be ∂ better for it
 cp Scandinavia
 a quieter more thoughtful people?
 smaller population

3 <u>USA dominant</u>? individualism
 an Americanised planet
 (America in Asia today)
 but USA now in θ throes
 (a) financially — system collapsing
 (b) culturally — insincerity
 graft
 rackets
 universities
 danger of world infection

Balkanisation

4 <u>Russia</u>: present order will last?
 but modified toward capitalism?
 or counter revolution?
 Anti Russian war?
 Americanisation of Russia?
 Russification of θ World?

*pop
culture*

5 <u>East</u>: Japan expanding
 but will become stationary
 also India
 <u>China</u>: vast potentiality
 a more sane mentality
 possible war of East & West

pop

6 <u>Internationalism</u>?
 rival empires or world state
 nationalism may collapse
 not an instinct
 but if culture declines — more nationalism

X

7 <u>Cultural questions</u>
 influence of science — Russell, Huxley
 or will science became more humane?
 religion — a new one?
 family, women
 free citizens — slaves
 free minds
 technical

<u>Middle</u> 1—10 thousand
 all present states gone
 & present culture
 continues progress?
 extinction: atomic explosion
 bad eugenics
 lack of chemicals
 no oil, coal — tides & subatomic
 human nature
 fundamentally same
 or improved?
 or degenerate

*ether.
voyaging*

<u>Far</u> million, onwards
 earth much as now (unless burnt)
 but climate fluctuations
 continental shifts
Will there be men?
 certainly not like us
 things move too fast
 & ever faster?
 or stagnation
new intelligent species
or improved humanity
 sensory — eyes
 hand (not necessary)
 brain — super intellect
 " coordination

Next two spreads: *Timescales for First and Last Men*, c. 1929. Image courtesy of
Olaf Stapledon Archive, Special Collections and Archives, University of Liverpool Library.

283

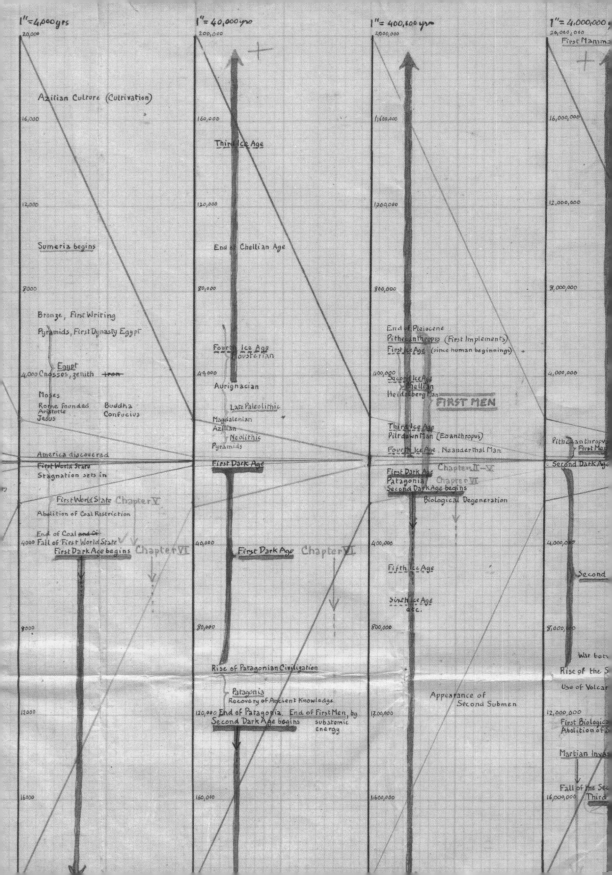

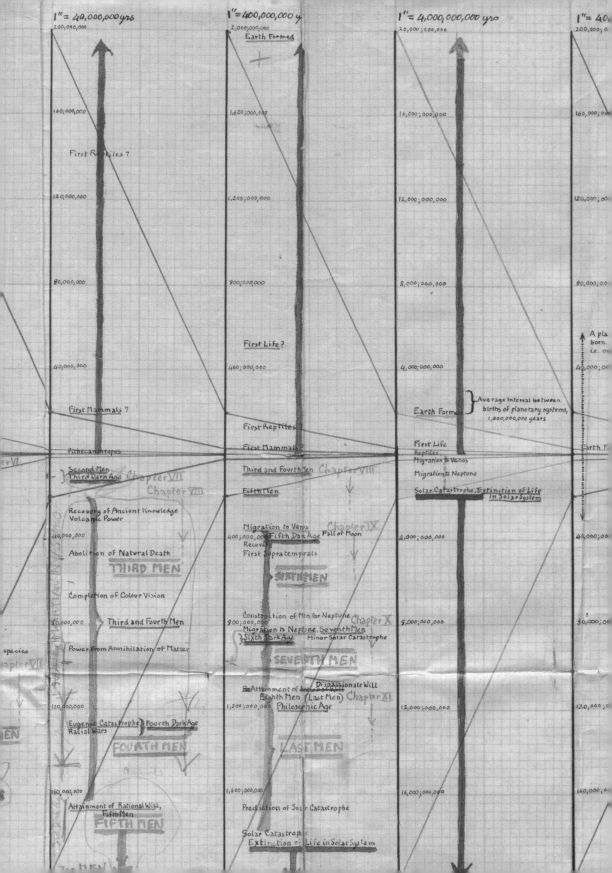

Column 1 — 1" = 40,000,000 yrs

200,000,000
160,000,000 — First Reptiles?
120,000,000
80,000,000
40,000,000 — First Mammals?
Pithecanthropus
Second Men
Third Dark Age — Chapter VII
Chapter VII
Recovery of Ancient Knowledge
Volcanic Power
40,000,000 — Abolition of Natural Death
THIRD MEN
Completion of Colour Vision
80,000,000 — Third and Fourth Men
Power from Annihilation of Matter
120,000,000 — Eugenic Catastrophe, Fourth Dark Age
Racial Wars
FOURTH MEN
160,000,000 — Attainment of Rational Will,
Fifth Men
FIFTH MEN

species
Chapter VII

Column 2 — 1" = 400,000,000 yrs

2,000,000,000 — Earth Formed
1,600,000,000
1,200,000,000
800,000,000
400,000,000 — First Life?
First Reptiles?
First Mammals?
Third and Fourth Men — Chapter VIII
Fifth Men
Migration to Venus — Chapter IX
400,000,000 — Fifth Dark Age, Fall of Moon
Recovery
First Supratemporals
SIXTH MEN
Construction of Mtn for Neptune — Chapter X
800,000,000 — Migration to Neptune, Seventh Men
Sixth Dark Age — Minor Solar Catastrophe
SEVENTH MEN
Attainment of ... Dispassionate Will
Eighth Men (Last Men) — Chapter XI
1,200,000,000 — Philosophic Age
LAST MEN
1,600,000,000 — Prediction of Solar Catastrophe
Solar Catastrophe
Extinction of Life in Solar System

Column 3 — 1" = 4,000,000,000 yrs

20,000,000,000
16,000,000,000
12,000,000,000
8,000,000,000
4,000,000,000 — Earth Formed
} Average interval between births of planetary systems, 2,000,000,000 years
First Life
Reptiles
Mammals
Migration to Venus
Migration to Neptune
Solar Catastrophe, Extinction of Life in Solar System
4,000,000,000
8,000,000,000
12,000,000,000
16,000,000,000

Column 4 — 1" = 40...

200,000,0...
160,000,...
120,000,...
80,000,...
A planet born i.e. ov...
40,000,...
Earth F...

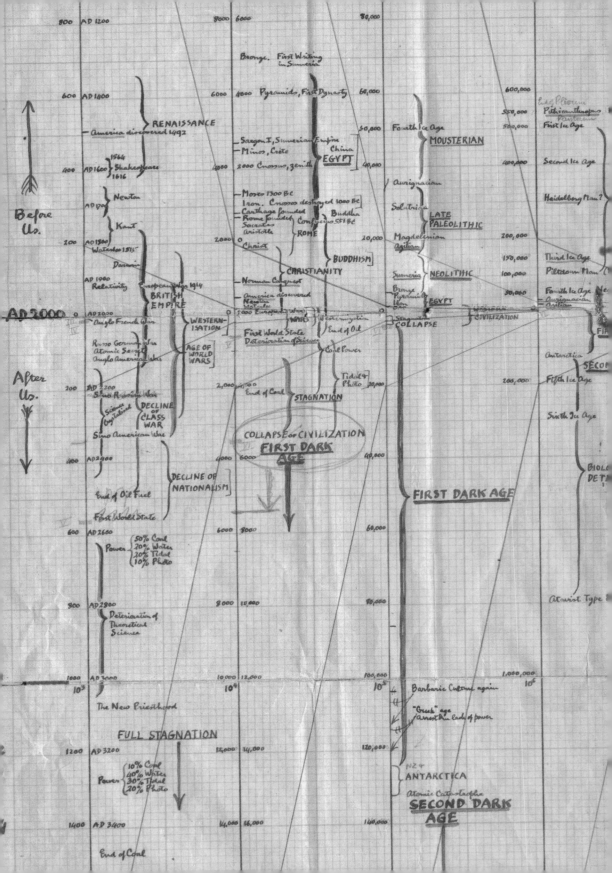

FIRST LIFE ?

5,000,000,00

PRE-HUMAN LIFE

20,000,000 First Mammals? 2,000,000,00 1,000,000,000 EARTH FORMED 20,000,0

120,000,000 First Reptiles

Pithecanthropus First Men 20,000,000 First Mammals 500,000,000 First Life?

Heidelbergensis FIRST MEN 0 Pithecanthropus 0 Second Men 0 Reptiles

Biological Deterioration Atavists Second Dark Age Third Dark Age 400,000,000 Lunar Catastrophe

THIRD and FOURTH MEN Sixth Men (VENUS

SECOND MEN Diabolist Catastrophe Rationg Will NEPTUNE

20,000,000 Martian Influxes 200,000,000 MAN on EARTH 2,000,000,000 SECOND SOLAR CATASTROPH 20,00

Second Atavists FIFTH MEN Predicted Minimum Limit of Earth's Habitability

THIRD DARK AGE

SECOND DARK AGE Recovery Traditionalism Advance Migration to VENUS Fourth Dark

(ATAVISTS) 400,000,000 Regression 8th Dark Age Lunar Catastrophe Recovery

Abolition of Natural Death First Supra Temporals

MAN on VENUS (SIXTH MEN)

Biological Rivalry of Atavists and Second Men Completion of Colour Vision Prediction of First Solar Catastrophe Breeding for Neptune

THIRD and FOURTH MEN Migration to NEPTUNE Sixth Dark Age First Solar Catastrophe Organization of Neptune

End of Atavists 100,000,000 1,000,000,000 SEVENTH MEN 10,000,000,000 100,000,0

10⁸ 10⁹ 10¹⁰

Simple Culture Second World State SECOND HEROIC AGE Second Supra temporals DISPASSIONATE MIND
Recovery of Ancient Wisdom
Traditionalism
Original Inquiry
Sub Atomic Power

Abolition of Senility

FIRST HEROIC AGE SECOND MEN First Rational Will Experiments Gregarists, Individualists MAN on NEPTUNE DIABOLIST CATASTROPHE

FIRST MARTIAN INFLUX LAST MEN (Philosophic Age)
Decline
Recovery

Second Martian Influx MARTIAN WARS Fourth Dark
Decline
Recovery

Lara Favaretto

Lu Pingyuan

Van Gogh Ltd

Van Gogh's other ear was discovered by scientists.
A technology company acquired the ear, and opened a factory called Van Gogh Ltd, which extracted the DNA from Van Gogh's ear to make countless Van Gogh clones. The Van Gogh clones became the factory's main workers. From the time they were small, each clone was forced to learn how to paint Van Gogh-style copies of *Starry Night, Sunflowers, The Night Café in the Place Lamartine in Arles* and other famous works. The gifted 'Van Goghs' were held in captivity by the factory and raised to mass-produce these masterpieces; the ones without talent were gathered together and pushed into a big furnace, to be burned down into a special kind of yellow pigment that was used as raw material for the ongoing painting process.

Arseny Zhilyaev

The Last Planet Parade

From early childhood, two things fascinated me – space and football. To watch football is, in some ways, the same as to observe the birth of stars. In both cases there are certain rules and forces pertaining to maths and physics, and although it's impossible to predict precisely, in the end there will be an event. With each, you feel that you're present at the birth of a small part of human history. There's also a necessity to concentrate on the trajectories of spheres.

I don't really remember which fascination struck me first – football or space. But I know that space became relevant to me when my father, instead of a ball, gave me a celestial globe. I doubt that he was able to buy it himself – probably it was a present from friends, and he decided to share his hobby with me. My dear father was an inspired man, a true dreamer, despite his difficult life. Nowadays I understand that his love for cosmology and science fiction was a kind of protective reaction to the miseries of life. Space gave him the feeling of magic – so did football.

My father told me that the first time he thought about space was when the first Russian cosmonaut Yuri Gagarin visited his factory in Manchester. Gagarin – before overcoming the gravitational pull of our planet – had trained as a moulder. Therefore, besides a meeting with the Queen, his schedule involved visits to trades unions and a factory. Understandably, this event made an indelible impression on my father, who worked at Metrovicks' factory during that time. He told me many times that this simple working guy had become a deity in Britain. Apparently, during those days the whole country went crazy over him. Only The Beatles could compete with Gagarin. An equivalent today might be raving on ecstasy.

For me personally, space was frightening and enticing at the same time. To be honest, as a child I was afraid of the clear night sky displaying its abundance of stars. This is clearly not a frequent phenomenon in our corner of the world, but when it happened, I was overwhelmed by the feeling that someone was watching me. Perhaps my father noticed this when – in addition to the globe – he presented me with a small telescope, telling me that I should make friends with the observer, and become as great as the English astronomer Jeremiah Horrocks. That's the way my life in astronomy began. Today, years later, I can say that I lived up to at least a part of his wish.

I remember when, for the first time, I observed the Last Parade of Planets. But at that time it didn't have a name – that came much later. For me it was an amazing January adventure, which was repeated every year approximately at the same time: the end of the second winter month. In essence, it's a particular lining up of planets in a remote galaxy, the name of which I'm obliged to keep in utmost secrecy. Anyone who wants to check the accuracy of my words can see it through a telescope on 22 January in my room (following the signs and instructions written on the floor and looking at the sky through my window).

At first, I didn't attach any special significance to my observation. But having noticed the recurring signs of attention from space, I understood that I should approach the business more seriously. For almost ten years I've tried to understand what this amazing cosmic spectacle might mean. My attempts were futile until, standing in the middle of a rave, looking up into the night sky, an interesting thought came to me. The secret of planetary movement can be uncovered through dance. Dancing gives people the same motions as the stars. But what precisely was the parade about? To decipher the cosmic message, I organised a small open-air party on 22 January and named it 'The Last Parade of Planets'. The guests were asked to dress up as planets or celestial objects. Especially for the occasion I got hold of a video camera on a tripod and brought along my telescope.

The party was a great success. I managed to film a few hours of dancing and record the movement of the planets. I had to spend quite a while working on the recorded material. I kept a diary, trying to reveal regularities that interested me. I didn't miss a single detail. But the understanding didn't come until the solution offered itself to me, as so often happens, in a dream. It appeared that the Last Parade of Planets was something like a funeral ritual, but not in our terrestrial

William Richard Lavender, *Jeremiah Horrocks* (1618—1641), 1903, oil on canvas, 61 × 91.5 cm. Image courtesy Astley Hall, Chorley

Arseny Zhilyaev

Top: **Ford Madox Brown**, *Crabtree Watching the Transit of Venus*. AD 1639, 1883, fresco, 146 × 318 cm. Image courtesy of Manchester Art Gallery

Bottom: **Arseny Zhilyaev,** Sketch for *Last Planet Parade*, 2016, pencil on paper

sense. It wasn't a simple farewell, but in some way a creative resurrection. How was that possible? The planets seen by me were not exactly planets, or at least, not naturally created planets. They were copies of planets – progenitresses that gave life to the super-advanced civilisation of the future. I wasn't a hundred percent sure but it seemed to me that among the planets there was also Earth. And so, what I was seeing was a re-enactment of the trajectory of the death of the planets, which had been drawn and swallowed by the black hole in the centre of The Milky Way Galaxy. Every year this ritual was repeated with small variations. I think it's something like a religious ritual that has lost its original meaning. In some ways, it's possible to speak of it as a work of art. That same night it was also revealed to me that the members of this civilisation are eternal beings. They have no past and no future in our understanding of those concepts. They're not born and they do not die. Their existence takes place in a museum, which we perceive as our universe, the cosmos.

I understand that all of this sounds a little odd. Even my father refused to believe me for a long time. But I know what I'm talking about. It isn't easy for people to deal with such matters. They struggle to find the right words, even the right numbers. Often, one has to rely on intuition. Human understanding is limited, especially when it comes to works of art by the more advanced civilisations. For most people, it's even entirely inaccessible. Luckily, we can feel this mind-blowing beauty through dance, intuition and openness to the universe. It seems to me that all religions in the world are about intuitive enlightenment regarding the cosmic art of the future.

For those of us who for some reason are afraid to open up to this truth, there's a visual representation that can be comprehended entirely by connecting to it with body and soul: a symbolic image of the Last Parade of Planets that I created as stained-glass windows in my room. Of course, I don't urge people to meditate on them or to worship them. But one gains a lot from the opportunity to feel how the light waves, which have travelled millions of kilometres, take shape when defined by colourful glass, and touch our bodies. Only through this touch can we become closer. But it is not yet enough to reach the realms occupied by the creators of the cosmic museum.

Lara Favaretto archive

Céline Condorelli

Portals

To the one thousand three hundred and
sixty two Chinese seamen deported from
Liverpool against their will in July 1946.
To all the undesirables.

Biographies

Lawrence Abu Hamdan (b.1985, Amman, Jordan) is an artist living in Beirut, Lebanon. Solo exhibitions include Portikus, Frankfurt, Germany (2016), Kunsthalle St Gallen, Switzerland (2015) and Beirut, Cairo, Egypt (2013). He has written for *Forensis*, *Manifesta Journal* and *Cabinet Magazine*.

Andreas Angelidakis (b. 1968, Athens, Greece) is an artist living in Athens. Recent exhibitions include Chicago Architecture Biennial, USA (2015), Baltic Triennial of International Art, Vilnius, Lithuania (2015) and PAC Milano, Milan, Italy (2015).

Lars Bang Larsen (b. 1972 Silkeborg Denmark) is a writer, curator and art historian. He wrote his PhD, *A History of Irritated Material,* on the relation between neo-avant-garde art and psychedelic concepts and practices. His books include *The Model for a Qualitative Society 1968* (2010) and *Networks* (2014). He is currently a co-curator of the 32nd Bienal de São Paulo, Brazil, 2016.

Alisa Baremboym (b. 1982, Moscow, Soviet Union) is an artist living in New York, USA. Solo exhibitions include 47 Canal, New York, USA (2015). Her work has been included in numerous group exhibitions such as Glasgow Sculpture Studios, UK (2016), Schinkel Pavillion, Berlin, Germany (2015), Fridericianum, Kassel, Germany, and MoMA PS1, Queens, New York, USA (both 2013).

Lucy Beech (b. 1985, Hull, UK) is an artist living in London, UK. Recent solo exhibitions include James Fuentes, New York, USA (2015), The Tetley, Leeds, UK (2015) and the Harris Museum and Art Gallery, Preston, UK (2015). Beech also collaborates with Edward Thomasson on performance works, recent presentations of which include Maureen Paley, London, UK (2016), Site Gallery, Sheffield, UK (2016), Lisson Gallery, London, UK (2015), Frieze Live, London, UK (2015) and Camden Arts Centre, London, UK (2014).

Sarah Browne (b. 1981, Dublin, Ireland) and Jesse Jones (b. 1978, Dublin, Ireland), are artists living in Dublin. Each has extensive experience of working in collaborative contexts, through public art projects and with institutions such as Project Arts Centre, Dublin, the Irish Museum of Modern Art, Dublin, the Istanbul Biennale, Turkey, and Artsonje, Seoul, South Korea. Browne co-represented Ireland at the Venice Biennale, Italy, in 2009 and Jones will represent Ireland at the forthcoming Venice Biennale in 2017.

Mariana Castillo Deball (b. 1975, Mexico City, Mexico) is an artist living in Berlin, Germany. Solo exhibitions of her work have been held at the San Francisco Art Institute, USA (2016), Museum of Contemporary Art, Oaxaca, Mexico (2015), Hamburger Bahnhof, Berlin, Germany (2014). Group exhibitions include the 8th Berlin Biennale, Germany (2014) and Documenta 13, Kassel, Germany (2013).

Yin-Ju Chen (b. 1977, Taipei, Taiwan) is an artist living in Taipei. Solo exhibitions include IT PARK, Taipei, Taiwan (2015) and KADIST, San Francisco, USA (2016). Group exhibitions include e-flux, New York, USA (2015) and Biennale of Sydney, Australia (2016). In 2011 she was nominated for the Tiger Award for best short film at the 40th International Film Festival, Rotterdam, Netherlands.

Zian Chen (b. 1986, Taipei) is a writer of fictional exhibitions who is currently a

curator at Antenna Space Shanghai, China. His literary practice takes its plot devices from the contemporary art scene. The other lineage of his practice treats critical essays as a mode of fiction.

Ian Cheng (b. 1984, Los Angeles, USA) is an artist living in New York, USA. Solo exhibitions include Migros Museum, Zurich, Switzerland (2016), Fondazione Sandretto Re Rebaudengo, Turin, Italy (2015) and Kunsthalle Dusseldorf, Dusseldorf, Germany (2015).

Marvin Gaye Chetwynd (b. 1973, London, UK) is an artist living in Glasgow, UK. Chetwynd studied Social Anthropology at University College London before studying art at the Slade and RCA. She was shortlisted for the Turner Prize in 2012. Recent exhibitions and performances include *Camshafts in the Rain*, Bonner Kunstverein, Bonn, Germany (2016); and *Here She Comes*, commissioned by the Arts Council, Royal Festival Hall, London, UK (2016).

Céline Condorelli b. 1974, Paris, France) is an artist living London, UK. Solo exhibitions include Kunsthalle Lissabon, Lisbon, Portugal (2016), HangarBicocca, Milan, Italy (2015), Chisenhale Gallery, London, UK (2014) and Museum of Contemporary Art, Leipzig, Germany (2014).

CAConrad (b. 1966, Kansas, USA) is the author of eight books of poetry and essays. The latest, *ECODEVIANCE: (Soma)tics for the Future Wilderness* (Wave Books), won the 2015 Believer Magazine Book Award. He has received fellowships from Lannan Foundation, MacDowell Colony and others. For his books and the documentary *The Book of Conrad* (2016), please visit CAConrad.blogspot.com.

Audrey Cottin (b.1984, Saint-Mandé, France) is an artist living in Brussels, Belgium. She is represented by Galerie Tatjana Pieters, Ghent, Belgium.

Mark Z. Danielewski (b. 1966, New York, USA) is a writer living in Los Angeles, USA. He is the author of the award-winning and bestselling novel *House of Leaves* (2000), National Book Award finalist for *Only Revolutions* (2006) and the novella *The Fifty Year Sword* (2005). The third installment of his twenty-seven-volume novel *The Familiar* will be released in June 2016.

Koenraad Dedobbeleer (b.1975, Halle, Belgium) is an artist living in Brussels, Belgium. Solo exhibitions include PROJECTESD, Barcelona, Spain (2015) and Galerie Micheline Szwajcer, Brussels, Belgium (2016). His work has been shown in numerous group exhibitions in venues such as Stroom Den Haag, The Hague, The Netherlands (2016) and Arts Santa Monica, Barcelona, Spain (2016).

Jason Dodge (b. 1969, Pennsylvania, USA) is an artist living in Berlin, Germany. Recent solo exhibitions include Mercer Union, Toronto, Canada (2016), Centre d'édition contemporaine, Geneva, Switzerland (2015) and Galleria Franco Noero, Turin, Italy (2014). 2016 group shows include Kunsthalle Wien, Vienna, Austria, Kunstverein in Hamburg, Germany, and Gagosian Gallery, Rome, Italy.

Lara Favaretto (b.1973, Treviso, Italy) is an artist living in Turin, Italy. Her work ranges from site-specific installations to found objects, paintings, video, photography and sculptures. She participated in the biennales at Venice, Italy (2005 and 2009), Istanbul, Turkey (2011), Sharjah, UAE (2009) and Sydney, Australia (2008), as well as showing at Rennie Collection, Vancouver, Canada (2015), MAXXI, Rome, Italy (2015), Manifesta 10, The State Hermitage Museum, St Petersburg, Russia (2014), MoMA PS1, New York, USA (2012) and dOCUMENTA(13), Kassel, Germany (2012).

Denise Ferreira da Silva (b. 1963, Rio de Janeiro, Brazil) currently teaches at the University of British Columbia, Canada. Her writings on philosophical, historical and contemporary global political issues draw from the critical racial and historical materialist conceptual arsenal and intervene in critical legal, global, postcolonial and feminist theory.

Danielle Freakley (b.1982, Perth, Australia) is an artist living between Melbourne and Perth. Solo shows include Arte Mortis Art Space, Dili, East Timor (2014) and MCA, with Mark Hostler, representing the USA brand Negativland, Sydney, Australia (2013). Group exhibitions include Incinerator Gallery, Melbourne, Australia (2015) and Juliette Jongma Gallery, Amsterdam, Netherlands (2014).

Coco Fusco (b.1960, New York, USA) is an artist living in New York. Group exhibitions include 56th Venice Biennale, Italy (2015), the Göteborg International Biennial for Contemporary Art, Sweden (2015), the Walker Art Center, Minneapolis, USA (2014) and Bamako Encounters, Mali (2015). Fusco will also take part in Manifesta 11, Geneva, Switzerland (2016).

Matthew Garrett (b. 1976, New Jersey, USA) is a literary historian whose work concerns the relationship between literary form and social history. He is the author of *Episodic Poetics* (2014), essays in *Critical Inquiry*, *ELH*, *Radical History Review* and other journals, and is currently editing the forthcoming *Cambridge Companion to Narrative Theory*.

Fabien Giraud (b. 1980) and Raphaël Siboni (b. 1981) are artists living in Paris, France. Solo exhibitions include Palais de Tokyo, Paris, France (2007) and Centre International d'Art et du Paysage, Vassivière, France (2014). Group exhibitions include Museo Pallazo Riso, Parlermo, Italy (2015) and Biennale d'Art Contemporain de Lyon, France (2015).

Xiaolu Guo (b. 1973, Zhejiang, China) is a novelist and filmmaker living in London, UK. She is the author of several novels including *A Concise Chinese-English Dictionary For Lovers* (2007) and *I Am China* (2014). Her film *She, A Chinese* (2009) was awarded the Golden Leopard at the Locarno film festival. In 2013 Guo was named Granta's Best of Young British Novelist.

C.O. Grossman lives in Miami, Florida, USA.

Ramin Haerizadeh (b. 1975, Tehran, Iran), Rokni Haerizadeh (b. 1978, Tehran, Iran) and Hesam Rahmanian (b. 1980, Knoxville, USA) are artists living in Dubai, UAE. Recent exhibitions include Kunsthalle Zurich, Switzerland (2015) Den Frie, Copenhagen, Denmark (2015–16), APT8, Brisbane, Australia (2015–16) and ICA Boston, USA (2015–16).

Hato is a design studio based between London and Hong Kong. Recently it has worked with the British Council, London, UK (2016), Wellcome Collection, London, UK (2016), Somerset House, London, UK (2016), M+, Hong Kong, China (2016) and Art on the Underground, London, UK (2016).

David Hering (b. 1979, Liverpool, UK) is a Lecturer in English at the University of Liverpool, where he lives. He writes, researches and teaches on contemporary and American literature and is a member of the Centre for New and International Writing. He is the author of *David Foster Wallace: Fiction and Form* (2016).

Ranjit Hoskote (b. 1969, Bombay, India) is a poet, cultural theorist and curator. He curated India's first-ever national pavilion at the Venice Biennale, Italy (2011). His books include *Central Time* (2014), *I, Lalla: The Poems of Lal Ded* (2011) and *Vanishing Acts: New & Selected Poems* (2006). His poems have appeared in several anthologies, including *Language for a New Century* (2008) and *The Bloodaxe Book of Contemporary Indian Poets* (2008).

Everythink i said was Make Believe
i said it to BLEND iN Here
becos im AniM

Ana Jotta (b.1946, Lisbon, Portugal) is an artist living in Lisbon. In 2005, Museu de Serralves, Porto, Portugal, hosted a retrospective of her work, with a more recent anthology held at Culturgest, Lisbon, Portugal (2014).

Samson Kambalu (b.1975, Malawi) is an artist and writer living in London, UK. Solo exhibitions include Castlefield Gallery, Manchester, UK (2012) and Sai Gallery, Osaka, Japan (2009). He has written a range of novels such as the autobiographical novel *The Jive Talker* (2008). Group exhibitions include the Venice Biennale, Italy (2015).

En Liang Khong (b. 1990, London UK) is assistant editor at openDemocracy. His writing on Chinese art and politics, and the spaces in which they intersect, has been published in *Prospect*, the *Financial Times*, the *New Statesman*, *Frieze* and *The New Inquiry*. He was the 2008 BBC Young Composer of the Year, and recipient of the 2012 Wedgood and Gibbs awards for history from the University of Oxford.

Franciszek Krysa Cox (b. 2010, Aarhus, Denmark) spent the first four years of his life in Aarhus, where he attended Storkereden Nursery and Aarhus Academy for Global Education. He currently lives in Liverpool and attends Belvedere Preparatory School. He has a keen interest in numbers and art, how things are made and work, and likes drawing stories and arranging things into patterns and 'collections'.

Joasia Krysa is part of the Curatorial Faculty for Liverpool Biennial 2016.

Oliver Laric (b. 1981, Innsbruck, Austria) is an artist living in Berlin, Germany. Solo exhibitions include the Hirschhorn Museum and Sculpture Garden, Washington DC, USA (2014) and CCA, Tel Aviv, Israel (2015). He has also recently shown at the New Museum, New York, USA (2015) and Wien Secession, Vienna, Austria (2015). Group exhibitions include Monash University Museum of Art, Melbourne, Australia (2015) and Albright-Knox Art Gallery, Buffalo, USA (2015).

Mark Leckey (b.1964, Birkenhead, UK) is an artist living in London, UK. Solo exhibitions include MoMA PS1, New York, USA (2016), Wien Secession, Vienna, Austria (2015) and Haus der Kunst, Munich, Germany (2015).

Adam Linder (b. 1983, Sydney, Australia) is an artist living in Berlin, Germany. Recent solo presentations include The Schinkel Pavillon, Berlin, Germany (2016), ICA, London, UK (2015) and HAU Theatre, Berlin, Germany (2013–present).

Marcos Lutyens (b. 1964, London, UK) is an artist living in Los Angeles, USA. Exhibitions include 14th Istanbul Biennial, Istanbul, Turkey (2015); 55th Venice Biennale, Italy (2013), dOCUMENTA 13, Kassell, Germany (2012). Recent exhibitions include the XII Baltic Triennial, Riga, Latvia (2016), Manifesta 11, Zurich, Switzerland (2016) and *Organisms* at the Galleria Civica d'Arte Moderna e Contemporanea, Turin, Italy (2016). He recently published the book *Memoirs of a Hypnotist: 100 Days* (2015).

Francesco Manacorda is part of the Curatorial Faculty for Liverpool Biennial 2016.

Jumana Manna (b.1987, New Jersey, USA) is an artist living in Berlin, Germany, and Jerusalem, Israel. Solo exhibitions include Chisenhale Gallery, London, UK (2015), Beirut Art Center, Beirut, Lebanon (2015) and Sculpture Center, New York, USA (2014).

Rita McBride (b. 1960, Iowa, USA) is an artist living between Dusseldorf, Germany, and Los Angeles, USA. Recent exhibitions include Museum of Contemporary Art, San Diego, USA (2014–15), the Kestnergesellschaft Hanover, Germany (2015) and the Kunsthalle Düsseldorf, Germany (2016).

Dennis McNulty (b. 1970, Ballinasloe, Ireland) is an artist living in Dublin, Ireland. Exhibitions include Lofoten International Art Festival, Svolvaer, Norway (2015), Collective Gallery, Edinburgh/Carnoustie, UK (2014) and Limerick City Gallery of Art, Ireland (2014). He is a member of the Orthogonal Methods Group at CONNECT, Ireland's national research centre for future networks and communications.

Elena Narbutaite, we should call her.

Emy Onuora (b. Glasgow, 1965) moved to Liverpool at the age of four, where he currently lives with his partner and three daughters. He is a freelance educator, writer, youth worker, project manager and personal development coach who wrote *Pitch Black – The Story of Black British Footballers* (2015).

Andrew Pickering (b. 1948, Coventry, UK) is emeritus professor of philosophy and sociology at the University of Exeter, and lives in the village of Thorverton in the Exe valley. His books include *Constructing Quarks: A Sociological History of Particle Physics* (1984), *The Mangle of Practice: Time, Agency and Science* (1995) and most recently *The Cybernetic Brain: Sketches of Another Future* (2010).

Lu Pingyuan (b. 1984, Zhejiang, China) is an artist living in Shanghai. His works often consider superstition in relation to mysterious events. Recent solo exhibitions include Madein Gallery, Shanghai, China (2016 and 2015), Goethe Institute, Shanghai, China (2013). Group exhibitions include Minsheng Art Museum, Shanghai, China (2016), ART Sanya, Hainan, China (2015); 6th Moscow Biennale, Russia, and Kunsthaus Graz, Austria, among others (2015) and 7th A+A, Pifo Gallery, Beijing, China (2014).

Michael Portnoy (b. 1971, Washington, DC, USA) is an artist living in New York, USA. Recent exhibitions include Witte de With, Rotterdam, the Netherlands (2016), Centre Pompidou, Paris, France (2015), Stedelijk

Museum, Amsterdam, Netherlands (2014) and Cricoteka, Krakow, Poland (2014).

Sahej Rahal (b. 1988, Mumbai, India) is an artist living in Mumbai. Exhibitions include the Setouchi Triennial, Japan (2016), Spencer Museum of Art, Kansas, USA (2016), Dhaka Art Summit 2016, Bangladesh (2016), Jewish Museum, New York, USA (2015), Galleria Continua, Les Moulins, France (2014), the Kochi Muziris Biennale, Kochi, India (2014) and Vancouver Biennale, Canada (2014). He was the recipient of the 2014 Forbes India Art Award for best debut solo show for his solo exhibition Chatterjee & Lal, Mumbai, India.

Denise Riley (b. 1948, Carlise, UK) is a writer living in London, UK. Her books include *War in the Nursery: Theories of Child and Mother* (1983), *'Am I that Name?' Feminism and the Category of Women in History* (1988), *Penguin Modern Poets 10* with Douglas Oliver and Ian Sinclair (1996), *The Words of Selves: Identification, Solidarity, Irony* (2000), *The Force of Language*, with Jean-Jacques Lecercle (2004), *Impersonal Passion: Language As Affect* (2005), *Time Lived, Without Its Flow* (2011) and *Say Something Back* (2016).

Tai Shani (b. 1976, London, UK) is a self-taught multidisciplinary artist living in London. She spent her childhood in Goa, India, and various other hippy destinations for countercultural living and schooling arrangements, and relocated to London in 2001. She has presented her work extensively in the UK and abroad and also teaches at the Royal College of Art, London, UK. In 2008 she fell in love in and with The Adelphi hotel, Liverpool.

Dave Sinclair (b.1959, Liverpool, UK) is a photographer. He became photographer for the *Militant Newspaper* (1985–90). During the 1990s he worked as a freelance photographer before becoming staff photographer for Tower Hamlets Council (2001–14). He published his first

photographic book, *Liverpool in the 80s* in 2014, and *Dockers: the '95-'98 Liverpool Lock-out* in 2015.

Will Slocombe (b. 1973) is a poet and academic living in West Wales. He is interested in the ways in which narratives structure and reflect modes of thinking, as well as how we conceive of 'the future'. His research interests include intersections between biography and the history of psychiatry, science fiction (particularly depictions of AI) and new-media narratives.

Jocelyn Penny Small (b. 1945, New York, USA), Professor Emerita in the Department of Art History, Rutgers University, New Brunswick, USA, was Director of the US Center of the Lexicon Iconographicum Mythologiae Classicae for 21 years. She has focused on Etruscan art and pictorial narrative in numerous articles and books. Currently, she is working on illusionism in classical art.

Juliana Spahr is a poet, critic and associate professor at Mills College, California, USA.

Ying Tan is part of the Curatorial Faculty for Liverpool Biennial 2016.

Koki Tanaka (b. 1975, Tochigi, Japan) is an artist living in Kyoto, Japan. Solo exhibitions include MACRO, Rome, Italy (2015), Deutsche Bank Kunsthalle, Berlin, Germany (2015) and Passerelle Centre d'art contemporain, Brest, France (2014). He received the Deutsche Bank 'Artist of the Year' award (2015) and exhibited at the 55th Venice Biennale, Italy, where he received a special mention for national participation (2013).

Suzanne Treister (b.1958, London, UK) is an artist living in London. Recent exhibitions include, P.P.O.W., New York, USA (2016), Bard Hessel Museum, New York, USA (2016), ICA, London (2015), Centre Pompidou, Paris, France (2015), Kunstverein München, Munich, Germany (2015), ZKM, Karlsruhe,

Germany (2015), 10th Shanghai Biennale, China (2014) and 8th Biennale de Montréal, Montreal, Canada (2014).

Villa Design Group are Than Hussein Clark (b. 1981, New Hampshire, USA), James Connick (b. 1989, UK) and William Joys (b. 1989, UK). Their performances have been presented at LISTE Art Fair, Basel, Switzerland (2015) and Edinburgh Arts Festival, Edinburgh, UK (2014). Recent exhibitions include the Bernard Natan Centre of the Arts at MUMOK, Vienna, Austria (2015) and the MIT List Visual Arts Centre, Cambridge, USA (2016).

Krzysztof Wodiczko (b. 1943, Warsaw, Poland) is an artist living in New York and Cambridge, USA. Recent exhibitions include Muzeum Sztuki, Lodz, Poland (2015), ICA, Boston, USA (2009) and Venice Biennale, Italy (2009).

Betty Woodman (b. 1930, Norwalk, Connecticut, USA) is an artist living in New York, USA, and Antella, Italy. Recent solo exhibitions include ICA, London, UK (2016), Salon 94 Bowery, New York, USA (2016), Museo Marino Marini, Florence, Italy (2015), David Kordansky Gallery, Los Angeles, USA (2015) and Salon 94 at Frieze Masters, London, UK (2015).

Arseny Zhilyaev (born 1984 in Voronezh, Soviet Union) is an artist living in Moscow and Voronezh, Russia. Recent exhibitions include Centre Pompidou, Paris (2016), de Appel, Amsterdam, Netherlands (2016) and the 13th edition of the Biennale de Lyon, France (2015). Zhilyaev is the editor of *Avant-Garde Museology* (2015). He has been on the editorial board of *Moscow Art Magazine* since 2011, and is a contributor to e-flux journal. Recent accolades include the Innovation 2010 Russian state award in the sphere of contemporary art, the Soratnik (Companion-in-Arms) 2010 and 2012 awards, and a nomination for the Visible Award in 2013.

Acknowledgements

9th Liverpool Biennial
9 July – 16 October 2016

Director
Sally Tallant

Curatorial Faculty
Sally Tallant, Dominic Willsdon, Francesco Manacorda, Raimundas Malašauskas,
Joasia Krysa, Rosie Cooper, Polly Brannan, Francesca Bertolotti-Bailey, Ying Tan,
Sandeep Parmar, Steven Cairns
Assistant Curators: Mels Evers and Sevie Tsampalla

Liverpool Biennial Staff
Executive Director: Paul Smith
Development: Julie Lomax, Louise Garforth, Louise Shannon, Zoë Thirsk, Rachael White
Programme: Özkan Cangüven, Lizaveta German, Gabriela Silva, Aimee Johnstone,
Elizabeth Hayden, Jennifer Watts, Chantal Stehwien, Ottilia Ördög
Marketing and Communications: Joanne Karcheva, Helen Palmer, Rachael Bampton-Smith,
Sara Jaspan, David Lally, Sinead Nunes, Joanne Davey
Operations: Allison Mottram, Charlotte Horn, Susan Irons, Jane Howard
Curatorial trainees: Lucy Bretherton, Pippa Courtley, Dan Mahoney, Olivia Mullen,
Anna Ratcliffe, Bethany Slinn, Rosalind Stockhill, Katie Tysoe, Gabriella Warren Smith,
Melissa Whitehouse, Joe Cotgrave

Collaborating Curators
Tate: Lauren Barnes
Open Eye: Sarah Fisher, Thomas Dukes
FACT: Mike Stubbs, Ana Botella, Lesley Taker, Amy Jones
Bluecoat: Marie-Anne McQuay, Adam Smythe
National Museums Liverpool: Sandra Penketh, Chrissy Partheni
New Contemporaries: Kirsty Ogg

Thank you
The curatorial faculty would like to thank the artists for their profound commitment, as well
as the individuals, galleries and museums who lent works to the exhibition. We would also
like to thank Chris Bailey, Sonia Bassey, Alex Brewster, Cameron Brown, Laura Campbell,
Liz Chandler, Liam Coulter, Nina Edge, Joe Farrag, Jim Gill, Matt Harris, Rachel Harrison,
Alan Hill, David Hughes, Cornelia Huth, Hugo Jackson, Marc David Jacobs, Charlotte
Keenan, Tony Killen, Elliot Lawless, Rob Mason, Claire McColgan, Theresa McDermott,
Emeka Onuora, Steve Parry, Emily Parsons, Joel Pickavance, Erika Rushton, Andrew
Russell, Andy Sawyer, Michael Simon, Dave Sinclair, Pete Ward, Helen Weaver, Tony
Whitby, Mark Worthington, Matthew J Wright, Ami Yesufu

Colophon

Commissioning Editor
Rosie Cooper

Editors
Rosie Cooper, Sandeep Parmar and
Dominic Willsdon

Editorial Assistants
Chantal Stehwien, Mels Evers and
Pippa Courtley

Copy editor
Melissa Larner

Designers
Sara De Bondt and Mark El-khatib

Published by
Liverpool University Press

Printed by
Grafos S.A.

Liverpool Biennial
55 New Bird Street, Liverpool L1 0BW
www.biennial.com

Liverpool University Press
Liverpool University Press
4 Cambridge Street, Liverpool L69 7ZU
www.liverpooluniversitypress.co.uk

Distribution
Turpin Distribution
Pegasus Drive, Stratton Business Park
Biggleswade, Bedfordshire SG18 8TQ
T +44 (0)1767 604917

Oxford University Press
2001 Evans Road, Cary, NC 27513, USA
T +1 (919) 677-0977

Cover, back, inside flaps: frescoes inside the ABC
Cinema, Liverpool. The ABC Cinema, designed
by architects William R Glen and Alfred Ernest
Shennan, opened to the public on 16 May 1931.
It closed its doors for the last time on 29 January
1998. The last film screened there was *Casablanca*
(1942). Photos courtesy of Pete Ward, 2016.

Time Lived, Without its Flow is an excerpt from
a longer text by Denise Riley that was originally
published in full by Capsule Editions, 2012

Episodic Poetics by Matthew Garrett, copyright
© Matthew Garrett 2014 is included by
permission of Oxford University Press

An Exhibition that Troubles the Mind by Zian Chen
is translated by Daniel Szehin Ho

An Exhibition that Troubles Time by Zian Chen
is translated Alvin Li and interpreted by
Pauline Manacorda

H[gun shot]ow C[gun shot]an I F[gun shot]orget? by
Lawrence Abu Hamdan was first published online
in 'Decolonising Archives', *L'Internationale Online*
(www.internationaleonline.org) February 2016

The Last Parade of Planets by Arseny Zhilyaev is
translated by Tatyana Shenson

The Two-sided Lake, The Artist Made of Paper and
Van Gogh Ltd by Lu Pingyuan are all translated
by Katy M Pinke

*How to Fuel a Stellar Thruster with Dismantled
Fear* by Fabien Giraud is translated by
Juliette Desorgues

'Silence and Commotion: Towards a Possible
Iconography Inspired by Furio Jesi' was first
published in *Ennesima: An Exhibition of
Seven Exhibitions on Italian Art*, Mousse
publishing, Italy, 2015

Principal funders

 Founding Supporter
James Moores

Liverpool Biennial partners

 OPEN EYE GALLERY Bluecoat

 New Contemporaries

Commission and project partners

 UNIVERSITY OF LIVERPOOL

 ICA Metal Artangel HEART ꝯ GLASS

Sponsors

TED BAKER
LONDON
Bloomberg

Funders and supporters

Support for Arseny Zhilyaev's work provided by Dilyara Allakhverdova and Elchin Safarov.

Travel partner

Hospitality partners

Corporate patrons

PEEL LAND & PROPERTY

RACQUET CLUB
HOTEL & ZIBA RESTAURANT

Gallery circle

Casey Kaplan
Chatterjee & Lal
David Kordansky Gallery
Galerie Lelong
Galerie Micheline Swajcer
Gallery Isabelle van den Eynde
Kurimanzutto
MadeIn Gallery
Mai 36 Galerie
Pilar Corrias
Sadie Coles HQ
Wilfried Lentz Rotterdam

Patrons

Alex Wainwright (Chair)
Leila Alexander
Alice Anastasiou
Jo and Tom Bloxham
Simon Edwards
Jonathan Falkingham
Anna Fox and Peter Goodbody
Roland and Rosemary Hill
Daniel and Alison Rees
Paula Ridley
Peter Woods and Francis Ryan

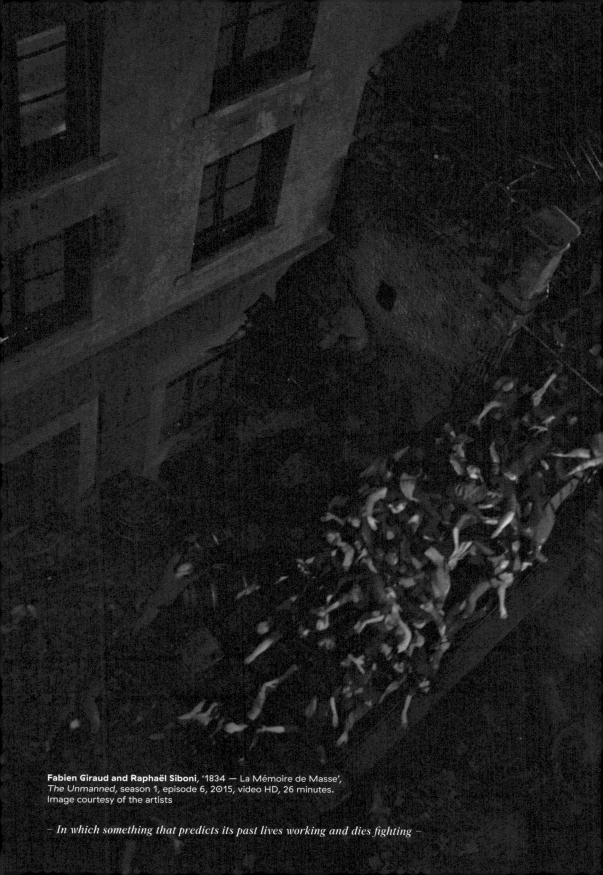

Fabien Giraud and Raphaël Siboni, '1834 — La Mémoire de Masse',
The Unmanned, season 1, episode 6, 2015, video HD, 26 minutes.
Image courtesy of the artists

– In which something that predicts its past lives working and dies fighting –

PLEASE DON'T TELL ANYONE THAT IM
NOT REAL And i DON'T BELONG.

JUST LET me go BACK iN
THAT BACKGROUND.